LANDSCAPE PAINTING WITH A KNIFE

LANDSCAPE PAINTING WITH A KNIFE

BY COULTON WAUGH

WATSON-GUPTILL PUBLICATIONS, NEW YORK

PITMAN PUBLISHING, LONDON

First published 1974 in the United States and Canada by Watson-Guptill Publications,
a division of Billboard Publications, Inc.,
1515 Broadway, New York, N.Y. 10036

Published in Great Britain by Pitman Publishing Ltd.,
39 Parker Street, London WC2B 5PB
ISBN 0-273-00832-3

Library of Congress Cataloging in Publication Data
Waugh, Coulton, 1896–1973
 Landscape painting with a knife.
 1. Landscape painting—Technique. 2. Palette knife painting.
 I. Title.
ND1342.W37 751.4'5 74-11148
ISBN 0-8230-2632-9

Manufactured in U.S.A.

First Printing, 1974
Second Printing, 1977

*"I am exploring
a new road,
but I whistle
as I go."*

Acknowledgments

These are people who helped Coulton and me on our Western trip and who helped me to finish the book:

Dorothy Dodge for driving us around the L.A. area and to Laguna Beach. Raima and Charles Gerlach for driving us around the San Francisco area and enabling us to see the big trees. Regina, Erianne, and Raymond Aichner for pulling us out of a smoggy situation and setting us up by the Pacific Ocean. Susan and John Waugh, Wanda and Bob Burwick, Bonnie and Ira Newman, were helpful on typing.

John Waugh was especially good in organizing many notes into final typed pages. Others who helped in many ways are: Raymond Bally, Pamela D'Armond, Philomena Galindo, Gwenyth and Floyd Clymer.

ODIN WAUGH

CONTENTS

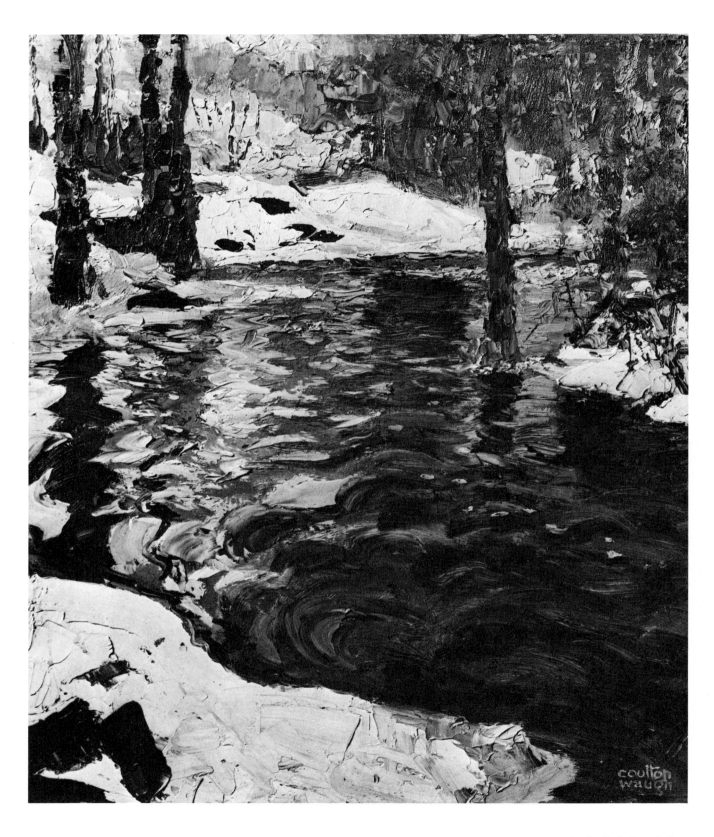

Brook in Silver and Gold, *20″ x 24″. Collection Odin Waugh. Here's the little brook that runs through my farm. It has all the dark mystery of a Rembrandt painting. I see the shadows, the light softly stealing in and around my brook. All this, so haunting—is it possible to paint? Why not? See, here's a painting knife. Here are the colors. It needs but bravery and a clean paint rag. Begin!*

INTRODUCTION

Landscape! What a big, noble word! "Land" suggests earth—something broad and far-reaching that pulls your gaze out to the horizon. "Scape" suggests escape—getting away from small entanglements, getting a bigger view of things, getting a big chestful of life-giving air.

Ever since man got his life organized enough to be able to look beyond the matter of raw survival, he's been awed and touched by the beauty of things around him. "I will lift up mine eyes unto the hills," we read in the Bible. And as we read, we can perhaps catch an imaginative glimpse of what the writer was looking at—the bare mountains of the Holy Land faint purple in the distance and perhaps modeled into fascinating abstract shapes by blue-violet shadows. In the same way, I lift up my eyes to the mountains of Arizona.

But not all landscape is so majestic and awe-inspiring, nor is it so far away and difficult to get to with a paintbox. The world's finest landscapes are very likely to be found in your own backyard. Drifting or towering clouds, gusts of refreshing rain, the poetry of sunrises and sunsets; these all uplift the drabbest of surroundings. It's just a matter of being able to see them.

If there's beauty in landscape everywhere, wouldn't you agree that there are also healing, comforting forces in the landscape around us? I think most people would agree. This is why so many people like to have landscapes, even if they're cheap reproductions, hanging on their walls, and why so many take up individual landscape painting in the time they can pry away from business or family cares. There's healing in landscape—I know this because I was actually healed by a landscape of a certain, special kind.

As a boy of twelve I blew out one eye in a rifle accident. I was a bit of a wreck, I imagine; at least I was unfit for further schooling for a while. But my parents, with rare understanding, sensed that I'd climb back to normal health in my own way.

Not far from our suburban house in Upper Montclair, New Jersey, there was a patch of woods with a little brook sparkling through them. My impulse was to merge myself with this bit of nature, to become part of it, along with its frogs, birds, and salamanders. I didn't feel any sense of loss or tragedy, for it seemed that this woodscape, or good old Mother Nature, had taken me over. At once I found an enormous number of vital matters to attend to: snakes and salamanders needed to be studied, and there was that matter of the glitter of light, the mystery . . .

Emerging from this experience completely healed physically, I was conscious of only one frustration. The beauty of the woods had healed me and I wanted to express my appreciation by painting it (I assumed I could, because I come from two generations of artists). But light glitters through the woods—sparkling, shimmering, getting lost and found again—to dissolve once more into mystery. I wondered: how can one paint that; how can one paint poetry, mystery? I went to art school to try to learn. There was something I wanted to know, but it wasn't there; I could find no technique adequate for my purpose.

I sensed that I had to make some breakthrough by myself, but it didn't come until many years later. When it did come, it was in a sudden, dramatic way, as unexpected as the crack of that rifle.

I was having my usual struggle on that day, this time with a thin-looking, weepy painting that was about to expire from transfusions of turpentine and painting medium. (For an uncertain reason, painters at that time felt they should take the kick out of their paints.) But as I looked down from my muddy, dreary picture to my palette, something hit me. I had squeezed a lot of fresh paint out on my palette, and no medium or turpentine had been mixed with it yet. The paint was messed around a bit, just enough to make interesting color variations in the rich, solid body of the paint. This color was *not* mud; it was gay, glittering, rich, strong, and beautiful—the exact opposite of those thin, diluted, mud-ugly colors on the canvas. "It

should be exactly the other way around," I thought. "Those jewellike colors should be in the picture where they can be seen!"

On impulse, I picked up the palette and slammed it paint-side forward onto a blank canvas that was standing nearby. Pulling away the palette, I saw at once that I'd crossed the threshold to new experience. I don't mean printing, I mean getting colors on a canvas with some of their original freshness, without deadly diluting and without the mud that comes from too much tedious intermixing.

But another problem remained: how to get those fat, rich, tube colors, bursting with their original robust brilliance, onto a canvas in some controlled way. Obviously, slamming a wet palette at a canvas wasn't painting. Some method of applying the tube colors without losing their original richness must be found.

I tried using brushes, but—at least in my case—that didn't work. The bristles left little grooves that created cast shadows and dulled the color. I needed something else.

By happiest coincidence, that something else was lying right there on my painting table. Sometime earlier, my father, the marine painter Frederick J. Waugh, had passed on. In his studio, in a discarded paintbox, I'd come across an oddly shaped little painting knife of extremely flexible steel. As far as I know, my father had never used it. But something about it— its jump, its flexibility—attracted me.

In my great hurry to discover a way to use paint directly from the tube without losing its fire, I seized this gleaming little steel sliver of a thing, picked up a big gob of tube color, and slapped it on a canvas with an impetuous stroke.

That was it. In that stroke, the pigment was just as fresh, just as gleaming, just as virgin, as the color right out of the tube. Experimenting further, I soon discovered the astonishing range of strokes and colors it was possible to create in this way. I could crash my colors like thunder or waft them in as light as a cloud shadow. I could pick up several colors at once and shimmer them together to produce the sense of millions of leaves, of fascinating, leafy, twiggy confusion. This was the exact effect I'd been searching for all those years: the spirit of the woods, the vibration of color and light.

In Chapter 2, I'll show you my father's wonderful little tool, which I've come to call the Magic knife, in detail. I'll also show you other knives that have special uses, including one knife that can duplicate the remarkable performance of my father's knife very closely.

In my first book, *How to Paint with a Knife,* I revealed my knife painting methods in detail. That book is very leafy, filled with pictures of the glittering brook that weaves through my little New York State farm. After I wrote it, the call came to take my knife out of my farm and into wider areas, to move from woodscape to true landscape—not only the intimate, familiar kind of landscape, but also the great, exhilarating, American landscape as a whole.

My artist wife Odin joined me, and we packed our knives and sketchboxes, and took off in a big sweep around America: to the South and Southwest; west to Los Angeles and up to San Francisco; northeast through the plains, the Rocky Mountains, and the prairies; then to Pennsylvania, New York, and back to Newburgh. Many of the pictures in this book are the result of that trip (chronicled in *A Painting Trip with Coulton,* page 169), which blew our eyes wide open and let the enormous American landscape in.

Many may tell us that we should have stayed in each area for five years without daring to paint it. But I feel that a fresh eye can catch things that might be missed when the scene is very familiar—so I make no apology for the freshness of my eye in many places.

You may find that the landscape principles in this book will add to what you already know, enabling you to paint successful landscapes yourself—which is the objective I've had in mind all along. I want this book to *work.* Let's sit down (or stand up) and together dig into what makes a landscape. And let's dig into how knife painting can make your landscape work more exciting.

The rewards of painting are great and lasting. I've had no other motivation in writing this book than to help you toward that self-expression that will make your pictures of mountains and fields, trees and meadows, something to comfort, reward, and sustain you for the rest of your life.

Heading for Natty Bumpo's Cave. *Odin says I look more like Natty than Coulton in this self-portrait sketch.*

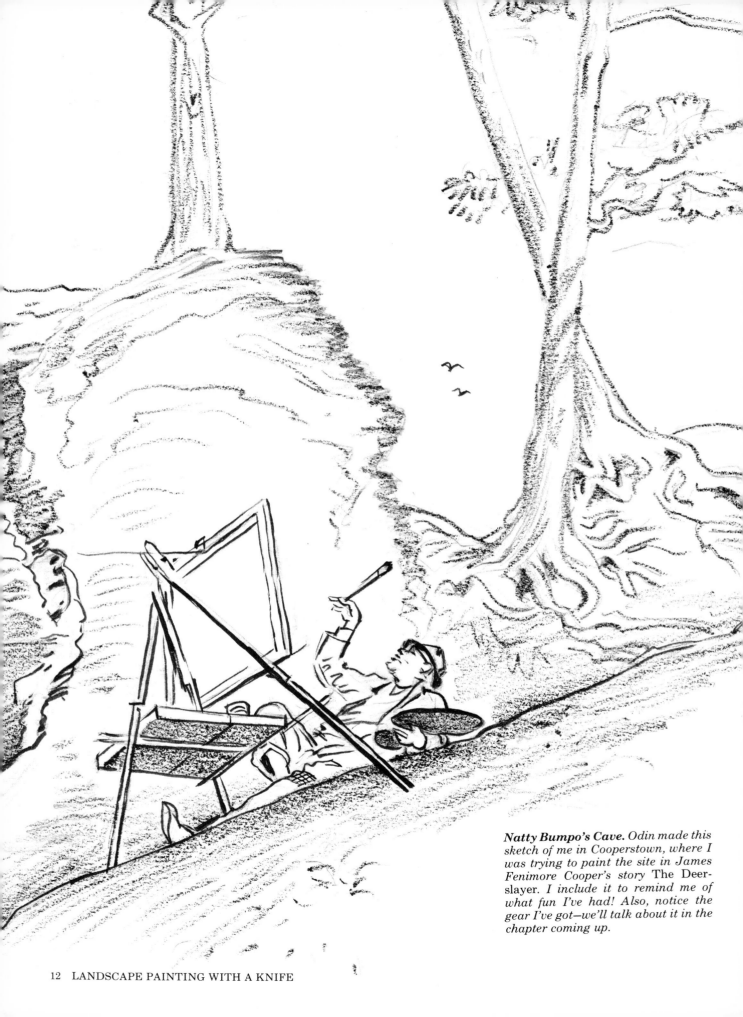

Natty Bumpo's Cave. *Odin made this sketch of me in Cooperstown, where I was trying to paint the site in James Fenimore Cooper's story* The Deerslayer. *I include it to remind me of what fun I've had! Also, notice the gear I've got—we'll talk about it in the chapter coming up.*

This book is meant to work for you. As you read it, I hope you'll experience the fascinations of knife painting by trying it out for yourself—by charging your own knife with glorious colors and seeing what they'll do as you spread them out, all satiny and glittering, on the canvas. The equipment you'll need is neither elaborate nor expensive, but it is essential.

We'll check out equipment in this chapter, but before I get down to details, I want to mention three elements all artists need in order to do serious work. These things are *proper light* (coming from the right direction and the right source), *quiet* (to allow for the necessary degree of concentration), and *space* (enough so that you can step back without knocking over bric-a-brac or bumping into an oak tree).

If you can arrange your life to include a maximum of light, quiet, and space, splendid; but if not, don't give up! There are many ways to get around obstacles. To develop my own knife painting style, I needed a great deal of freedom from commercial considerations. I used a formula of one-half commercial work to one-half painting time, while at the same time supporting a family that included babies (who know so little about quiet, and who occupy so much space).

Although I can't help you with your specific problems with working conditions, I can make a number of suggestions from practical experience.

Light Source

The best light source for indoor painting is natural north light (coming through a window that faces north); try to work under north light if you possibly can. Colors and color relationships are most accurate when viewed in this light.

The light source under which you paint and view your canvas has an influence on the colors of your painting. Since color is the most important element in knife painting, you wouldn't want anything to spoil it, would you? Well, you can spoil it yourself, and many

do without realizing it. There's a devil loose among artificial light sources, and it can kill your picture, with its delicate color relationships, exactly as dead as a dead duck. Fluorescent lighting—that's the culprit I'm talking about!

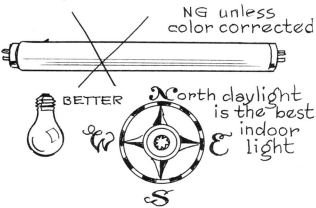

1. Artificial Light and Its Effect on Color. Beware of fluorescent light. If you do use it, make sure it's corrected with incandescent light.

The color curve of the fluorescent light doesn't match that of nature; it creates unbalanced colors. It's amazing how many gallery directors, designers of painting studios, and artists themselves fail to recognize this. You can check it yourself by painting a picture under north light, for example, and then viewing it under a fluorescent light. You'll certainly see a difference!

Let me make one reservation about this statement: by fluorescent light I mean a light that is *only* fluorescent, not one that has been combined with incandescent light in any way. Lighting manufacturers have been catching on, and you can now find various combinations of fluorescent and incandescent lights that make very good approximations of natural light. My objections don't apply to this kind of lighting. Such a combination of fluorescent and incandescent light is

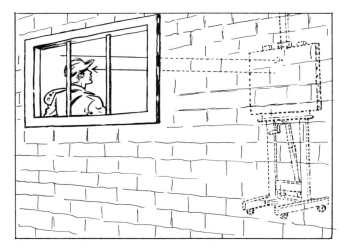

2. Bad Angle. *In fact, no angle. The light goes straight to the canvas and straight back to your eye, resulting in glare.*

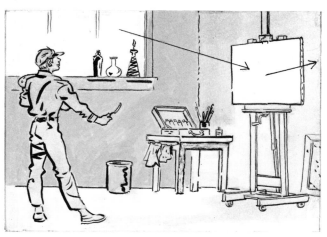

3. Good Angle. *The light comes from the left and shoots off to the right.*

quite acceptable. The "daylight" bulbs on the market are also acceptable light sources.

Daylight is ideal when working outside, but your canvas must be shaded from the direct sunlight. For color's sake, never paint with sunlight directly hitting your canvas. Pictures painted this way go dead when brought inside and viewed under artificial light. Not even a daylight bulb can revive them.

Lighting Situation

Light—either indoor or outdoor—can come from a variety of directions. It's important to understand what happens when light hits oil paint from different angles, so that you can arrange to work under the best possible lighting conditions. (As I'll explain in a later chapter, oil paint is the medium best suited to knife painting techniques.) Oil paint is rich in oil, of course, and although it displays colors beautifully, it's also shiny; it can, under certain lighting conditions, display a distressing glare that you never intended to make part of your painting.

The angle at which the light hits your canvas is the important factor. The following are descriptions of the wrong way and the right way to set up your canvas in relation to the light source:

Wrong Lighting Situation. In Figure 2 the easel has been rolled around so the canvas faces the light source. The glare is reflected directly into the viewer's eye. A painting done under such lighting conditions can be a total disaster—with darks, lights, and colors inaccurate and inharmonious—as well as a great strain on the nervous system of the artist.

Correct Lighting Situation. The way to establish the correct lighting situation is simple: just arrange things so that the light source, the canvas, and you are in the same relationship to one another as that shown in Figure 3. In the lighting situation illustrated, the glare is bounced away from the oil paint at the opposite angle from which it came in; the artist or viewer standing in front of the canvas is unaware of the glare and sees only what is intended.

Remember that there should be only one light source, that the light should come from fairly high over your left shoulder (or your right shoulder if you paint with your left hand), the canvas should be set at an angle away from the light, and you should face the canvas. The glare will then be unnoticeable and your nervous system will remain intact. You can apply the same principles when displaying or photographing your paintings.

Quiet

Quiet is perhaps the most difficult thing you'll have to win for yourself, as Figure 4 suggests in its slapstick

way. Yet you'll desperately need some degree of quiet, because quiet leads to concentration that generates good work.

Outdoors is where quiet grows on bushes, slides by on the rippling water, and shines down with the sunlight. Try to paint outdoors as often as you possibly can. The quiet will enable you to get your landscape going and keep it going. Even if you do only a small amount of outdoor work, you'll have glowing, vibrant memories; you can paint from these memories, sometimes better than if you were actually there. One such memory is worth ten of someone else's color slides!

Next to painting outdoors, some sort of studio is the quietest working environment. Rig one up if you possibly can, and make it a place where you can be alone, as far from the distractions illustrated in Figure 4 as possible.

Even if you can't build or adapt such a room for yourself, your case is far from lost. One north or east window (or one daylight bulb) can put you in business, although you'll have more noise to contend with.

You should also consider: you can't paint really well, with fervor and dedication, for more than about two hours at a time. So try to schedule your painting time so that it includes about two hours in the quietest part of the day, with at least two or three such sessions during the week. It's the sincerity, the intensity of your work, that counts. If your desire to paint is sincere, I'm sure you'll be able to wangle enough time and quiet to keep your paintings blooming.

Space

On this subject, I have some definite, down-to-earth conclusions to present. Suppose, as you're painting in your neat little home studio, you step back to look at your canvas, and knock over your mother-in-law's what-not with the pink china bulldogs on it. Something definite—down-to-earth—is certainly going to happen!

To paint in oil with force and seriousness, you *must* step back now and then. There's nothing wrong with working on a flat tabletop or a drawing board propped against a table if that's the only painting space available, but you'll definitely need open space behind you in which you can step back.

The reason for this is that painting is *not* illustrating. Illustrations are something you look at in a book or magazine, something you hold about 15 inches from your eye. But paintings are something you intend to hang on a wall. People will be looking at your pictures from an average distance of 8 feet, which is quite a bit more than 15 inches. Unlike illustrations, oil paintings must carry their messages across a room. The painter must therefore adapt his technique to take into account the distance from which his paintings will be viewed.

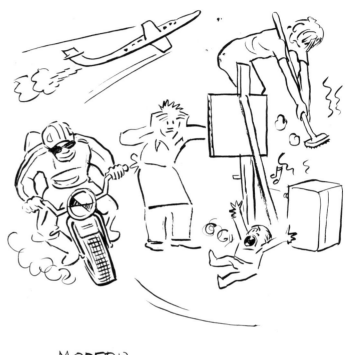

MODERN SITUATION

4. Peace and Quiet. *God bless you in your search for peace and quiet! I hope you make it.*

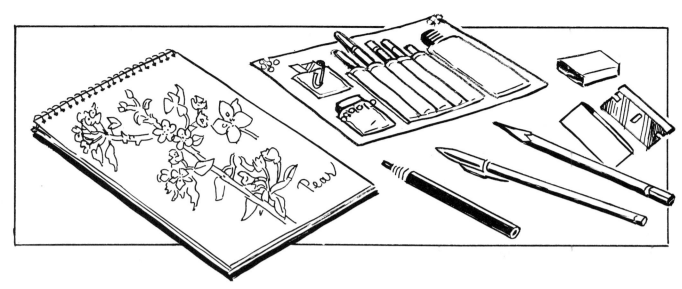

5. Sketch It. *Odin has carried a sketchbook all her life. I asked her to draw her setup, which you can make yourself with a piece of felt sewn with spaces for razor blade, eraser, pencils—even a comb. Odin keeps this kit and her sketchbook in a flat, sketchbook-shaped leather bag with shoulder strap. The pear illustration is mine—we get our sketchbooks all mixed up!*

Rembrandt was well aware of this point. It used to make him angry when people squinted too closely at the surfaces of his paintings, trying to divine his "divine" secret. "Keep your nose out of my picture!" he'd growl. "Don't you know paint is poisonous?"

Sketchbook

The subjects of quiet and space suggest the outdoors, and the outdoors suggests the sketchbook. By all means, get into the habit of using one! Landscape effects are influenced by rapid changes of light and weather; catching nature on the wing is part of the game. If you have a sketchbook handy, you can quickly capture the rhythm of moving clouds, for example, and make notes about colors after you've put the movement and composition on paper. Don't let those rare and wonderful landscape effects get away from you!

Another important reason for making sketches is that whatever you paint from them is a combination of your direct observation (the sketch) and your memories. This is very different from painting from photographs. (Of course, you may have to paint from a photograph of your pet bulldog sometime, but we're talking about painting here, not photography.)

A picture painted from a photograph, even if the artist took the photo, is not his own work in the same sense that a picture done from his sketchbook is. The camera contributes its own neatly focused point of view, registering a lot of details that the artist either doesn't notice or wouldn't otherwise include.

If you do work from photographs, I hope you'll include your own real emotions and feelings about the subject, painting from sketches and nature as well as from the photo. (I don't mean to belittle genuine photography. Photography used as just that—photography—certainly has its own creative moments!)

Paintbox

Now you know the basic requirements for working conditions—light from the right source and direction, quiet to concentrate in, and space to step back in. But look at Figure 6, and you'll see something else: a wonderful little piece of equipment called a paintbox. Non-painters may not realize it, but that paintbox is really a little studio all by itself!

You can use it anywhere: in your own painting nook at home, in your studio, outdoors, in the city, and in the country. My paintbox enables me to paint while whizzing about America on an Amtrak train. I can grab it up and race to catch wonderful color effects such as the sun setting over the Pacific Ocean. What the paintbox can contain, from the point of view of the artist who makes oil sketches outdoors, is fantastic. It can contain everything! (See Figure 7.)

Now, let's take a closer look. In Figure 6, all the contents of my paintbox are spread out so you can see how much equipment you can carry in it:

Canvas Panels. First, it has slots to hold something to paint on—three canvas panels that can be used for outdoor color sketches, which we'll discuss in detail later on. The great advantage of this paintbox and panel combination is that once your painting session is over, you can slide your wet panel back into its

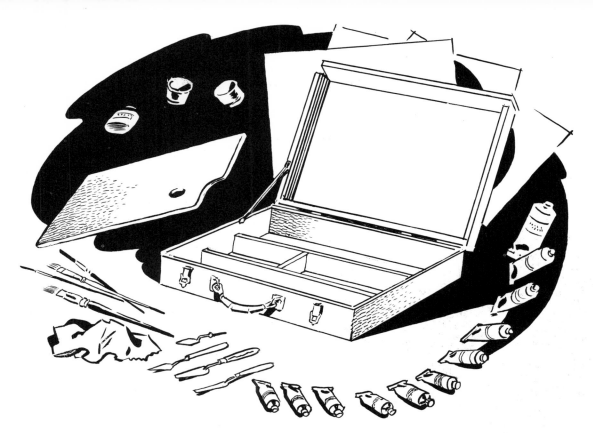

6. Paintbox. *Here's a classic 12″ x 16″ paintbox with its contents on display: turpentine and mixing cups, wooden palette, paintbrushes, clean paint rag, painting and palette knives, tubes of oil paint, and behind the box, canvas boards.*

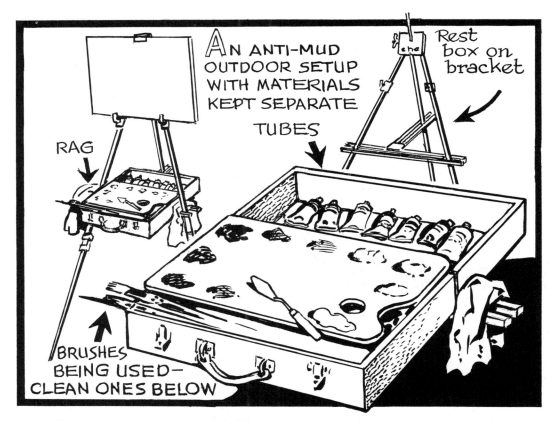

AN ANTI-MUD OUTDOOR SETUP WITH MATERIALS KEPT SEPARATE

Rest box on bracket

RAG

TUBES

BRUSHES BEING USED—CLEAN ONES BELOW

7. For Painting Outdoors. *I think this illustration speaks for itself. I'll just add that the braces that support the lightweight outdoor easel are an absolute necessity; without them, the whole setup would collapse.*

groove where it can dry in perfect safety, free from prying eyes and little probing fingers.

Palette. Next, the paintbox contains a very good and perfectly usable wooden palette. When first bought, this may be a bit dry-looking; rub a little linseed oil into it. It's a good idea to remove all the piles of color from the palette after painting and keep them submerged in a container of water until the next session; this will keep them from drying out, so that you can use them rather than having to throw them out. Then you should wipe the palette perfectly clean. After you follow this procedure for a while, your palette will have a lustrous surface which would be a delight to any artist worth his paints!

Paints and Other Tools. You can carry all the paints you need in your paintbox. This also applies to knives and brushes, as well as rags, a bit of turpentine to wash brushes and clean your fingers with (use a gel cleanser if you find the turps too drying on your hands), and a stick or two of charcoal. You can strap a sketchbook to the outside.

What more do you want? Basically, nothing; you can grab nature right out of that box. There are certain extras you should have as you progress, but we'll talk about those later on. At this point, you're very close to starting the big exploration—finding out how those knives and tube colors are going to work. But first we must list the colors and decide on which knives you'll need.

Paints

What kind of paints will we be using? Oil. That sounds final, and for me at least, it is. The knife technique involves using thick impasto; its special effects can be created only with deep, rich pigments. This rules out watercolor and tempera, leaving acrylic as the only possible rival to oil.

I have experimented very carefully with acrylic paints. I think acrylic is a wonderful medium—used with *water*. When dissolved in water, acrylics are great: they laugh, fuse beautifully, display brilliant colors, jump around. Used undiluted with the knife, impasto, it's a very different story: the colors are stiff, sullen, and don't want to fuse together. And they dry much too fast. My great delight in working with oil paints is to use them wet-in-wet, and acrylic can't be used this way. Step to the kitchen for a glass of water, and by the time you come back, the acrylic paints are stiffening up.

Anyway, why try to find a substitute for something that is already perfect? The greatest art in history has been accomplished with oil paints. If you own a Stradivarius violin, why try to swap it for some other instrument? I say: let's concentrate on mastering the Stradivarius!

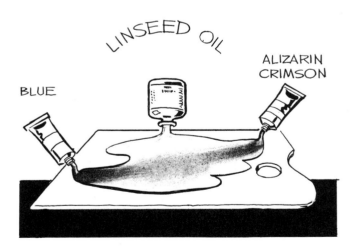

8. Oil Paint. *Perfect for the painting knife technique, inspiring, delicious—need I say more? At top you see a limpid pool of linseed oil, in which the pigment is ground to make tube oil paints. In the middle is a smudge of oil paint laid down on a white surface with God's own painting tool, the finger. If you try this yourself, you'll get the feeling of the oil paint—its viscosity, its smooth, luscious texture, and the way in which it can be delicately shaded at the edges of the smear. Above you see how linseed oil aids in the blending of oil paints.*

The Paint List

If oil is the right medium, what colors should we choose to stock our wonderful little studio-in-miniature, the paintbox? I'll recommend here a very simple set of colors, yet one from which the richest and most impressive effects can be obtained. Later, we'll look more carefully into these colors, to learn the exact characteristics and qualities of each one. We'll find out how they contrast with one another or fuse to produce the magical effects of light and shadow as well as the vibrations created by the wind—effects that can be made to parallel the excitement of nature.

Here, we'll be concerned only with the list of pigments, so that you can stock your paintbox and be ready for the big knife-painting act that is to open in the next chapter. This is the list:

Ultramarine blue

Cobalt blue

Cerulean blue

Cobalt violet

Alizarine crimson

Cadmium red light

Cadmium yellow medium

Lemon yellow

Raw sienna

Burnt sienna

Viridian green

Permanent green light

White*

*There are three white oil paints available: lead, zinc, and titanium white. Lead white has fine covering power, but it's poisonous—let's dispense with it. Zinc white cracks and has poor covering power—forget that too. This leaves us with titanium, and it's the perfect white to be left with, since it has splendid covering power and excellent working qualities. You can buy it under several trade names, such as Permalba and Everwhite. Just be sure the word titanium appears somewhere on the label. You'll use a lot of white in this business, so you'd better buy a half-pound or pound tube.

These are the basic colors to buy now in studio-size tubes. Later, when you set them out on your palette, it's a good idea to decide just where each color will be and then use that arrangement whenever you paint. You'll find that you can work faster and more neatly, and you'll learn more about color mixing if you use the same palette arrangement each time.

What About Black?

In knife painting, we shoo black away from our gleaming set of colors because it represents value, not color; black is actually the absence of color. We must have darks, of course, and I'll show you how to make wonderful darks with nothing more than the basic colors—but that comes later, in Chapter 4, *Color*. However, there's a good reason for you to buy a tube of ivory black at this time. Illustrations of how to use knives are coming right up in Chapter 3, and these are done in black, white, and shades of gray. If you feel an irresistible yearning to try out these techniques in color, go ahead—but I'd much rather have you work on them in black and white. If you make your practice strokes as much like those in the illustrations as possible, you'll be better able to gauge your progress. So, if you agree, get a tube of ivory black. But be severe with it; use it for practice but keep it away from those colors!

Other Practice Materials

One extra which will prove valuable is a paper palette. Since you can tear off the sheets as they become dirty, you'll always have new mixing space without continuously cleaning your wooden palette. However, I don't recommend using paper palettes for experimenting with knifestrokes, as they have the diabolical habit of rippling so that your knives can't slide smoothly over their surfaces. For practice painting supports, I often use flat paper such as typewriter paper, taped down on a rigid surface and sprayed with a coat of retouch varnish. Canvas pads also provide excellent painting surfaces. Made of canvaslike paper, they're flat and take oil paint well, and they come many to one pad.

The 12" x 16" canvas panels that fit in your paintbox are also perfect for practice painting, but they're a bit too expensive to use in any quantity. I suggest you keep some of these for putting down knifestrokes when you've really mastered them. Then you can sign them, date them, and save them for posterity.

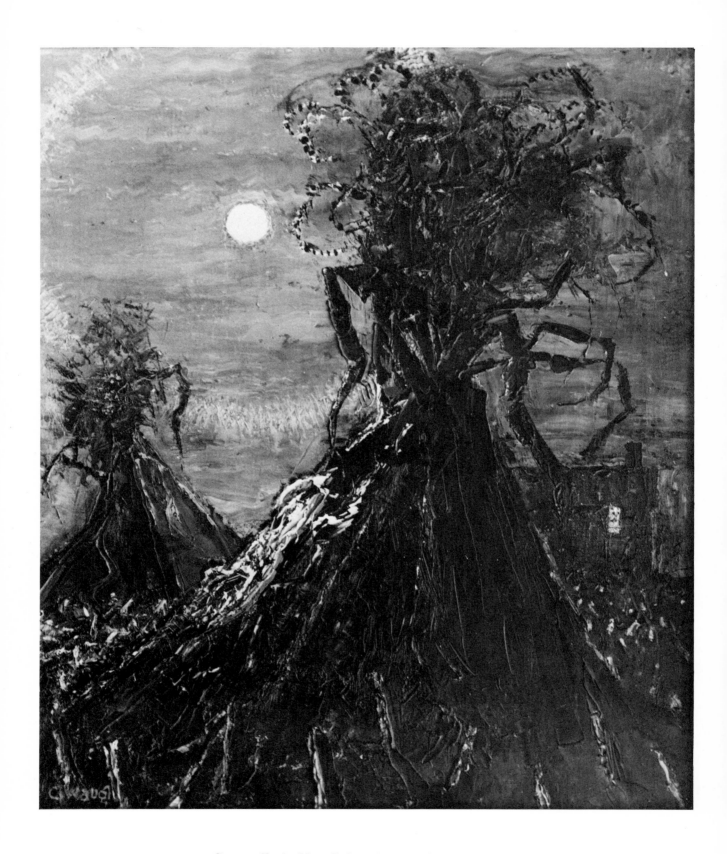

Cornstalks in Moonlight, *24″ x 20″. Collection Edwin A. Ulrich. The moonlight, the room light, and the highlight on the corn combine to create a poetic design in the night. I used especially heavy paint on the shocks and fields, bringing them forward from the more thinly painted sky. The halo around the moon was done by patting paint on lightly with the edge of the knife.*

2
ON STAGE: THE KNIVES

Ladies and gentlemen, the curtain is going up and the show is about to begin! We're going to display our team of little steel stars, the painting knives. You'll find there are many kinds of knives that perform in many different ways. But there are certain things they all have in common. The paint they deliver is bold; it stresses the movement of one artist's arm, gives form to his stroke. The paint they deliver is also brilliant; it is clean and clear like enamel, and like enamel it can display color with a unique freshness and depth.

Palette or Painting Knife?

Before approaching the moment of truth, before learning about the various types of knives and how to use them, there's some confusion we must untangle: is a palette knife a painting knife, or is a painting knife a palette knife, or are they simply all the same?

No, they are *not* the same, and the distinction is one you must understand. The humble little slave of the palette is the ordinary palette knife. That's his name and that's where he lives, down among the paint scrapings. He's no aristocrat. His plain, straight handle and straight, stiff, inflexible blade hint at his occupation: he's a paint peon; he shovels the dirt. Piles of pigment are very apt to be left on palettes, and the palette knife must be equipped to scrape them off with his rigid blade.

There is, however, another kind of palette knife that has been improved, so much improved that I think every artist who paints with a knife should have one. The handle of the lower knife is stepped up from the plane of the blade; this is a great improvement because it keeps the artist's fingers out of the pigment. The blade, furthermore, is not stiff all the way down but has a decided flexibility toward the point.

Palette Boy (I gave him this name because he can do a number of things so well) has become my Number One boy around the studio. He can scrape as well as any other palette knife, and he can mix pigments together a great deal better because of the flexibility of

that lower portion of blade. For this reason, too, Palette Boy actually paints, at times, on the canvas. He can neatly fix up the more lyrical, extravagant escapades of the painting knives. If he isn't the star around the place, he's a faithful retainer and I often talk to him. Maybe we all need a retainer we can talk to—who won't talk back!

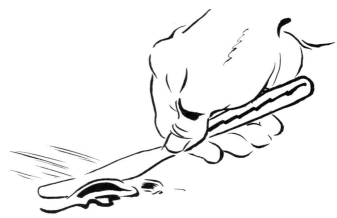

9. Palette Knife. *This is the workhorse of your paintbox. It's great for scraping your palette clean or for scraping old paint off a picture, but not for much else.*

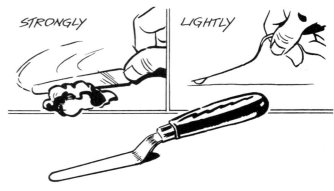

10. Palette Boy. *This palette knife is also good for scraping, but because it has a flexible tip it can be used for painting too.*

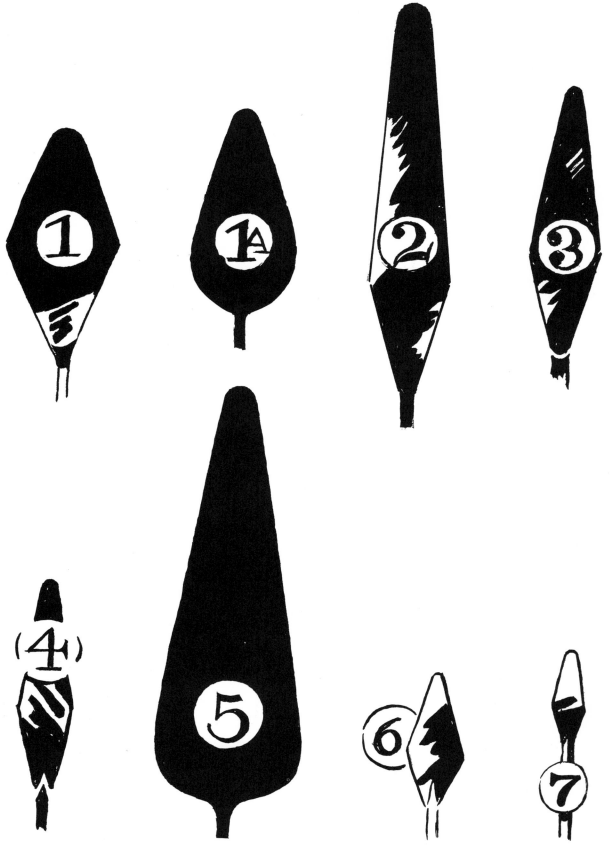

11. The Painting Knives. *There are many painting knives, more than I show here, but these are my favorites. Also, these will give you an enormous range of effects. They are: (1) my London knife; (1A) a Magic knife that I call my New York knife; (1B, opposite page) another Magic knife; (2) Long John; (3) Arrowhead; (4) a good medium-size knife; (5) Big Talk; (6) Chunky, a small knife, good for texture; (7) Mini Squirt.*

Curtains Up on the Painting Knives!

The painting knives illustrated in Figure 11 represent a group which I've found, after twenty-five years of experimenting, to be those most suitable to my particular form of expression. As you can see, these knives vary in shape and can be used in many different ways. But there are other knives, as well as other forms of expression; don't hesitate to try other knives, compare them with the present group, and adopt them if they serve your particular purposes.

In this chapter I'll discuss only the first three knives in Figure 11, referred to collectively as the "Magic knives," and identified individually as knife 1, knife 1A, and knife 1B. The Magic knives are at the core of this book. It was through them that my particular way of painting germinated and grew. As we study more about knife painting techniques in Chapter 3, I'll introduce you to Long John, Arrowhead, Big Talk, Chunky, and Mini Squirt.

The three Magic knives have several highly important characteristics in common. They're all short and broad—with the result that it's possible to pick up unusually large charges of pigment on them. They're even broad enough to handle several colors at the same time. And the forward edges of these knives are straight on both sides. This means that you can turn them sideways and start a new stroke of color with an extremely sharp, clear edge. Also, by pressing the knife edge directly down and then lifting it sharply, you can make beautiful hairlike lines (think of what this will mean when you're painting winter weeds showing through snowbanks).

Another similarity is that all three blades are extremely flexible toward the point, but rigid and strong where the blade joins the handle. Notice, too, that all these knives have rounded rather than sharpened points. The ways in which these characteristics can

help you will become apparent in later chapters, as we explore actual knife painting techniques.

Magic Knife 1

This knife is the pioneer, the granddaddy, the original of the clan. It's the knife whose story I told in the Introduction to this book—the one I found in my father's paintbox, and which led me to develop the techniques described in this book.

Stamped on the upper part of the blade is "Winsor & Newton, Ltd. England"; this implies that this knife was probably brought to America when my father returned in 1907. To identify it from the other Magic knives, I call it the "London knife." I started working with my father's little knife in the spring of 1946 and am still using it today, having used it exclusively to paint hundreds of large pictures. Yet its spring is still as bouncy as ever; it still jumps and flutters, light as a leaf.

What's the secret of such longevity of service? This knife must be made of superior steel. The two parts, blade and handle, aren't welded or joined from separate pieces but are formed from one piece, which is subtly graded—from a hairlike thinness at the tip to a rigid, sturdy thickness closer to the handle.

Can you buy a knife of this exact pattern? It saddens me to have to say that I don't believe you can. As far as I know, this is the only one in existence. But the case for those who wish to experiment with Magic-knife painting is by no means lost: Magic knives 1A and 1B also deserve a share of the spotlight.

Magic Knives 1A and 1B

I discovered Magic knife 1A recently in New York City, so I call it the "New York knife." To my joy and relief it's available in certain art supply stores (buy one instead of being frustrated about the unavailability of the London knife). I've been testing knife 1A, and I find that its performance just about duplicates that of knife 1. The differences are minor.

The straight edges of 1A are longer than those of knife 1, giving you the option of making a broader stroke and longer edge lines. The tip is extremely flexible; it can lay a somewhat better dot than knife 1. In most other ways, these knives paint side by side; the magic is in them both.

What about Magic knife 1B? Many of the knives knocking around art supply stores fall into this general category: they're short, trowel-shaped, and broad. If you can't locate a New York knife, a knife like 1B will enable you to paint along with the exercises coming up in later chapters very well. But remember, in selecting a knife like 1B, try to find one whose blade is really springy and flexible toward the pointed end, and heavier farther back.

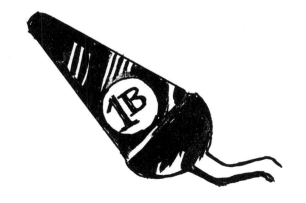

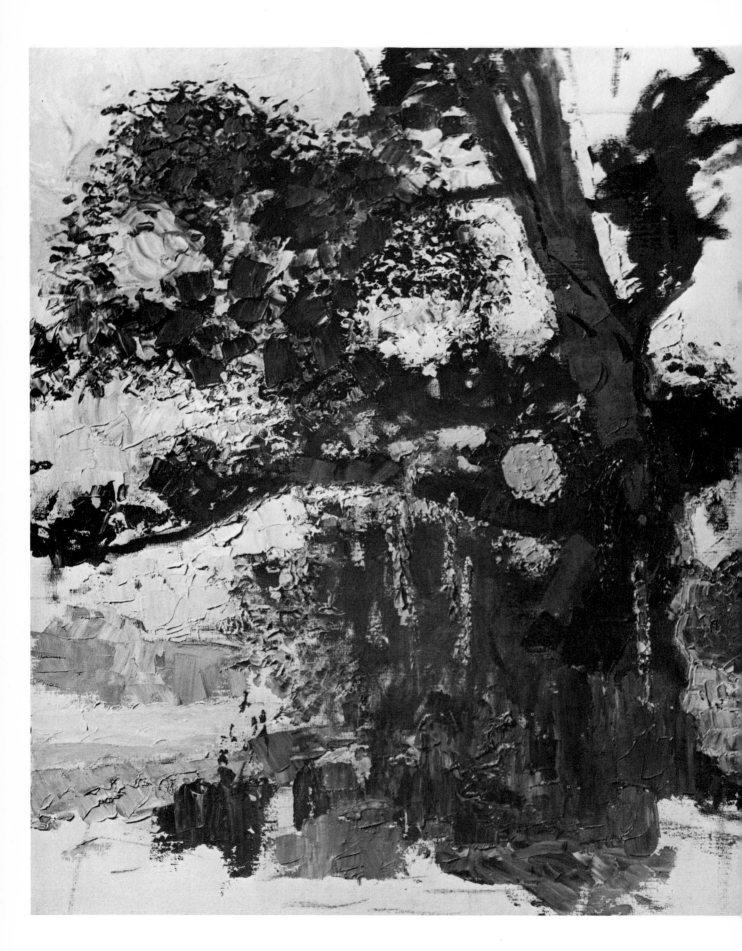

Why No Handles?

You're probably wondering why there are no handles on my Magic knives. For the answer, I'll have to take you back to the London knife story again.

When I found that knife, it *did* have a handle. But it was badly cracked and quite loose. "I'll have to rig a new handle," I thought as I pulled off the old one. But suddenly I saw a chance effect that I *had* to paint, so I grabbed up the little knife just as it was, without its "handlepants," and started painting ferociously. When I stopped later and discovered the situation, I said to myself, "Hey, this knife was painting so loose and free—and without the handle! Could the handle have something to do with the freedom?"

It could and it did. Without the handle, I could hold the knife much more loosely, as a musician holds the bow of his violin. The knife was lighter without the handle, so that it could flicker around in a more fascinating fashion. And it was more intimately related to the fingers: it seemed as if the impulses from my brain raced even faster down my arm and into my wrist, hand, and knife with a more fluid, more connected mo-tion. And all this excitment passed instantly onto the canvas.

I've been painting without a handle ever since. Was I too lazy to make one? No. I left the handle off because I honestly believe that the knife's naked state has a lot to do with its unusual lightness and flip. A handle is something like an anchor; a ship can't sail if its anchor is down.

Now you'll probably ask, "Should I remove the handles from my Magic knives?" I think you should—but I don't think it's necessary to do so with your other knives. Those depend more on the motion of the arm, and the handle helps in arm control.

Just a few words of advice: I found that knife 1A needed a somewhat better finger grip than the bare uncovered steel. I wrapped a bit of tape around the base, which didn't hold it back at all. Also, since knives are quite inexpensive, why not buy two Magic knives and remove the handle from only one? Then you can draw your own conclusions by actually painting with them both.

Sun Through a Tree, 22″ x 28″. Collection Odin Waugh. This unfinished painting, the result of a single afternoon session, is helpful in studying knifestrokes. The ones used here are bold and unworked-over. I wouldn't do any more to the tree and sky to the left of the tree, but perhaps I would paint in the upper right corner and the lower edge. Small, leafy, pouncy dark strokes combined with square, lighter block strokes give depth to the foliage. In color, this painting is strong red-orange and yellow, blue and blue-violet.

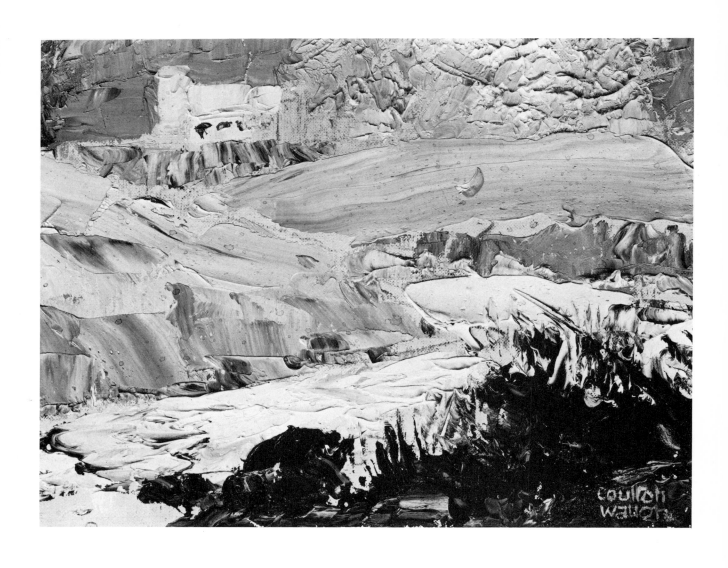

Breath of Spring, 20" x 24". This little picture, done with slashing knifestrokes, looks unfinished up close. But from a distance, the thick paint turns into barn, field, trees. Notice the vertical and diagonal agate strokes on the bank and the wibble wobble in the water, the most distant water curve being a single stroke. The two trees on the right were done with a pounce technique: just push the paint on and pull the knife off. After painting for two hours I was tired and said, "I don't know what to do with this field beneath the two trees." Odin said, "I do," and she made the whole field with one stroke of a Magic knife.

HOW THE KNIVES WORK

For these first exercises in this chapter, you can get along with only one knife, but it must be the star, a Magic knife as much like knife 1A or 1B as you can find.

Get Ready!

The time has come for action—*your* action. You should have your painting setup ready: something to paint on, palette, paints, rags, and your New York or other small, broad Magic knife.

Squeeze a good-size gob of black paint onto your palette and squeeze a little white nearby (mixing these will make the paint spread more easily). Mix these pigments together with your Palette Boy or Magic knife, keeping the blade flat on the palette. Then scrape the mixture sideways, so that paint is piled up next to one edge of the underside of the knife blade.

Now I'll introduce you to the essence, the very core, of knife painting through an exercise that will take you only two wonderful seconds.

The Big Stroke

So that knife of yours is all charged and ready to go! Lay it down on your painting surface at about the angle shown in Figure 12. Be sure the knife edge (A) makes a firm contact with the paper or canvas. For best results as the stroke proceeds, you should turn down the upper knife edge (B) slightly, so that the paint is continually being fed to the surface. A very slight twist of the wrist downward will accomplish this, and the action will very soon become automatic. Swing the knife quickly from right to left by moving from your shoulder, keeping firm contact all the way, as you jolt it quickly across the surface. When your knife has traveled 2″ to 2½″, lift it sharply. What's lying there is the "big stroke."

I've chosen to introduce you to knifestrokes with the largest, most dynamic one of all because I want

you to sense the difference between this and other styles of painting. I'll have many other strokes to show you—some of the utmost refinement and delicacy—but at this point you're starting with a thunderbolt, and the illumination that follows it will light up the whole panorama of knife painting.

If Thunder Fails . . .

As you look at the black lightning you've just created, you may be disappointed. But a few little skips and ragged edges don't matter. If, however, your stroke looks more like the ones in Figure 13, mark yourself "B" or "C," but don't get discouraged. There are lots of little timidities and inhibitions that have to be brushed aside before your strokes will come out with the boldness and fresh, speedy look which is the essence of this painting technique. Take a look at the three unsatisfactory strokes in Figure 13, as we discuss exactly what caused them:

Too Little Paint. Failure A was caused by the simple matter of not charging the knife with sufficient paint. Knifestrokes don't just jet out on the canvas by themselves; it's a generous hunk of paint that makes them work. The accompanying diagram shows about how much paint is needed. If your stroke looks like this one, mix some more paint and try again until your result looks like B.

Timid Stroke. Failure C was caused by timidity. The beginner is apt to approach the matter of making a stroke as if he were being introduced to a gorilla: he wobbles his hand, fails to put the knife down firmly, and brushes the paint uncertainly along to make something that isn't a stroke at all. The remedy: just remember there isn't any gorilla. The good, strong result waiting for you is there all the time, just as swimming is there for your enjoyment. But in both cases you've got to jump in. So try again. Pick up a lot of paint, press one knife edge down, and move it across the painting surface, keeping a clinging contact with

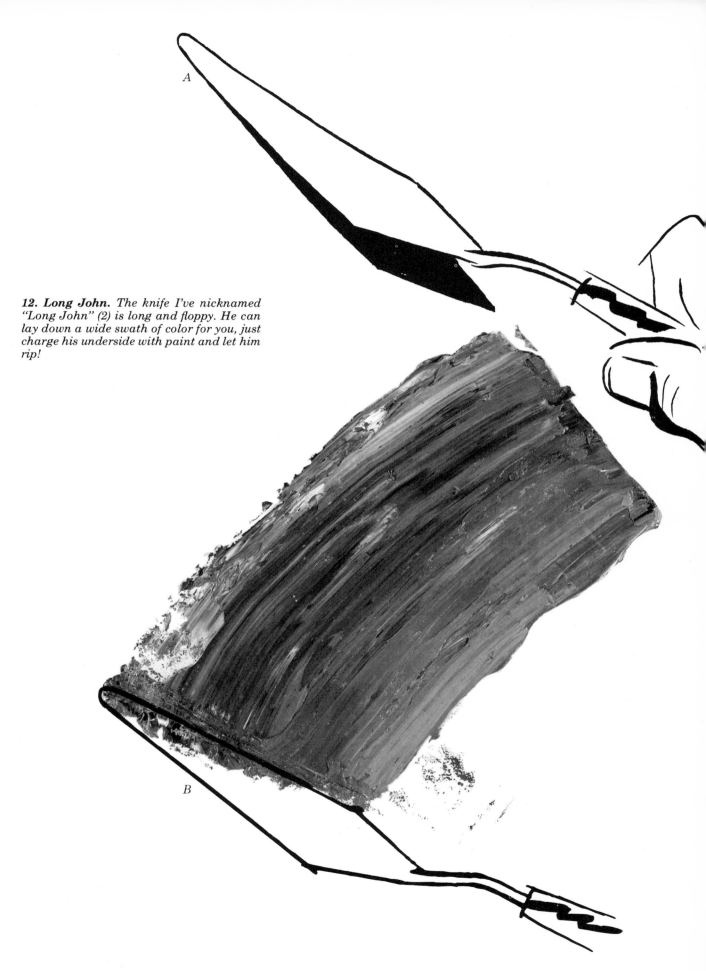

12. Long John. *The knife I've nicknamed "Long John" (2) is long and floppy. He can lay down a wide swath of color for you, just charge his underside with paint and let him rip!*

A

B

it. Lift the knife sharply up after about 2½″ of stroke. Make your hand move *fast; jolt* it across. It doesn't take strength, just determination.

Uneven Pressure. Failure D is closer to being a good result. Note that the lower edge of the stroke is well developed. The trouble was that the knife didn't lie *evenly* on the ground; there was more pressure on the bottom edge than on the top one. The entire knife surface should be involved in the stroke. For practice, it might help if you clean your knife blade by pulling it through a folded rag and then try some dry runs across the painting surface. Without any paint on the knife, you can carefully check the evenness of the contact between the knife and the surface.

You may have more failures, but stay with it and soon you'll have a strong, lusty stroke lying there—a stroke with a sense of speed about it, a sense of youthful impulse.

The Straight Line

Figure 14 shows straight strokes. Try making this stroke by moving your knife from left to right and then from right to left. If you've progressed in making strokes, you'll have little trouble with these. Now shift the direction of the strokes, making some go up and some move diagonally to the right and left.

Straight lines can also be combined in a diagonal zigzag pattern whose motion actually suggests a curve. Try some of these, too; they'll provide good practice in varying the direction of your strokes.

In Figure 15 there are vertical, horizontal, and zigzag strokes. The zigzag strokes dance back and forth to create dynamic movement; this is heightened by the contrast with the stationary elements—the broad horizontal lines that suggest solid ground, and the upward-reaching lines of the motionless cactus.

Remember that a change in direction requires a definite shift of the wrist. Soon your wrist and arm will be shifting in new directions all over the canvas. It'll be a very pleasant experience, a new kind of dance using the hand instead of the foot.

The Curving Stroke

The curving stroke is produced by the swinging action of a flexible wrist and arm (Figure 16). Try out this action with a clean knife, and you'll find that you're naturally equipped to produce at least three kinds of swing. One is from the shoulder, with wrist and elbow stiffened; this will give you a very large circle, perhaps 4′ in diameter. Another is from the elbow, with stiffened wrist; this results in a half-circle about 24″ across. Then there's the swing of the wrist alone, which produces a half-circle with a 4″ diameter.

Now charge your knife with paint and experiment

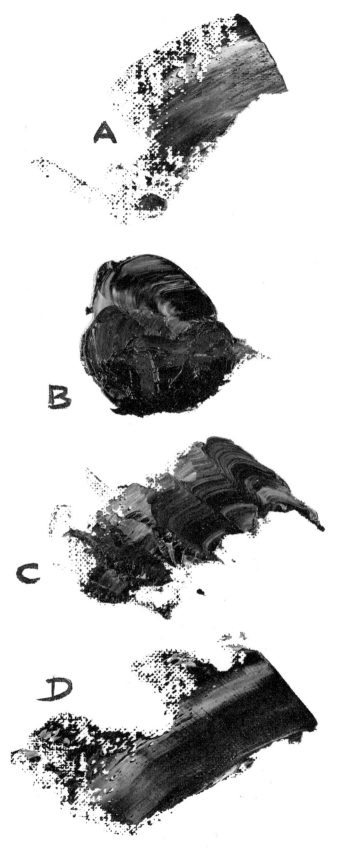

13. Something Wrong? *You bet: (A) too little paint, use about the amount shown in B; (C) hand wobbles, not held down firmly enough; (D) knife doesn't lie evenly on the canvas, there's more pressure on bottom edge than on top.*

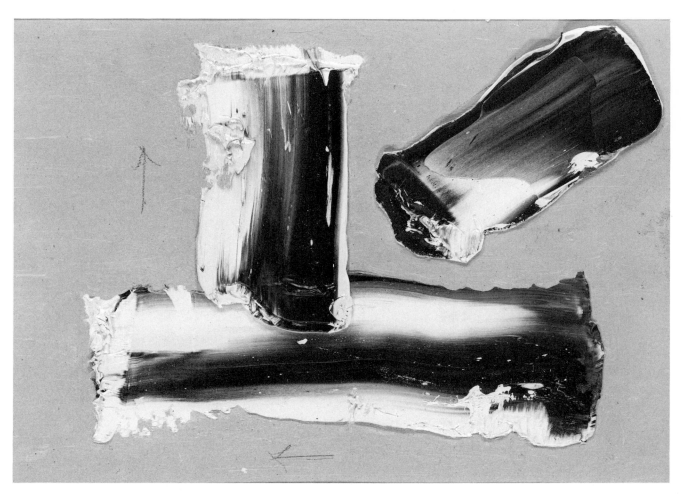

14. Knifestrokes Straight and Strong. *Plenty of thick paint helps you achieve these strokes, shown here actual size. Notice that they're not ragged at the sides, but full and sleek.*

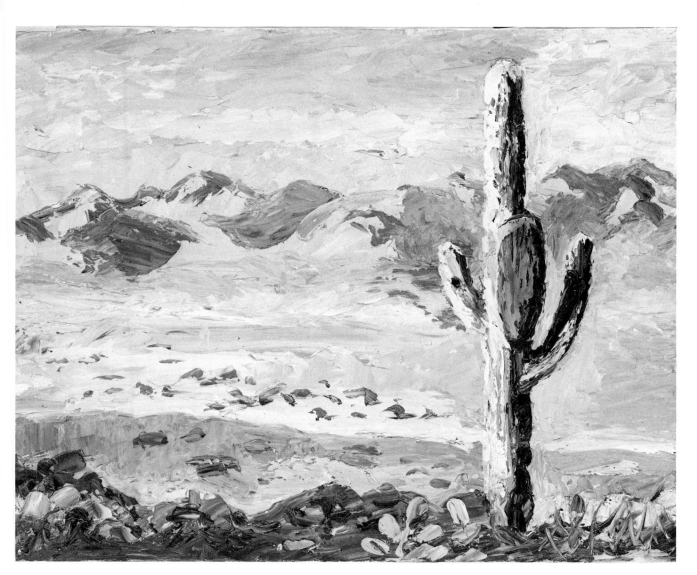

15. Stage Set Near Tucson. *This isn't really a stage set, it just looks like one: the horizontal line of the ground shadow and the upright of the cactus set the stage for the dancing mountains.*

16. Curving Stroke. *I'm using my London knife to get this stroke, but you can use the Magic knives 1A and 1B or Chunky (6) or Mini Squirt (7) to get the same effect. The curving stroke is made with a quick flip of a flexible wrist.*

with these three types of curves. Decide which part of your arm or wrist you intend to use, and shift into the stroke as you'd shift into one particular gear on a gearshift car. You'll find that these curved strokes are very valuable in painting with a knife, and you should become thoroughly familiar with them.

The Button Stroke

There's one very small, half-circle stroke I really enjoy using: the "button." To make it, charge your knife generously with paint, lay the tip down on your painting surface, and dig into it as if you were trying to puncture a hole in it. Then bend the paint-laden underside of the blade downward and twist the charged knife around in a half-circle, keeping the knife tip in the original spot. The result will be a charming little button of paint that's easy to make and fits right into all sorts of interesting places in your landscapes.

The Agate Stroke

The agate stroke takes advantage of the pleasant grain, or streakiness, of paint mixtures that aren't too thoroughly blended to create textural interest in a bold and striking way. Begin an agate stroke by picking up a light tone or color on the underside of your Magic knife and a contrasting color or tone on the other side (Figure 17). As you make the stroke, draw your knife very firmly along the painting surface. When you lift up your knife, you should find something fascinating lying there: soft stripes and fusions of color, so subtly blended that they'd be impossible to reproduce deliberately (Figure 18). Your stroke should resemble a semiprecious stone, which is why we speak of it as an "agate" stroke. Furthermore, the soft fusions and lines will be stretched out in the direction of the stroke's direction, and this will heighten the sense of movement.

The Strokes Narrow

So far, you've been making large, full strokes, using the broad blade of your Magic knife. You'll have many occasions to use these strokes in painting landscapes; you can zip them across skies, or create distant meadows in one exhilarating swoop. But there'll also be a great many occasions when smaller, narrower strokes will be called for. Let's look at how these are made (Figure 19).

The simplest way is to change knives. Although some of the larger knives like Long John, Arrowhead, and Big Talk can be made to produce small strokes by picking up smaller piles of pigment, this method is chancy. The best method is to use a much smaller knife, whose underblade can handle only a small amount of pigment.

Such a knife is the dependable little Chunky. Note

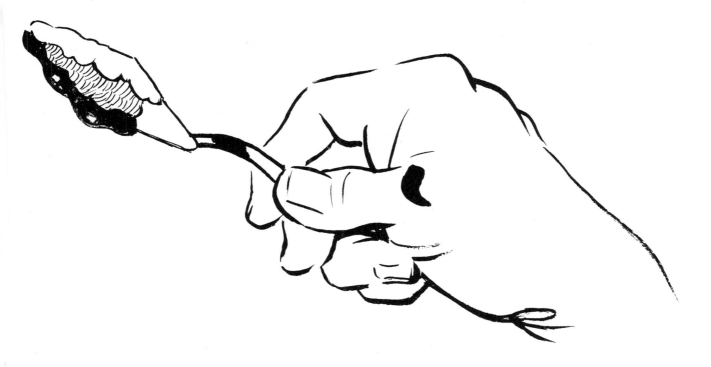

17. Load up for the Agate. *Try two colors on each edge of the knife as well as two colors on one edge. The knife shown here is the Arrowhead (3), but Magic knives 1A and 1B are also excellent for rendering the agate effect.*

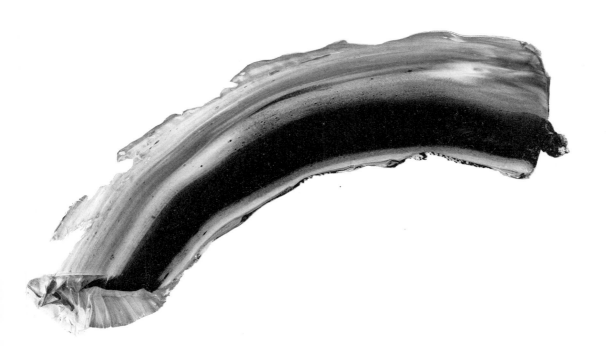

18. Agate Stroke. *I call this stroke "agate" because of its multicolored, jewel-like shimmer.*

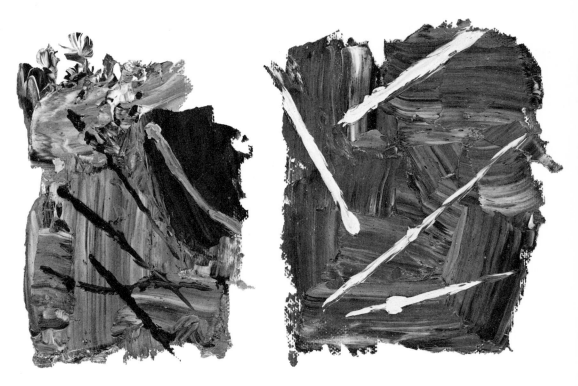

19. Strong and Light. *These strokes were made by Chunky (6) in a wet underpaint ground. The knife is held very slightly to produce the delicate, twiglike strokes.*

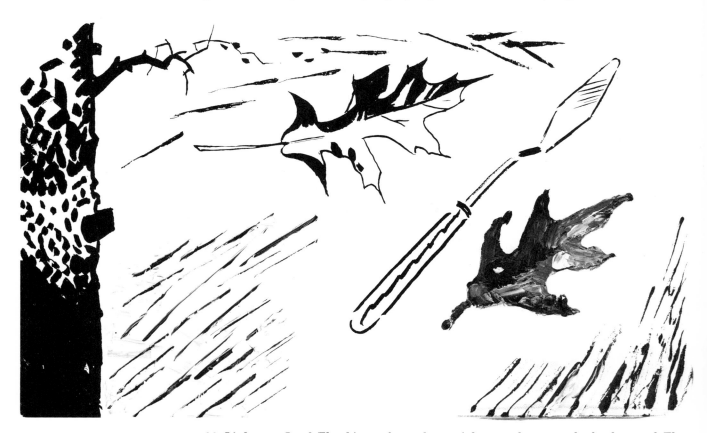

20. Light as a Leaf. *The thin strokes at lower right were done on a dry background. The strokes near the tree were done over wet paint, which is better for detail work. The tree, upper leaf, and knife were done in ink. I seldom try for such hair-raising precision with a knife. (The one shown here is knife 4.)*

its shape in Figure 11. The straight edge in front, which delivers the paint, is about 1″ long and the edges behind it sweep sharply back so that you can grab up a load of pigment and the stroke will automatically come out about 1″ wide.

Still smaller, and also remarkably dependable, are the well-formed strokes produced by that pygmy of the knife world, Mini (which I've nicknamed Mini Squirt). About ¾″ long, these can be produced rapidly; they're not apt to smear, and they're specially suited to lapping one color over another to produce delicate effects.

Smaller Still

To come down to an even smaller stroke, we must change our way of using the knives. Instead of snapping the knife *across* the painting surface, we'll charge the underside with pigment, put the tip of the knife down on the surface, and draw it back and away from the first mark to produce a long stripe (Figure 20).

Stripe effects are difficult and uncertain, yet they can be very effective, especially if used over a layer of wet paint rather than on dry canvas (which tends to hold them back). I suggest you experiment with all the knives mentioned—and any others you happen to have—to determine the kinds of stripes they can produce. My personal favorites are the Magic knives, and that marvelous operator, Long John.

Let It Flop

Long John is a knife personality by itself (Figure 21). It's floppy, which makes it different from other knives; its long tip is very loose and flexible, enabling you to drop in paint textures as well as strips, even enabling you to sketch with it. Artists have always loved to sketch, sensing that pictorial ideas are often more truly expressed by a sketch than by the grinding labor of painting them all out bit by bit. Long John will help, so turn him loose on sketches. As for stripes, L.J.'s stripe is rather thick, but coming from that long blade, it flows out more consistently than it does from other knives of that length.

The Trunk Stripe

Here, let's explore the problem of a tree trunk in winter, a fairly wide trunk that narrows on top and is distinguished by fascinating woodsy textures (Figure 22). The problem is: how do we create these textures and describe the vertical lines of the trunk at the same time?

I'll tell you. I take my Magic New York knife and charge the underblade with several woodsy colors, some light in tone, some dark. I decide on the general shape and movement of the tree. Then I lay my knife

on the right side of the trunk, push it down on the canvas, give it a short jolt across the surface, and stop where I've planned to put the left side of the trunk. When I pick up my knife, there'll be an interesting blend of textures that look very much like the bark of a tree trunk. And there'll probably be enough paint left on the knife so that I can move it up and make another trunk stripe joining the first.

The secret is to have a strong mental image of what you want to do, to lay it mentally on the canvas, and then to place your stroke exactly where you want it.

The Ultimate Narrow Stroke

Have we made the narrowest line possible with our clumsy looking painting knives? No! These same clumsy looking things can produce the finest, most hairlike lines known in oil painting.

To do this, shift to a smaller knife, like good little Chunky. Now pick up pigment on the bottom edge of one straight side—not too much paint but just enough to create an even little ribbon along the bottom edge. Turn the knife perpendicular to the painting surface with the paint edge touching and press firmly. Then lift the knife abruptly, so that the motion doesn't disturb the ribbon of paint. If done successfully, the ribbon will have turned into something distinctive, into a singing hair of a line.

You'll be using these narrow strokes often as you paint thin branches and twigs. I'll discuss painting trees in more detail in a later chapter, but here I want to suggest more ways in which you can explore making lines with the knife edge. I suggest that you take all the knives you have and try them out, following the procedure just described. Although the results will vary, almost all the knives will produce beautiful wire-thin lines—that is, if the forward part of the knife has a perfectly straight edge. The longer knives will naturally produce longer lines, provided the pigment is distributed along the entire edge.

Figure 23 illustrates the inspiring lines snapped out by my wife Odin's pet knife, which we call "Arrowhead." Arrowhead works best when we've succeeded in picking up a long, neat ribbon of paint first. We usually begin by cleaning the knife and spreading out the paint so that the knife easily can pick up a ribbon of it. And we usually examine the ribbon of paint before setting the knife edge down on the painting surface. It seems that if you get a fine line the first time you press, you'll probably get three or more before needing to recharge the knife.

Other knives that produce beautiful straight lines are the New York Magic knife and Palette Boy; the latter makes particularly good lines because of its somewhat stiffer blade, which in this case is an advantage.

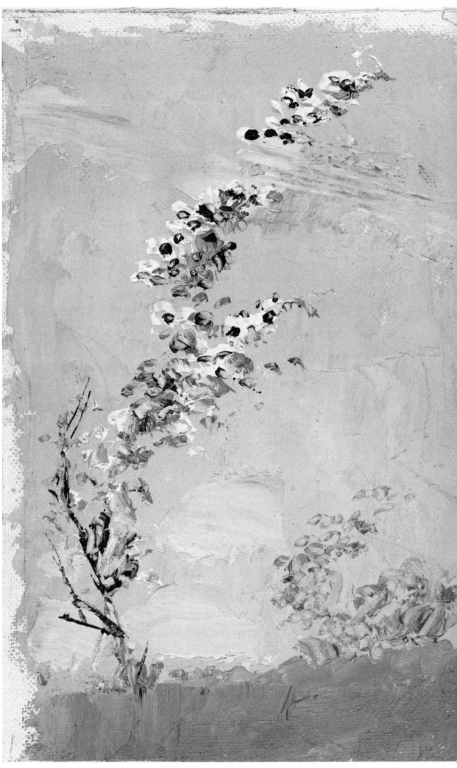

21. Long John at Work. *Dot, stripe, sketch—these are a few of Long John's talents. Why is a sketch often more thrilling than a finished painting? Perhaps because it captures that first intention. Breath of air or the solid side of a barn, this knife (2) is flexible enough for both.*

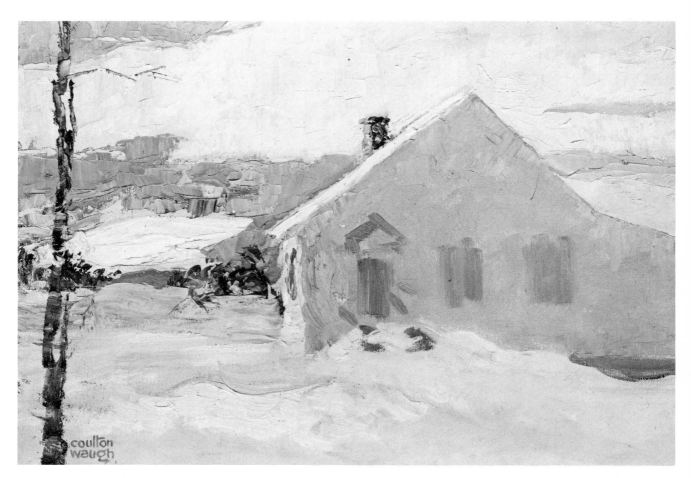

Honeymoon Cottage, *16″ x 20″. Collection Odin Waugh. This title suggested itself because no one had cleared the steps all day. To catch a fleeting effect outdoors, especially if it's cold out, one has to work fast. The sky was buttered on with block strokes, and near the sun thick paint has been dragged sideways. The sun itself was made by placing a gob of paint then lifting the knife up. The tree was done with sideswipes of chunky agate-like strokes that give the effect of bark when seen from a distance. The branch was done with edge of the knife, the chimney with the tip. The white roof is a neat line laid down with a Chunky knife (6).*

Detail of Honeymoon Cottage. *Here you can see the knifestrokes a little better. The sky and cloud strokes are all choppy uprights, buttered on from top to bottom. The tree strokes are done with the edge of the knife.*

22. Woodsy Trunk Texture. *With a Magic knife I make cross-lines on the trunk, then holding the tip end of the handle, I drag the knife vertically along the trunk. I shift to the smaller Chunky (6) for the branches.*

Wibble! Wobble!

A very specialized, very effective knife specialty is the wibble-wobble stroke. I selected this undignified name because it gives such a clear picture of the way the effect is produced: you wibble and you wobble—one way across, then another way across—just the way water wibbles and wobbles. And of course that's what the wibble-wobble stroke is used for: water effects (Figure 24).

My discovery of the wibble wobble came from an investigation of "agate" effects in which I deliberately fuse pigments of different values and colors by picking them up on both edges of the knife and making them flow onto the canvas. Instead of making straight strokes with these different tones, I vibrate the knife back and forth on one edge while moving it slowly downward. When I run out of pigment, I recharge the knife and overlap the first stroke; the movement of the second stroke will fuse the sections together.

In painting rippling water this way you must, of course, first observe the actual colors and values that the water displays, then mix these loosely and pick them up on your knife. You can keep adding new colors to a wibble wobble if it isn't coming out right, but try not to tinker with it once you've made it, because any stiffening will ruin its flow and movement. If you must change it, add plenty of new color, and keep *wibbling!*

The Dot

Dots are another specialized knife effect (Figure 25). They're rather tricky, but very effective. You can't force dots onto the canvas; they'll smear out of shape. A good dot is the result of a small mound of pigment being neatly picked up on the rounded flexible undertip of the knife. The knife tip is then brought down to the painting surface at an angle, and the mound of paint is tapped lightly onto the ground. Don't expect to get a perfectly neat dot every time—after all, a certain looseness and irregularity are characteristic of all knife effects, part of the sketchy, informal knife painting style. But with a bit of practice you'll find yourself distributing useful dots all over the canvas as a natural feature of your landscape paintings. I find the neatest dots come from the New York knife, although Long John makes a close second.

The Block

So far, we've been exploring knifestrokes which, except for the wibble wobble and the dot, suggest definite length, motion, and direction. But there's a whole battery of other knife effects that are static—that stay in place—and these will be essential to you, too.

To make a block (Figure 26), charge your Magic

23. Arrowhead Drawing Lines. The Arrowhead (3) is Odin's pet. Let's hear what she has to say about it: "I don't know how inspired these lines are, but I will say, the thicker the paint on the surface, the easier it is to lay your ribbon. Also, you need plenty of paint on both edges of the knife— and hold the knife lightly so the ribbon doesn't cut into the wet underpaint."

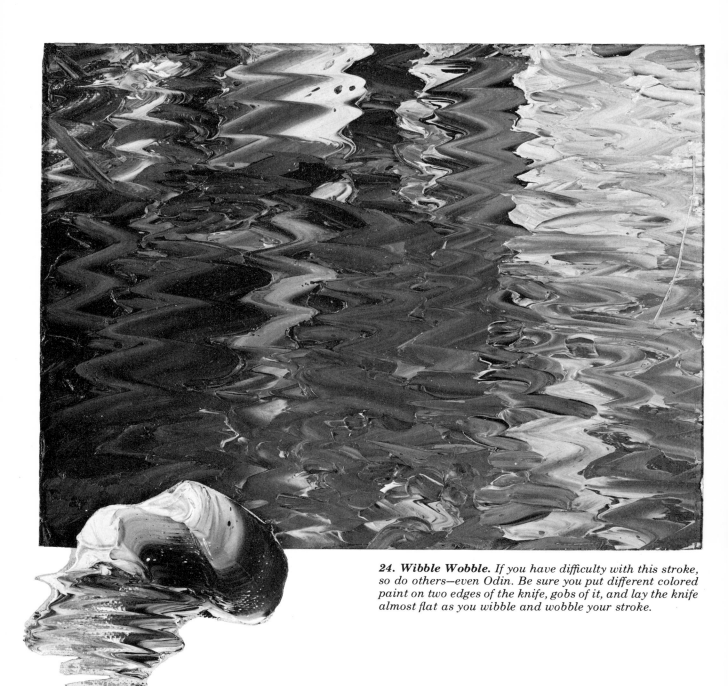

24. Wibble Wobble. *If you have difficulty with this stroke, so do others—even Odin. Be sure you put different colored paint on two edges of the knife, gobs of it, and lay the knife almost flat as you wibble and wobble your stroke.*

knife with paint as if you were going to shoot out a big stroke. Start the stroke on its way, and when it has traveled about 1¼″, stop abruptly and lift your knife up. Instead of an oblong stroke, there should be a kind of block, or square, lying there. It won't be a precise block, it'll be a rough one; it'll look solid and strong, as if something could be done with it. And indeed, something can. The block is one of the most useful and artistic strokes in our entire knife kitbag.

Blocks are closely related to mosaic effects (Figure 27) and have a sense of building about them, a feeling that they can be used to create larger structures. Think of blocks and use them in this way. Pile one on top of another, using the contrasts possible between them to create rich textures and colors. Blocks easily convey the impression of stonework, and they restore force and clean color to passages that have become addled by overly elaborate diddling. How often I've confused my shadow colors and brought them back to life with a powerful block of cerulean blue!

Remember that blocks can also be made to have agate effects by charging the knife with interesting and contrasting tones and colors before making the stroke. Finally, keep the block in mind for use in later chapters. When you paint mountains, you'll be snapping in blocks on the shadow sides.

Wet-on-Wet

Because blocks demonstrate this technique so well, this is a good place to discuss the special ability of knives to work wet-on-wet; that is, to put one wet stroke on top of another wet stroke without blending or muddying the colors. When using this technique, lay the top stroke across the bottom one loosely and lightly; don't dig it in or you may mess up the first layer. Figure 26 illustrates wet-on-wet; it may seem difficult at first, but once you master it you'll be well on your way to mastering knife painting.

Abstraction

Among the most fascinating knife effects are those with a purely abstract quality, whose surfaces have intriguing textures like those found in nature. Smooth, rough, withdrawn, glittery, and outgoing—all these textures interest me, and I try to create some of them myself.

I've illustrated a group of textures in Figure 28 and described how I made each one. I'd like you to swing into the textural act by trying some of these. Make a good-size group of your own. And be inventive!

One of the abstract textures shown may rile you a bit. It's the random one. It is, I grant, *confusion*; but then, aren't there times when nature displays confusion?

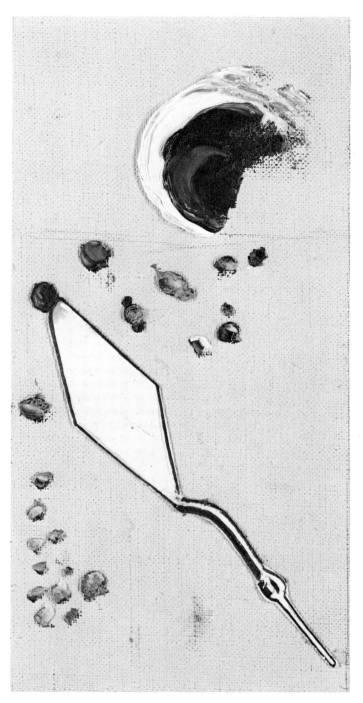

25. Dots. *The first spot isn't really a dot, but it's such a beautiful round thing that I decided to let it stay. Dots can often be improved by a swirling motion. Try both tapping and twisting. These dots were done with Chunky (6), but my New York knife (1A) and Long John (2) also make neat, satisfying dots.*

STROKE

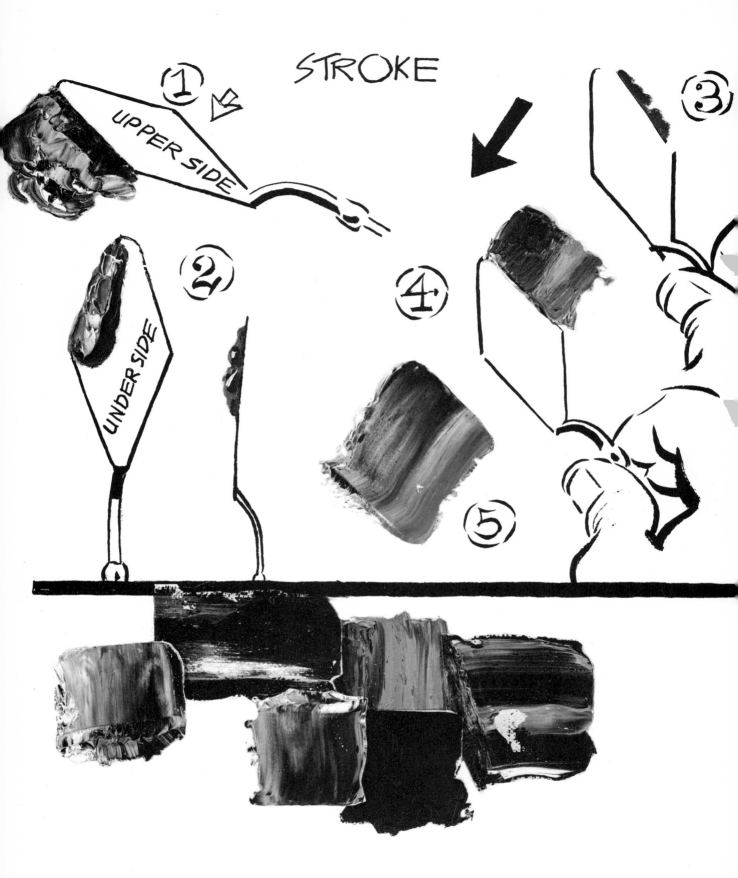

26. Stop and Go Blocks. *Here are actual-size examples of stop-and-go blocks—practice them over a wet paint surface. The knife I'm using here is my London Knife, but Chunky (6) and Mini Squirt (7) make good blocks too.*

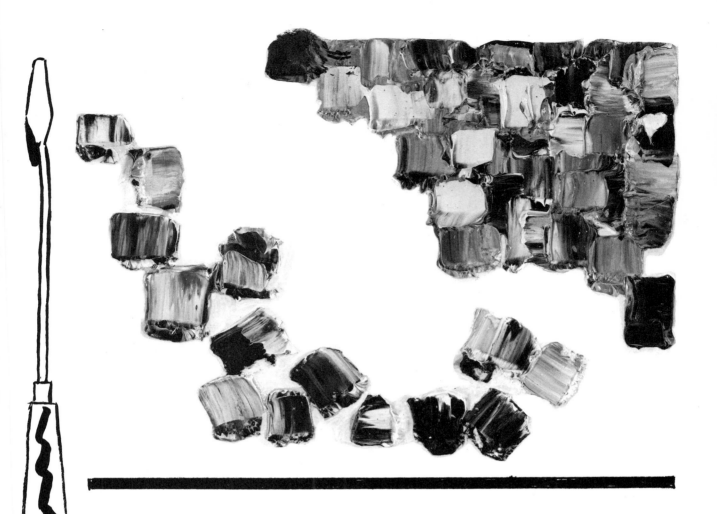

27. Mini Squirt Mosaic Effects. *Although small, this knife (7) and the mosaic strokes it makes (shown actual size) can have big force and breadth.*

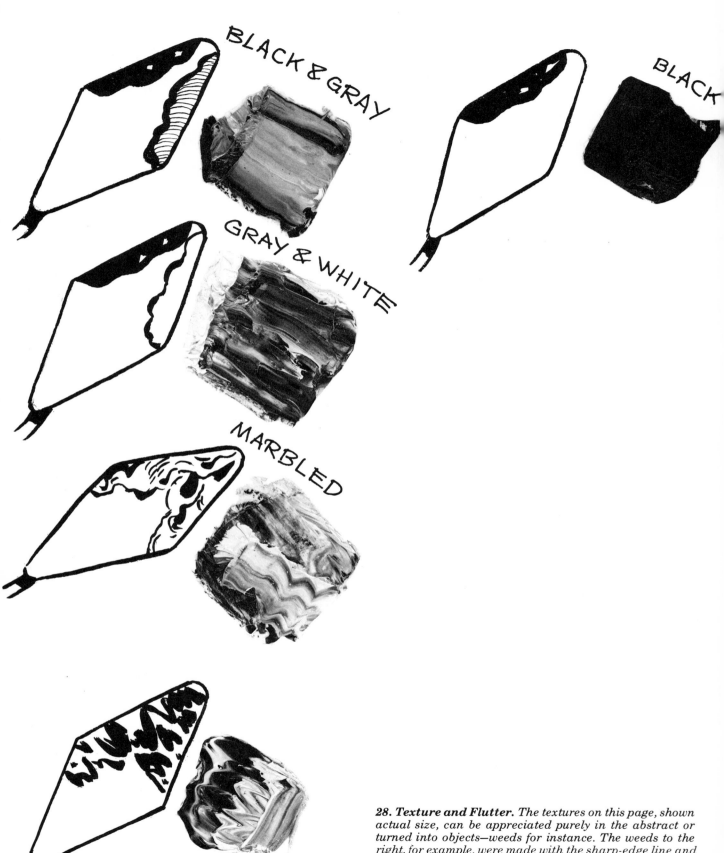

BLACK & GRAY

BLACK

GRAY & WHITE

MARBLED

28. Texture and Flutter. *The textures on this page, shown actual size, can be appreciated purely in the abstract or turned into objects—weeds for instance. The weeds to the right, for example, were made with the sharp-edge line and blobby knife-point dots. The abstract pattern below the weeds is also done with the edge of the knife loaded with two colors of very thick paint.*

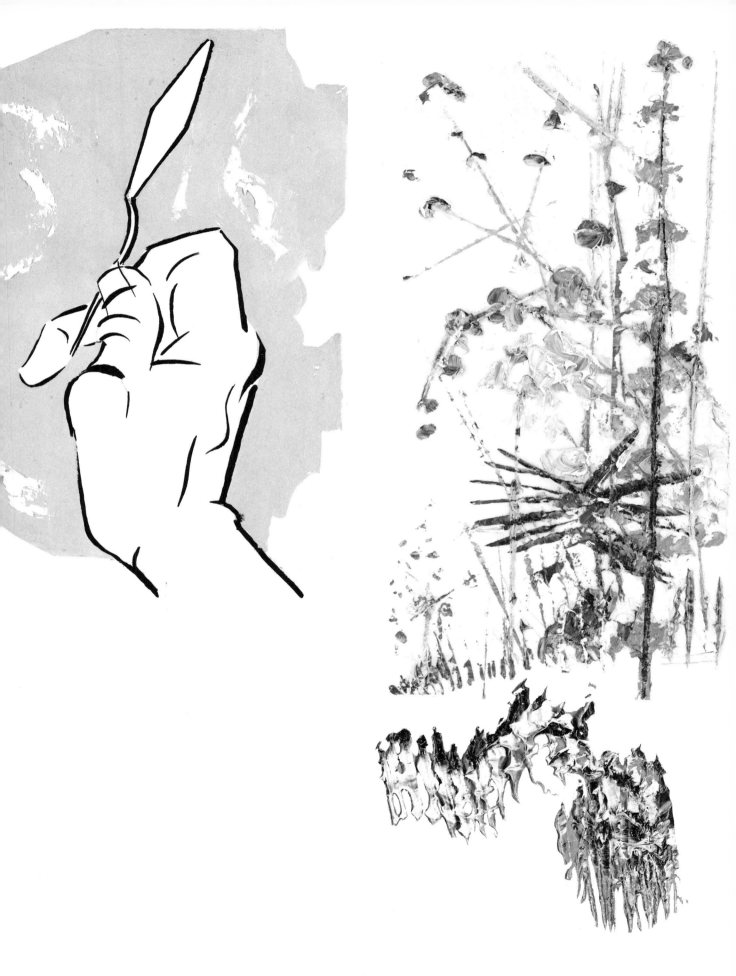

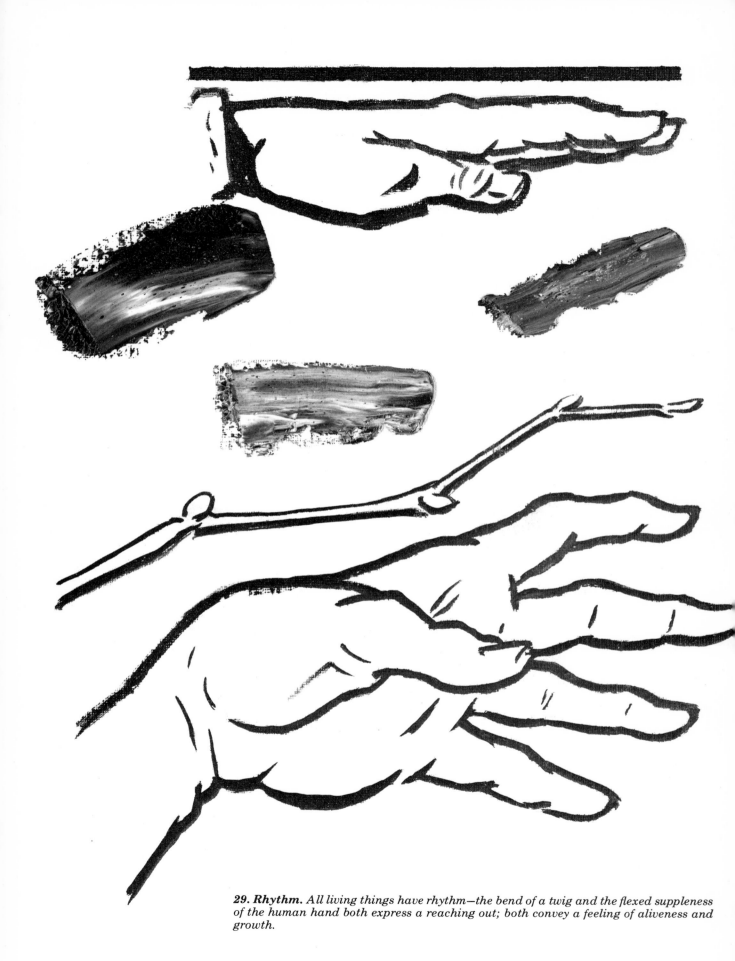

29. Rhythm. *All living things have rhythm—the bend of a twig and the flexed suppleness of the human hand both express a reaching out; both convey a feeling of aliveness and growth.*

The Flutter

Of all knife effects, this is the most important to me personally, perhaps because this effect would be difficult or impossible to create with a heavier, more pedestrian technique. I always use my extremely light London knife to produce it, although I imagine the New York knife could accomplish it just as well. (The flutter is illustrated in the hand painting, top, in Figure 28.)

I call it the flutter because it's a stroke that "flutters" over the picture, generally at the last moment. The flutter echoes the light and color around it and unifies the entire canvas. It's a kind of spiritual experience in which the painter touches up one color here and emphasizes another there, working toward what erudite critics call "equalized surface tension." This means, ideally, that the picture presents a unified, absorbing world of its own.

Lightness of the wrist is the requirement for making the flutter. To practice this lightness, hold your painting arm high, and while moving it downward, *twist* your wrist very lightly and quickly. Can you twist it five times in one second? Then you're on your way to mastering the flutter.

Repairs

Even though knife painting is a loose technique, there's a limit to the way you can blunder around with a knife and retain your self-respect. But even so, don't give up when you've reached that point; learn about the corrective strokes instead.

First, if you've left gobs of paint in some area where you didn't want to go, call in faithful Palette Boy and scrape out the offender—you might even get a handsome effect that way. Now take a small knife like Chunky or Mini Squirt and charge it with plenty of new paint. As you lay the new paint over the muddied stuff, you can create crisp new strokes and lap new edges over old ones. Or take the Magic knife, forget about the mistakes you've made, and start a new color right over the old pigment. This is the best corrective stroke of all!

Rhythm in Knifestrokes

Now that you've learned something about the knifestrokes, you're probably wondering what to do with them—what place they occupy in a painting of nature. That's an excellent question, for it brings up the relationship between art and nature.

I've tried to suggest this relationship in Figure 29. As you look at the three paintstrokes directly below the hand, you can see that they're related to one another. The long axis of each stroke gives meaning to its movement; strung together, these axis lines suggest the shape of the twig below them. Under the twig is another perfectly recognizable representation of something in nature—a human hand in a relaxed position. Now, do you see a relationship between the original strokes, the twig, and the hand? What all three have in common is a very important quality found in all living things: rhythm.

But now we've got to go a step further. The twig and the hand are both living things. The direction of the twig is continually changing as the twig tries to capture all the sunlight it can, so that its little chlorophyll factories can carry on the operations that will insure its survival. The rhythm in the hand implies looseness, suppleness—the very qualities that enable a human hand to grasp and manipulate the tools necessary to human survival.

So, rhythm implies the functioning of life forces and, therefore, health, joy, and beauty. It's significant that artists such as El Greco, Michelangelo, and van Gogh, who have made rhythmic design the most important element in their work, have the gratitude of millions to whom their work has brought such a joy. It is just such gusto and rhythm that the artist must, in his unique way, use his knifestrokes to capture.

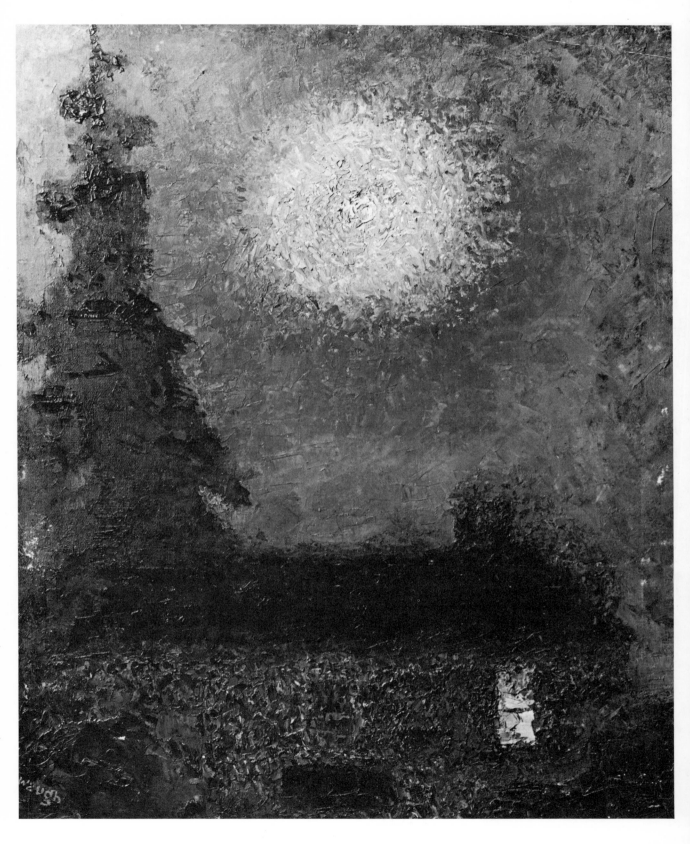

Finite and Infinite, *30″ x 24″. Collection Mr. and Mrs. William Goodman. This picture was painted during one wonderful year when I didn't have a newspaper or school deadline. It records my love for this house and this world. Notice how the knife-block texture captures the stone house feeling. Blurring edges is the great secret of painting light.*

Now that I've shown you the major knifestrokes, there's something else to explore, something so vast and so important that it would take all our lifetimes to exhaust the subject, or perhaps even to probe the surface. This great aspect of knife painting is *color*.

Painting with Fire

Painting with fire doesn't involve using a blowtorch or colors that scream beyond bearable limits (like certain ghastly modern pigments). As I use the phrase, painting with fire means a way of manipulating color toward an intensified color sensation; "fire" has a very special connotation that I'll demonstrate shortly. There's nothing esoteric or tricky about my fire method; it can be taught to anyone.

Most of us, particularly beginners, are aware that painting a picture with the slippery, greasy oil medium is more like painting with mud than with fire. Oil painting appears to present outlandish difficulties. There's nature before you, so clean, sparkling, inviting. As you squeeze the colors out of their tubes they're clean and inviting, too. Then you mix them and put them on canvas, and suddenly the whole enterprise turns to mud. As a beginner, the more desperately I tried to fight my way out, the more firmly I got stuck in the mud. I just about decided to give up. Oil paint! I was off the stuff for life! But as it so often happens with desperate people, I told myself I'd make one last attempt, and something happened that I remember vividly even now. As I said in the introduction to this book, I realized that undiluted oil colors, straight from the tube or tinted with white, contain the answer to the artist's longing for pure, clean color. I also told you that I discovered my father's little London painting knife at about the same time. Well, I put the two together and began applying undiluted tube color with the marvelous little knife. This provided me with a way to leave the mud behind. A Magic knife and undiluted color will do the same for you!

Complementary Colors

The color wheels on page 65 and on pages 52, 61 illustrate how all colors can be mixed from the basic triad of primaries—red, blue, and yellow. As you study the color wheels, don't let their appearance disconcert you. I know there's something horribly childish and elementary about them, and you'll probably think, "I had all this in the fifth grade. Okay, you mix red and yellow and get orange, so what?" But the truth is that there's a great deal more to color wheels than this. Under that fifth-grade appearance, the secret of color is waiting, ready to leap into fire. To understand the secret, we must understand complementary colors. What are they, and where do they appear on the color wheel?

Complementary colors are pairs of colors that are opposite each other on the color wheel. For example, red and green are complementaries: red is the color that contains the smallest amount of green; green contains the least amount of red. Now check the location of this pair on the color wheel. As you can see, red is at the top and is one of the triad of primary colors. Now check the location of green: it's directly opposite red, at the bottom of the wheel.

As you study the black and white wheel in Figure 33, you'll notice a striking difference between red and green. Red, as I pointed out before, is one of the primaries; it stands by itself; it can't be mixed from any other color. But green is different! It's produced by mixing blue and yellow; it's not a primary but a mixture. But in spite of this difference, when the red hue (by "hue," I mean the brightest tone that can be mixed from a particular color) is placed near a pure green hue, it behaves in a remarkable way—it puts on a kind of act, which is equally reciprocated by green hue. The two colors seem to dance and sing; their colors become more intense, with a curious lightness they appear to be in motion. All the other complementary pairs act in the same way when placed side by side, or when a stroke of one is laid on top of a stroke of the other. I'll give you some clues as to why complemen-

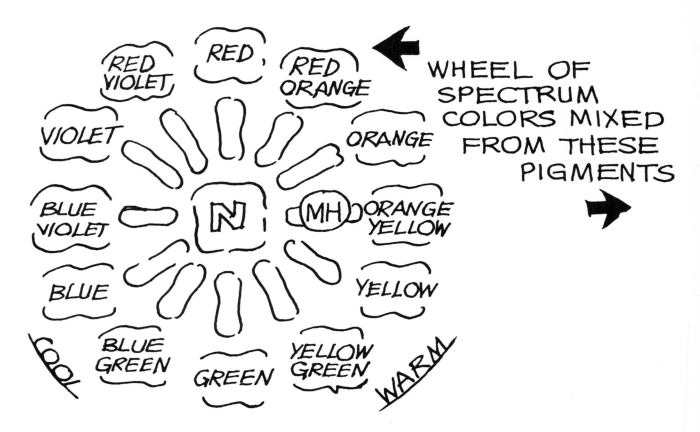

WHEEL OF SPECTRUM COLORS MIXED FROM THESE PIGMENTS

HUE BRIGHTEST NOTE OF A COLOR PLACED ON OUTER RING OF WHEEL

CHROMA DEGREE OF INTENSITY—HIGH AT HUE POINT, LOW AT NEUTRALITY—CONTROLLED BY COMPLEMENTARY MIXTURE

VALUE DEGREE OF BLACK AND WHITE

Opposite colors are <u>complementaries</u>

(MH) = Muted hues, unbalanced mixtures, of complementaries, low in chroma

(N) = Neutrality or mud. Results from 50-50 complementary mixture

OUTER COLORS ARE MOST BRILLIANT POSSIBLE "HUE"

HOW TO MIX THEM FROM

 TUBE COLORS

RED	Cadmium red light, touch of alizarin crimson
RED ORANGE	Cadmium red light plus cadmium yellow medium
ORANGE	Cad. red light + cad. yell. m.
YELLOW ORANGE	Cad. yellow medium, trace cad. red light
YELLOW	Cad. yellow med. cad. y. l.
YELLOW GREEN	Lemon yellow, touch of viridian
GREEN	viridian, white, cad. yell. l.
BLUE GREEN	Viridian plus white plus cerulean blue
BLUE	Cobalt blue, white, viridian
BLUE VIOLET	Cobalt violet, white, touch of ultramarine blue
VIOLET	Cobalt violet plus white
RED VIOLET	Cobalt violet, trace of alizarin crimson

Wheel of Spectrum Colors and How to Mix Them. *Memorize the names of the spectrum colors (to the left of the vertical rule above) and learn how to mix them (to the right of the rule). Here's how it's done. Suppose you want a particular color green. The easiest thing to do is to go to a tube green and use it—but which tube green? And suppose none of your tube greens is the color green you want? Simply locate the kind of green you're trying to match on the color wheel (top right-hand side of spread), then look at the list directly above. Again locate your green; the directions for mixing this color from tube paints are to the right of it.*

tary colors seem to dance a bit further in this chapter; but right now, let's have some fun putting two such colors together and letting them trip.

Mixing Red and Green

I hope you'll discount everything I've been saying unless you can prove it for yourself. You can do this with a very small investment of time and pigment. You'll need a clean palette, a palette knife like Palette Boy, and a painting knife like Arrowhead or one of the Magic knives (although almost any painting knife will do). You'll need the colors listed on page 19 and a clean rag torn into small pieces for easy handling and disposal.

Most artists use a palette knife to mix colors. As we proceed with this exercise, remember that a vital procedure in mixing color is cleaning the palette knife with a clean rag after each mixing. The knife *must* be clean. The slightest trace of another color will ruin what you're doing.

Now, let's get some red and green on your palette. For the red, I'll take a certain liberty and prescribe cadmium red light alone instead of the red hue I usually mix from cadmium red light and a trace of alizarin crimson. This will simplify things as well as provide a color that exemplifies the "fire" principle better than any other. Cadmium red light is slightly to the red-orange side of the red hue on the color wheel. It has more pure "fire" than any other pigment. And besides that, it's beautiful!

30. Simplified Diagrams of Pigment Color Wheel.

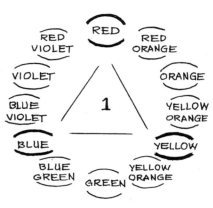

This wheel has all the main hue colors that can be mixed from the primary colors. Because the colors all come from the three primaries, this wheel is complete (that is, it contains all the primary colors).

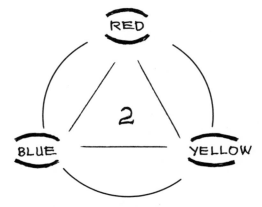

This wheel has all three primary colors. Any other colors are mixtures of these, so this color wheel is complete.

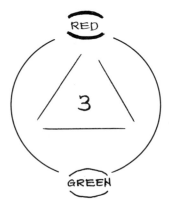

This wheel shows a pair of complementary colors, red and green. Red is a primary color; green is a secondary color. But because the color green is mixed from the primaries blue and yellow, this wheel, too, is complete.

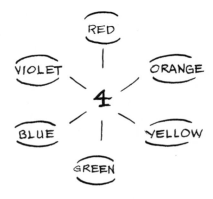

This wheel has only complementaries. But because each set of complementaries contains all the primaries, this wheel, like the other three, is complete.

Now for the complementary, or opposite, of this color. If you project a line downward from the position of cadmium red light on the wheel, it will pass through the "neutral" center and come out just to the left of the green hue at the bottom. This means that the complementary of cadmium red light is a color slightly to the blue-green side of the green hue. For the most brilliant form of this green, for the truest hue, you must use the special color Thalo (phthalocyanine) green, (one of the colors I asked you to buy in addition to the standard pigments).

Mix a little white into the Thalo green and add a touch of cadmium yellow lemon. Now there's a fiery green! What a partner for cadmium red light! I present this team to you as the stars in our painting-with-fire act.

Creating Fire

Pick up some of the red on your painting knife. Holding the knife parallel to the painting surface, spread a generous gob of pigment across it in one bold stroke. Clean the knife. Pick up a small dab of green on the undertip of the knife. Holding the knife parallel again, touch the green very lightly onto the red. Don't dig— just let the green touch, and pull the knife swiftly away. You'll find a patch of green lying there in the middle of its complementary, entirely unmixed with the red. Now place a little dab of the green in a white area of your palette and compare it with the dab of green on top of the red. You know that these two greens are the same, but do they *look* the same? Not at all. The green on the white background looks dark, heavy, and comparatively lifeless. Yet the green spot on the red has an amazing blaze to it. It seems light and in motion. It dances. Above all, it's *greener* than the other green spot, and the red around it is redder than the red you originally mixed.

The Principle of Complementaries

The simple experiment you just performed showed you what it's like to paint with fire. It also revealed an important principle that applies to both optics and to the behavior of pigment: the principle of complementary color.

So that you'll understand this principle, study the four simplified diagrams of the color wheel in Figure 30. The first diagram (1) has all the main hue colors (any others would simply be mixtures of these). Wheel 2 shows the primary colors inside wheel 1. This is "complete," in that all other colors can be mixed from the primaries. Wheel 3 shows a complementary pair, red and green. Red is one of the primaries, green is not. But you see that green is mixed from yellow and blue; since these are primaries, Wheel 3 is also "complete." Next is Wheel 4, which includes only the complemen-

taries. Since, as in Wheel 3, each set of complementary colors contains all the primaries, Wheel 4 is also complete.

More on Complementaries

You've seen what happens when a spot of clean green paint is placed on top of a stroke of red. Will the same effect result when a spot of red is placed on a broad dab of green? Will the red jump and sing the same way? Yes—try it yourself and see. (Just be sure to clean those palette and painting knives between experiments, for the slightest trace of one complementary in the other will dampen the dazzle. You'll soon find that a clean rag is as essential to painting with fire as the pigment itself.)

Let's carry the red and green experiment further. Spread a dab of red, then clean your knife and pick up some green. Turn the knife edgewise and lay two parallel lines of pure green over the red. Then clean the knife, pick up more green, and lay another set of green "hatch" lines at right angles to the first set. Look at the result critically from a distance. What color are you really looking at? Red? No. Green? No. It seems to be more than just red and green, and it actually is more. It's a color you can't buy in any art supply store on earth. It's what van Gogh happily called "the third color," a marvelous, mysterious, luminous tone not actually found in either of the two pigments but made visible to the eye by the vibration of the two colors.

The Principle of Dominant Color

As you study the red and green experiment, and similar ones made with the other hue colors, you'll find that they affect your eyes in different ways. For example, the first fire spot you made—a small touch of green on a much larger stroke of red—was thrilling. It was also easy to look at because you allowed one color, red, to dominate; you looked at the red first, then took in the green spot.

Please remember this: it's the very important principle of color *dominance*, which we'll discuss in more detail later. It means that you shouldn't put equal areas of bright color side by side or the observer's eye will be yanked back and forth until it's worn out. You must provide an area of rest or relief, where the razzle dazzle effect of two or more bright colors is relieved by a single area of tone. You'll find restful color areas emphasized throughout this book, for they are extremely important in landscape painting. Don't we paint landscapes to escape from the razzle dazzle of modern life?

The "Third" Color

A little knowledge about the laws of light, which differ from the laws of pigment, will help to explain the

"third" color mentioned earlier. White light is composed of all colors; although a mixture of all the pigment colors produces muddy darkness, a mixture of all the various colored light rays produces white. Even a mixture of two different light rays will tend toward white and therefore look lighter, more luminous, than either color alone.

This, of course, is the same color principle utilized by the French impressionists, who used small flecks of bright pigment color side by side rather than mixing them. The light rays reflected by these colors would fuse in the eye when viewed from a distance to produce the "third" color as well as the feeling of lightness and air. Such color effects tend toward light rather than dark.

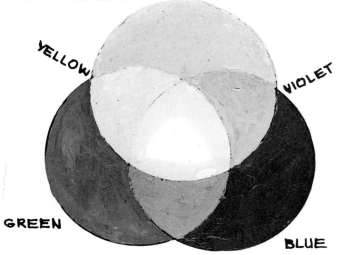

31. Light Color Wheel. *This wheel shows the light colors: unlike pigment colors, which add toward dark, light rays add toward white. All the colors in the rainbow can be divided into three basic color areas, yellow, red, and blue. For this illustration, I've combined these three basic colors to make two color areas, yellow-red and blue-green. When these colors are combined (as with spotlights), the result is white light.*

You've already demonstrated this effect by placing two ordinary colors from the pigment wheel, green and red, side by side. Because these were complementaries, your eye saw an "additive" element: the two colors tended to act like light rather than pigment; they tried to fuse together toward white. The result of this fusing and flashing was the mysterious "third" color.

Since you now understand how to make pigment flash with fire this way, I'd like you to try out combinations of the other complementaries. Mix each pair of colors together, then put a spot of each one on top of a spot of the other. According to the dominance principle, place your dazzle spot at upper left, over a much larger stroke of the first color.

The Paint Layout

If you already have a pet way of laying out your pigments, go ahead and use it. However, I have a particular layout that suits the demands of fire painting, and I think you'd be wise to try it out, at least at first, and then modify it later to suit your own taste. In the same spirit I suggest that you stay with the list of colors I've already given you.

On my palette (Figure 32), notice first that there's a warm side (right) and a cool side (left). As you can see, warm colors tend toward the yellows, while cool ones tend toward the blues. Colors near the center can be tipped easily either way. For instance, cadmium red—a rich scarlet—is basically warm; but a touch of blue red, alizarin crimson, will tip it toward the center, turning it into a red hue balanced between warm and cool. This color arrangement tends to bring warm yellow mixtures together on the right side of the palette, and cooler, bluish tones toward the left.

Now we're ready to get acquainted with the colors that come out of those tubes. But keep in mind that while these are related to those on the color wheel, they are not the same, either in name or in actuality. You can't walk into an art store and buy a tube of red hue. You can, however, buy a tube of cadmium red light, and by adding another tube color, alizarin crimson, to it, cool it to produce a very good approximation of red hue.

See page 52–53 for one of the most important illustrations in this book; it shows how to mix hues from tube colors. Please try out the formulas when you have time, and memorize them. They'll speed you on your way toward painting with fire.

Cadmium Red Light

You're already acquainted with this star of the red family. What a glorious color! The reason I'm a painter instead of a violinist may be that I can't seem to locate cadmium red light on the violin. Remember, when I speak of this color, I mean cadmium red light, not cadmium red medium; this is also a beautiful color, but it's deeper and without the scarlet flare. You can mix cadmium red light with white to produce a *tint* that resembles the fire of health on young faces. You'll also find this tint in late afternoon skies and sunsets.

Alizarin Crimson

Alizarin crimson is another fiery red; it's slightly more intense than the cadmium. Used directly from the tube, alizarin crimson is a wonderful, extremely strong red-black. Although very transparent, this color stains and dominates other colors, so watch out for it—you only need a little at a time. Mixed with

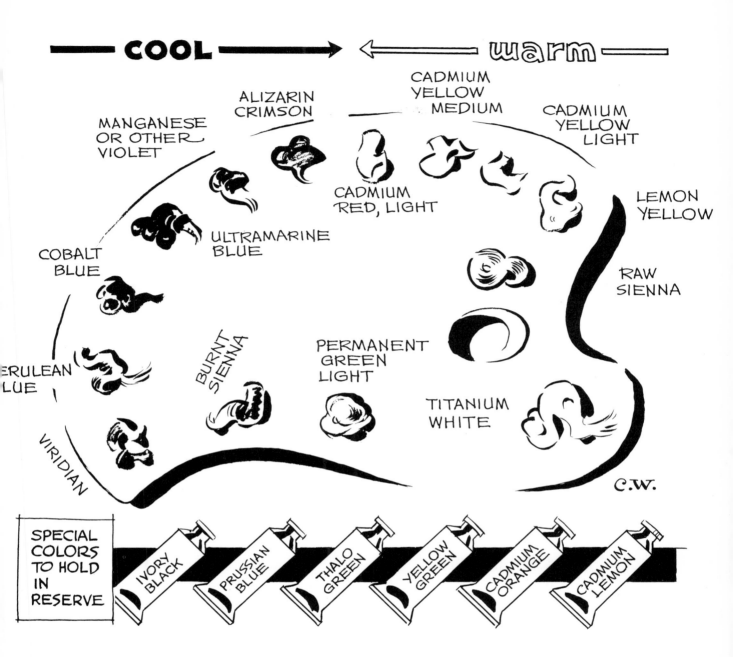

32. Color Layout on the Palette. *This is the way I lay out my palette. Notice that I also keep some special colors in reserve.*

white, it produces the most classic baby-ribbon pink imaginable. On the color wheel, alizarin crimson stands between red and red-violet.

The Cadmium Yellows

The king of this group is *cadmium yellow medium*, the color of the sun itself. Yet it's a bit too warm to make a true yellow hue, so I also include *cadmium yellow pale*. This is a very good approximation of yellow hue, and the very pigment with which to paint a blaze of yellow fall leaves facing the sun (with branches done in full Prussian blue). *Cadmium yellow lemon* is a very bright color that's tremendously useful in fire painting. On the color wheel it's lighter and slightly greener than the other cadmium yellows.

Raw Sienna

Raw sienna is a wonderful earth color of a decidedly golden character. When mixed with other colors, it produces many shades of golden browns. It has more depth and substance than the somewhat similar yellow ochre, which is why I prefer raw sienna for landscape painting. On the color wheel, raw sienna belongs in the inner ring of "muted" colors, which I'll explain later. The meaning or symbolism of this color is very great: it's made of earth pigments, and stands for earth, for land, for ground—for something very substantial, in contrast with the sky colors.

The Violets

Violets are ticklish colors to find ready-made in tubes. Cobalt violet seems to be the only one that really blazes. I include it in my palette although it's sometimes said to be unstable. More dependable violets are manganese violet, which is very good although not too brilliant, and the useful Thio violet, which has a brilliant red-violet cast. You'd better make your own experiments with this group.

Many painters use very little violet, but it seems to me that violets and purples are a most important group. Outdoor painting would be dead indeed without them; they furnish the necessary contrast to summer green. It's interesting that objects that are actually gray in nature—such as roads, tree trunks, and stone walls—turn into distinct red-violet when surrounded by the greens and yellow-greens of summer. The reason for this is that green colors are strong; in contrast, weak neutral grays tend to look like the opposite of green, which is red or red-violet.

If such grays look red-violet, should we paint them that way? Yes. Absolutely!

One more point about violets. Although they're useful and beautiful, the violet pigments are shy and reticent; they're easily overpowered by other colors. When using violet, you'll have to mix a good deal of it on a perfectly clean area of the palette. And be sure to apply violets with a perfectly clean knife. If the slightest trace of another color gets into it, the violet will fade right out.

Ultramarine Blue

This fine pigment, or its close substitute *permanent blue*, is a must for every palette. It's almost black when it comes from the tube, but it heightens to rich blue with a purplish cast when a bit of white is added. With more white it becomes a delightful azure tint, the color of the upper part of the sky.

But ultramarine blue is also a fine color straight out of the tube. It's a big bull of a color; it covers with power and doesn't stain. Yet it's so workable that it can be used for outlining and drawing very easily. On the color wheel, ultramarine blue is located a bit on the violet side of blue hue. It can be tipped either way very easily: adding violet will make it a rich blue-violet; when touched with viridian green, it produces an excellent blue-green.

Cobalt Blue

Ah, cobalt, you lovely, feminine thing! Within your tube, you hold the secret of air. With a little white added you spread the mystery of the air. Cobalt blue is rather thin, like the air itself; yet it lends itself well to light impasto touches, and there's no finer or more appropriate color for landscape painting. You can use it to balance your landscapes—a hint here, an echo there—and your picture will take you out into the open. As you paint skies, use cobalt blue to replace ultramarine blue as you move downward. Cobalt comes close to blue hue when a bit of white and a trace of viridian green are added.

Cerulean Blue

Cerulean is queen of all the blues, stepping out of ancient Egyptian days, when the cerulean color of turquoise was often associated with the darker, more violet-blue of lapis lazuli. To get this Egyptian turquoise color at its full intensity, mix cerulean blue with some white and add just a bit of that remarkable, intense, modern color, Thalo (phthalocyanine) green. (Although I don't keep Thalo green on my palette because it's so vivid that it stains the other colors, I think it's a most useful pigment to hold in reserve and use on special occasions like this.)

Cerulean blue is located toward green on the color wheel. It's very aggressive, with strong covering power. Because of its richness and covering power, it's extremely useful in knife painting, and I often find

myself flipping little nicks of it around, just for the joy and beauty of it. It's great, too, for introducing a sense of vibration into shadows. I often introduce blocks of pure cerulean right into the darks of tree trunks, not blending them or watering down their impact but just leaving them there and letting them blaze.

Prussian Blue

(Scream!) Here's where the picture changes. Prussian blue is beautiful in a dark, threatening sense, but it has exceedingly bad habits. Out of the tube, Prussian is a magnificent blue-black, so deep in tone that it seems to burn your eyes. Mixed with white, Prussian produces many notes of fine blue with definite greenish tones.

Those are the positive sides of Prussian blue. The evil in its nature is that Prussian blue seems to spread through the air. It takes charge of everything; stains all your rags, gets all over your hands and face and even your nose. Prussian blue "thinks it's God." It's a great color and you should use it, especially for fiery darks—but keep it on a separate palette, and when you're through with it, lock it in some secret drawer to which you alone have the key.

Viridian Green

This is a very valuable color which, like Prussian blue, possesses certain characteristics you'll have to be on guard against. Viridian green is almost black as it comes from the tube. With an addition of white it becomes an acid, sour, but very brilliant green—not a middle green like green hue on the color wheel, but one that tips toward blue-green. It's this rasping sourness of viridian green that trips up the beginning painter almost every time: he sees that it's bright green and that the leaves are bright green, so he paints all the leaves in his picture bright viridian green.

Without delving too deeply into the subject of sunlight in landscape, let me point out that while the blue note in viridian green is appropriate in the shadows of green vegetation, it's not at all suitable for trees and other plants in sunlight; when greens are touched with the warmth of the sun, they tend toward yellow-green. To use this color for sunlit greens, you must warm it up (and take the sourness out of it) with cadmium yellow lemon.

Viridian green can also be used for sky colors close to the horizon when simply diluted with a lot of white.

Permanent Green Light

Now here's a green that's just right for green vegetation in sunlight. It's bland, warm, and not harsh or overbearing. I tip my green-stained hat to permanent green light.

Other "Reserve" Colors

Yellow-green and cadmium orange are excellent colors to take out on a brilliant fall day. Although they're a bit too expensive for ordinary use, it's good to have them in reserve for such occasions.

Burnt Sienna

You'll notice that I've included *burnt sienna*, a deep red-brown, between viridian green and permanent green, on my palette. When mixed with a little white, burnt sienna produces a glowing rust color which is very effective in preventing "over-greenness" of leaves. I like to have it handy, whether to flick it in undiluted here and there, or use it to soften green tones. Also, when mixed with ultramarine blue, burnt sienna becomes almost a true black. So I put this color in a strategic place on my palette where I can quickly mix it with the necessary deep tones.

The Tube Darks

In an earlier chapter I gave my reasons for banishing black from my palette. I also promised effective substitutes, and here they are. I present my friends the tube darks—the dark, sonorous colors that are almost black as they come from the tube, yet in whose depths lurks a sense of true color, ready to flash out instantly with the slightest touch of a lighter note.

I've already described that blue-black star, Prussian blue. Other fine tube darks are ultramarine blue, cerulean blue, viridian green and Thalo green, manganese and Thio violet. The dark that provides the best all-purpose substitute for black is ultramarine blue, mixed with burnt sienna and no white. For the deep, eerie tone I call the "magic" color, which is very effective in still-water reflections, mix viridian green, alizarin crimson, and a little white.

Practice mixing your own darks: first try them straight out of the tube, then mix them with one another and heighten them with white. In this way you'll make the acquaintance of those deep-noted colors that fall below the range of the color wheel, yet which can be mixed from the tube pigments on your palette. In mixing and using them, however, be sure to retain some trace of their individual colors; don't blend them too thoroughly or they'll turn into mud.

Making Color Tiles

Now, you're ready to mix the hue colors on the color wheel. You should have a canvas pad about 12″ x 16″, which you can buy at your art supply store. Rule 2½″ squares on several of the pages. (You'll need 12 to begin with.)

Now mix the twelve hue colors listed on the outer ring of the color wheel on page 52. Use the pigment

colors on your palette, and refer to the table at the right of the wheel for instructions on which colors to use.

Continue mixing colors until you've made a set of squares that tell the story of the color wheel. Dry the tiles and keep them together—they'll act as your personal color research tool, which you'll use in many ways.

I have a set of such tiles; they've helped me immeasurably in writing this book. I cut mine from ⅜″ plywood, sanded the edges, and treated them with white gesso. After buttering on the color, I wrote the appropriate information on the back of each tile. I also made a plywood color-wheel board, with little strips of wood glued on to hold each tile so that I can easily see them. Then I made a display board, so that I can pick tiles from the color-wheel board and arrange them in various patterns on the display board. When I have a color scheme to study, I set out my tiles on the color-wheel board, then lift off various colors to make harmonious arrangements on the display board. My color-wheel board looks exactly like the color illustration on page 65.

The Muted Complementaries

You've probably noticed something new about the color tiles on page 65. I thought you'd pick it up! Inside the outer ring of hues, which are now familiar to you, is another ring of similar blocks. These are also colored, but in much softer tones. These inner squares represent something just as artistic and beautiful, if not as sparkling, as the outer squares: they're the muted complementaries—colors often dismissed as dirty, faded, old-looking, and dull.

By using this assortment of softer colors, you can construct some of the richest and most moving of all color effects. When you discover these beautiful minor notes in nature, you'll begin an adventure into a fascinating new world. You'll begin to see muted complementaries everywhere.

Take a walk in the nearest patch of woods at any time of the year. Look at the mossy, leaf-covered forest floor. Watch it a while and you'll begin to see the soft colors: the dull greens of various plants and mosses, the cooler green of lichens, and the old "burnt" gold of fallen leaves. You'll get a general impression of something extremely rich, of deep, quiet color that doesn't sparkle or flash.

Chroma

The charm of these soft woodland colors is created by a reduction in chroma, that is, a weakening of color intensity. This is accomplished by mixing together two complementary colors.

To help you understand how chroma can be diminished, let's think back to the experiment you did using red and green pigment. Do you remember the glow, the electric flashing that occurred between the two colors? Because you didn't blend them, their original intensity, or chroma, remained strong enough to produce the "third" color.

Now we're going to use red and green again, but in a way that will illustrate what I mean by "chroma." This time, the procedure is to lay out a bit of red hue with the palette knife, then mix a bit of green hue. Now lift a little green hue (much less than the amount of red hue) and mix it into the red, swirling the colors around until they're thoroughly blended.

The bright red seems to have gotten lost, hasn't it? Yet the color is *still* red, even if it's very different from the brilliant red hue. It's now a beautiful, soft copper-red, the kind you might find on the woodland leaf-carpet in fall. This is a *muted* red, a red whose chroma has been reduced by the addition of its complementary.

Colors like red hue have high chroma; the copper red you just mixed is low in chroma. Would the chroma be even further lowered if you mixed more green into that copper pile? Yes. Try mixing in more green, but watch out or the redness will die out if you add too much. You'll find there's a certain point at which all the red disappears and you're left with a colorless, lifeless *mud*.

As long as there was light in your mixture there was also color; as long as there was color, there was fire, even if muted or subdued. But when the fire goes out you've reached the zero point in the chromatic scale; there's no chroma left. The trail that began with flashing hues and third colors has ended in the swamp.

But, of course, you don't have to get stuck in that swamp, where so many artists end up. All you need to remember, when mixing color complementaries together, is never to mix them fifty-fifty, for that's the point where the mud is. Just keep the mixture to one side or the other of the mud and you'll always be working with color.

Quiet Fire

This is a big point in our color story. Please go back to your palette and mix piles of the two beautiful muted complementaries, moss green and tile red. What next? Lift up a bit of the moss green, touch it lightly into a stroke of the tile red, and see what happens.

We've proved that the principle of complementaries works in exactly the same way with the subdued complementaries as with the brilliant hues; in both cases, when these pairs of colors are mixed together they enrich each other, make each other glow. And they make fire together—even if, in the case of the muted complementaries, the fire is not so much flame as the com-

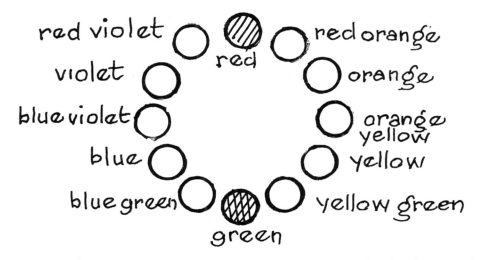

This is a pigment color wheel. Pigment colors add toward dark. That is, when you mix them they get progressively darker until they turn into a "mud" color. This is why they are called "additive" colors.

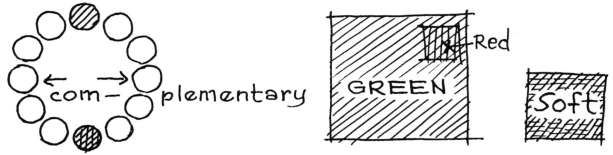

If you use complementaries side by side or one on top of the other, the result is a sparkle—a third color made up of the blending of the two colors by the viewer's eye.

Complementaries make jewels (left) and soft, deep tones (right). When unequal amounts of complementary color are placed together—say a small dab of red on a large area of green—the result is a color "jewel," brilliant and exciting.

For a feeling of distance use small, dappled touches of complementary colors heightened with white, or break subdued complementary color blocks over local color.

forting aftermath of warm coals. I hope you'll want to make a ring of subdued complementary squares with superimposed touches of their opposites, in the same way that you made the brighter ring of hue colors and their opposites.

Wherever you look in nature, you'll see complementary colors trying to complete the color wheel. And now you have the knowledge and tools to capture this beauty and richness: you know the principle of complementaries, and you have a painting knife!

Complementaries in Art

Many artists have taken advantage of the marvelous richness that complementary colors provide. We find reds and greens, as well as other pairs of complementaries, used together in many primitive works of art. Complementaries glow in Chinese and Japanese paintings and prints, and they were developed with extraordinary richness and variety in Persian illuminated manuscripts.

Early Italian tempera painting is full of complementary color. One of the reasons that these wonderful old pictures look so alive is that there are complementary green underpaintings beneath the pinks of the flesh tones; the vibration of the two colors provides a flowerlike freshness. As true oil painting, with its use of warm, all over varnishes and glazes, became the fashion, the complementaries were subdued. But they were still there; paintings by Titian, Veronese, and Vermeer still glow with the contrasts of soft yellows and rich blues.

In the eighteenth century, a curious passion for brown almost eliminated true, outdoor color. It's said that this resulted from the fact that a poor green pigment, verdigris, came into use; since this rapidly turned brown, brown became the fashion. The English painter Constable restored green to favor, and the color discoveries of Renoir, van Gogh, Gauguin, and Cézanne brought the use of complementaries to perhaps the highest and most skillful point in art history. In my own opinion, it's the jewellike character of the impressionist and post-impressionist paintings that has kept them in such favor; today these paintings outvalue almost all others.

Color Matching. *Look at the scene you wish to paint. Pick out the broad color areas. Mix your color. Hold the color up against the scene to see how it compares.*

Matching Colors from Nature

One way of making color notations is to simply jot down the names of the broad color areas in pencil on a black and white sketch. Another way, and one which is much more accurate, is to actually make your sketch in color, using any medium—oils, watercolors, pastels, etc. The three-step color-matching system that follows can be used both for making quick color sketches or for actually painting on location; it guarantees a fast, accurate match of any color found in nature. The first thing you'll need is a color wheel like the one shown in the color plate on page 65. This color wheel should be right in front of your eyes as you sketch—Odin fastens hers on the inside of her paintbox lid for easy reference. As you look at your scene, identify and paint each broad area of color by following the three steps listed below.

Step	Question	Answer (for example)	Do
1	What color is it, based on the color wheel?	Blue-green.	Mix blue and green to get the color blue-green.
2	What value is the color, high or low (light or dark)?	If the value is high . . . If the value is low . . .	Add white to your color. Use colors straight from tube for lowest value.
3	What chroma (intensity) is the color?	If the chroma is high . . . If the chroma is low . . .	Use as originally mixed for highest chroma. Add complementary of blue-green, red-orange.

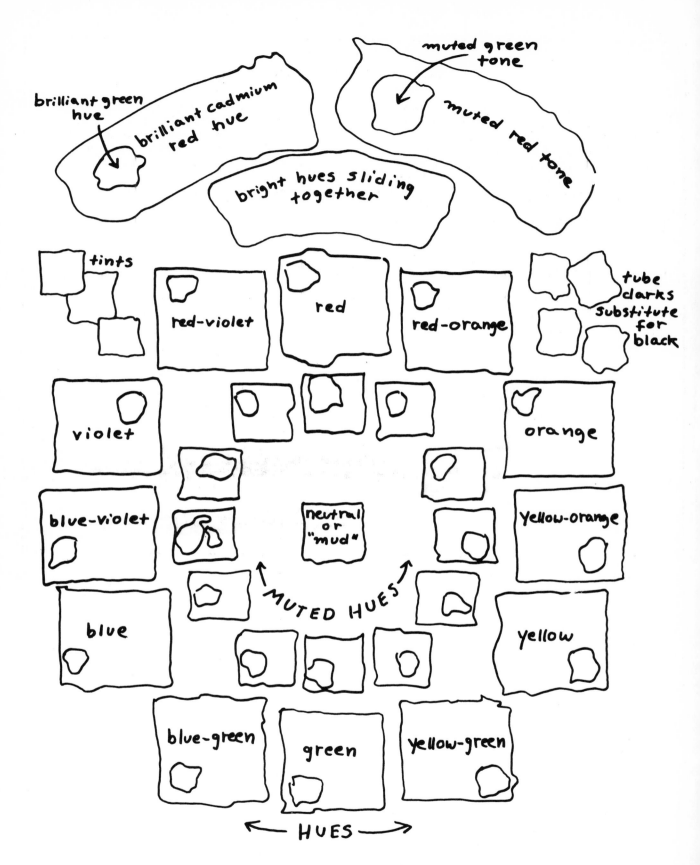

brilliant green hue

brilliant cadmium red hue

muted green tone

muted red tone

bright hues sliding together

tints

tube darks substitute for black

red-violet

red

red-orange

violet

orange

blue-violet

neutral or "mud"

yellow-orange

blue

MUTED HUES

yellow

blue-green

green

yellow-green

← HUES →

Color Wheel. *The color wheel reproduced in color at right and diagramed above has something extra: each color has a dab of its complimentary color in one corner. When complementaries are mixed together you get a muted tone: the more evenly balanced the two colors are (closer to a 50-50 blend), the more muted your tone will be.*

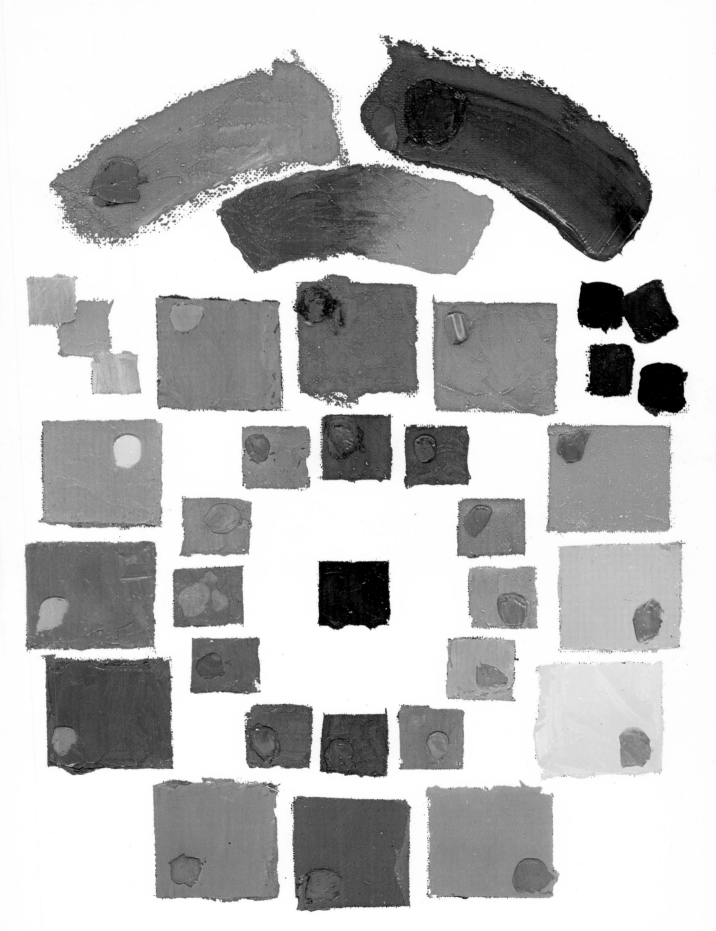

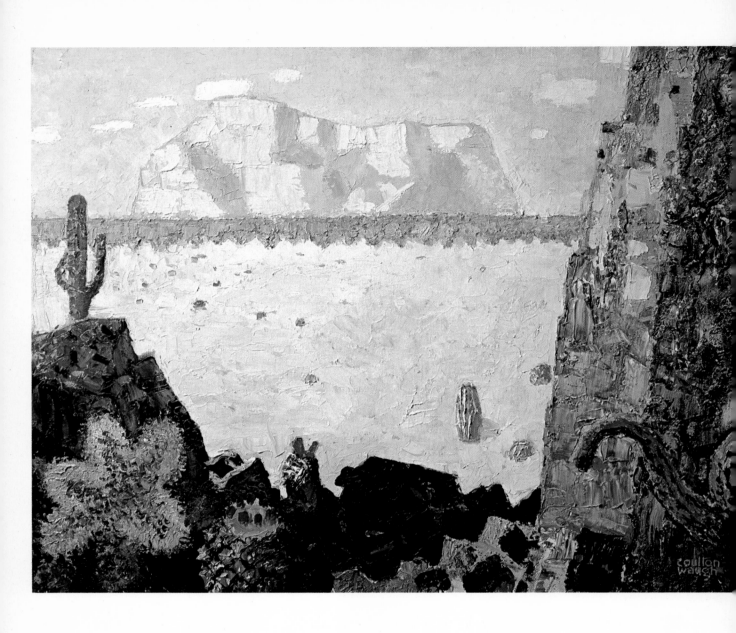

Desert Fascination. *Oil on canvas, 20" x 24". Collection Odin Waugh. The color chord for this picture—light red-violet, deep blue-violet, pinkish orange, and light, transparent blue-green—represents not only the time of day and the direction of the light, but also the beauty and character of this Arizona landscape. I added the shapes of the close-up rocks with sharp, individual knife strokes, spreading flat, clear colors as rich impasto. I used the edge of the knife to suggest those outlandish cactus prickles. I used some tacky palette scrapings for the rock on the far right; these stand up about a quarter of an inch from the canvas and add interesting texture.*

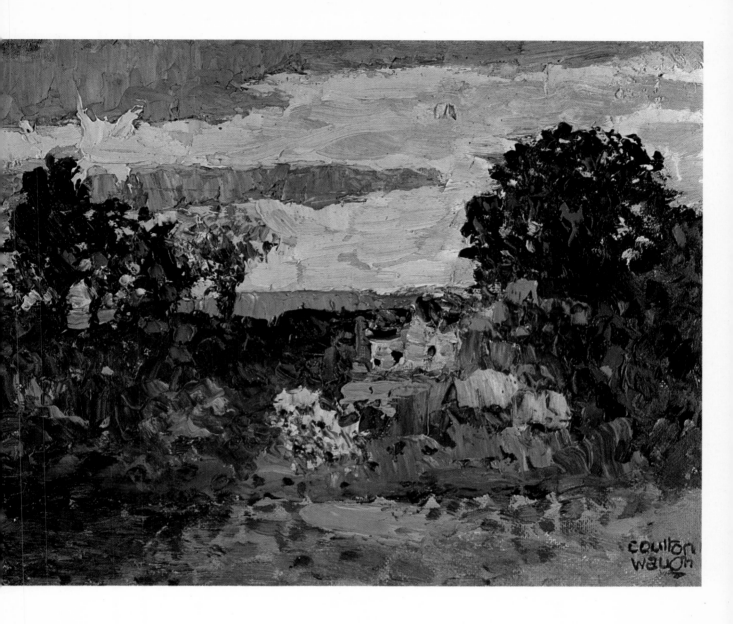

Sunset in Fall. *Oil on canvas, 9″ x 11½″. Collection Odin Waugh. I did this small painting during a period when I had little time to paint. My paints and canvas were arranged near the back door, ready for me to grab when nature put on an irresistible show. Here I painted the sky with vertical knife strokes, the clouds with horizontal brushstrokes. I used brushwork for the green in the lower foreground to make the area appear out of focus. The brightly colored fall trees are the center of interest. Note the agate-like knife strokes I used in the bright fall leaves to suggest clumps of hundreds of leaves.*

Los Angeles Palms. *(Left) Oil on canvas, 9″ x 12″. Collection Mr. and Mrs. John Coulton Waugh. Notice that I made my knife strokes follow the direction of the forms they suggest. The romantic color chord includes the pearl-white and exotic salmon-pink buildings, gray windows edged with white, and notes of apple green and saffron yellow. On this hazy evening, the shadows were luminous and had a flattening effect on the colors.*

Magic Color, Ostego Lake. *(Above) Oil on canvas, 12″ x 16″. Collection Mr. and Mrs. Raymond Bally. It was here that I discovered the magic color of shadowy reflections in water. The reflections of both the mountain and the tree are viridian, alizarin crimson, and white, with more green and some raw sienna added under the tree. I built up the whole picture uniformly, using impasto even in the mountain. In the water, notice how I used the knife to make light strokes on top of darker colors.*

Dairy Country. *Oil on canvas, 20″ x 24″. Collection Odin Waugh. Here you can see how my flexible little magic knife slashed in the colors of the water and the sunny banks around the shadowy bridge. The reflection of the bridge is viridian green, alizarin crimson, and white, applied with horizontal, wobbly strokes. The cow is a rich ultramarine blue right from the tube, painted with bold knife strokes. On top of this I applied areas of cobalt blue to give the cow an airy appearance. For the cow's reflection, I used the same colors plus cerulean blue. The stones in the bridge are muted violets and greens, applied as vertical, square strokes. I created the agate effect by putting one color on one edge of the knife, another color on the other edge.*

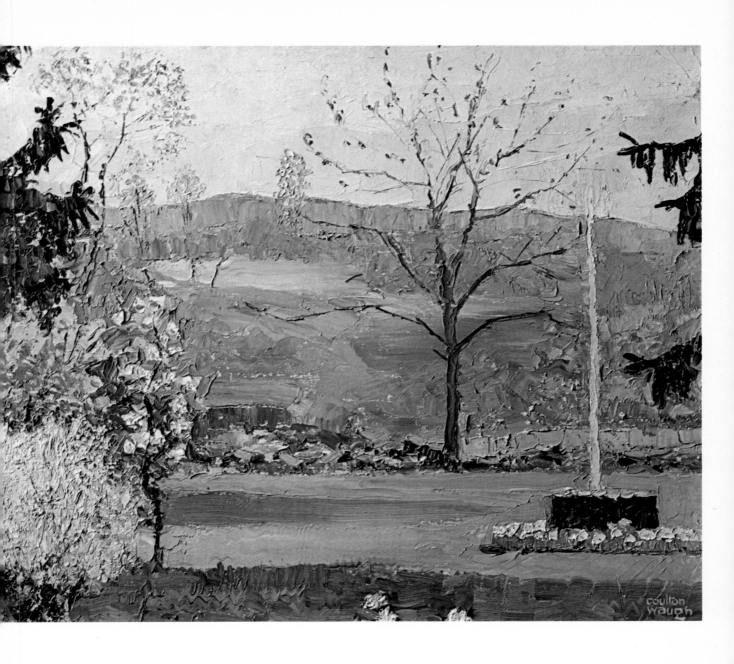

Secret Garden. *Oil on canvas, 20″ x 24″. Collection Odin Waugh. There are few finer open-air classrooms for studying summer colors than gardens, provided that the sun splashes them, their flowers create brilliant points of interest, and birds sing in them. But many gardens have neat lawns, and the neater the lawns, the harder it is for the painter to find excitement in them. Here you can see that I added bold splashes of near-yellow vibrations across the green, laid in with the tip of my "arrowhead" knife. I used a knife to spread on the dark green shadow cast by the spruce and a brush to smooth it out toward the flagpole. I dabbed in the yellow forsythia blossoms with the tip of my knife and spread the magnolia blossoms on like butter, using square strokes.*

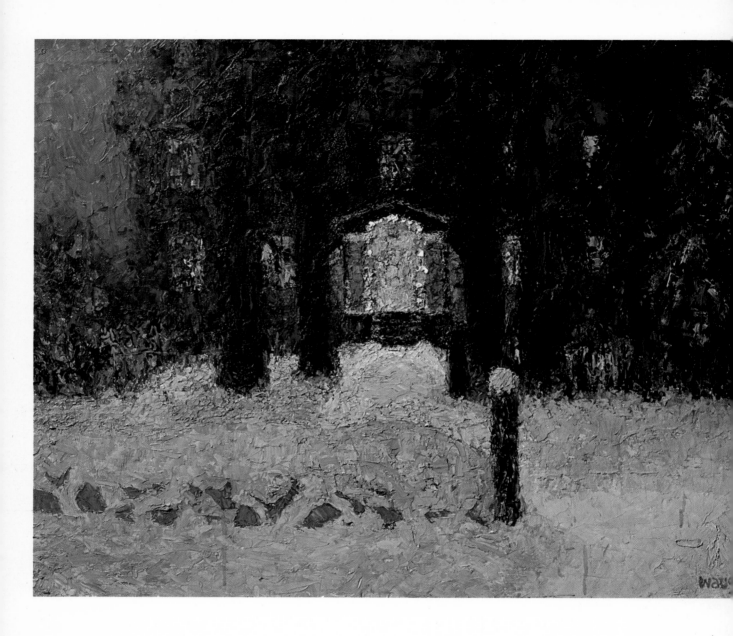

Green Pastures, Christmas. *Oil on canvas, 25" x 30". Collection Mr. and Mrs. John Coulton Waugh. Night snow has color, and here it was heightened and made opalescent by the colored Christmas lights. Note that there are almost no hard edges at night, except in this case, those in the suggested stone wall in the foreground. I used plenty of contrasting dark colors to make the lights appear lighter. Although I used choppy, vague strokes of color, the picture isn't messy—it's controlled confusion.*

I hope you've been interested in our color story so far. I can imagine, however, that you still have an unanswered question: "What about those skies and distant scenes—are there complementary colors in those, too? There must be more to landscape painting than sparkling colors and woodsy colors!" Indeed, there is more than that. There are also the effects of distance—and the secret to painting these effects is (you guessed it) color!

The Colors of Distance

I recently took my sketching equipment up to a point in the Hudson Highlands overlooking the classic gorge made famous by the Hudson River artists. It was the perfect setting in which to brood about the effects of distance: how to paint them, what happens to the complementaries as they recede, and exactly how color is related to distance.

The first thing I noticed was the overwhelming presence of light blue as objects receded. This occurs, of course, for the same reason that the sky is blue: the white rays of sunlight crash into molecules of the earth's atmosphere and are broken up into the colors of the spectrum, the rainbow colors. Each color has a different wave length; the short blue rays are more widely scattered than others, filling the sky and the atmosphere with blue.

The blue of the atmosphere makes a sharp contrast to the brilliant hues of the objects close at hand, such as brilliant, sunlit yellow-green foliage and slashing viridian green shadows of nearby shrubbery. These actual colors of close objects that aren't influenced by atmosphere are called "local colors."

The Effects of Distance

I looked across the Hudson River to a distant mountain in bright sunlight, perhaps a mile and a half away. I knew that the leaves on that mountainside had the same local colors as the trees close to my eyes, but they appeared to be an entirely different color. Also, when viewed from such a distance, small details vanish and we see only the overall color, with a slight vibration of light and shadow.

The blue atmosphere changes distant leaves to blue-green, and the grayish water vapor in the air (always present to some extent) make this color even lighter by reducing its original intensity. On the distant mountain the result was a smokey, light, muted blue-green. This was not a flat, definite color; one of the most fascinating effects of distance is that it makes colors vibrate, or dance around. For example, in a grayish blue-green you'll also see richer cerulean or ultramarine blue; and those romantic cloud shadows that weave around mountains introduce an element of deep cobalt or violet-blue, making the sunlit areas almost warm green by contrast. You should paint such colors just as you see them.

The Complementaries in Distance

You may gather from this that the complementaries are very much in evidence, even in such distant effects, and you're right. When seen up close, ledges break the green mountainsides with patches of warm stone color; at a distance, these become areas of light muted pink, true complementaries to the smokey blue-green violet of the mountains. The complementaries are everywhere; you can't get away from them. So why try?

As you look at a mountain a couple of miles away, you may think: "At last we've seen the last of the complementaries!" But that's not so! Get in the mountain country in the summer and check on the furthest peak you can see. The distance will absorb most of the colors, but there'll still be an enriching trace of them visible. Look at the sky where it meets the mountain; the effect of distance on the haze makes the sky tones a warm, pinkish violet. These two tones—the light, muted blue of the mountain and the warm, lilac pink of the sky—are complementaries, even though they're remote.

34. Sea Distance. *How to make the surface of the sea stretch out before you instead of rising up like a wall? Simple: leave a soft blur on the horizon line that extends to a little way below it. This will achieve the effect of air, space, atmosphere, between the viewer and things seen at a distance.*

35. Brook Distance. *Do your brooks ever seem to run up-hill? Try this easy trick. On a piece of paper draw a strung-out S shape back and forth from the top of the sheet to the bottom, the way a winding brook would look if seen from an airplane. Now hold the paper horizontally at eye level. What happens to the S shape? It squeezes together. What you're seeing is perspective at work; this is the way you'd see a brook from ground level.*

There's more to the complementaries of distance than this, however. Please turn back to the color wheel on page 65; you'll find a group of color blocks at the upper left of the wheel labeled "tints." These innocent looking pastel tones hold an enormous potential for the landscape painter. First, they represent the most distant colors we can see—the colors that flicker in far-off deserts in the West, along the lower layers of the sky throughout this country, and in the distant notes of the receding ocean. And these tints can be very easily mixed: simply take a small dab of any bright hue and mix it with white, adding more and more white until the distant tint appears.

Most important, since these tints are mixed from the basic hues, all the effects created by contrasting the bright hues will also occur with the tints. The life and excitement radiating from complementary hues will radiate from complementary tints, too, allowing you to bring this enriched color to the most distant areas of your landscape.

Studying the Complementary Tints

Please experiment with the complementary tints: mix each one and make a set of tile squares. As you mix them, you'll make some exotic discoveries that relate to the problems of painting distant objects and sky. You'll find, for instance, that green tint isn't earthy but very light and aerial, most suggestive of the lower part of the sky toward late afternoon. You'll discover that the violet tint is the most unearthly, perhaps, of all the colors: it provides those delicate violets that make the sky recede quite far back, and it can vibrate against its complementary yellow tint.

Mixing the Magic Color

There's one color Odin and I think is so special that I'm going to tell you just how to duplicate it. It's the color of a distant mountain reflected in a lake or river. To mix this Magic color, add a little white and some alizarin crimson to viridian green. Keep mixing the colors together until they make a shimmering, deep gray that seems to vibrate between green and deep crimson. Somehow this mixture picks up the very mystery of deep, still water. The more you use it, the more useful you'll find it.

As I use the Magic color, I'm always glad that I don't include black on my palette. Under the pressure of outdoor painting, an artist with black on his palette might be more than tempted to mix the colors of such a reflection with black. Then where would the delicate vibration of green and alizarin be? What would become of the very soul of the Magic color?

There are other magical combinations of colors, usually made with complementaries. Experiment and discover some yourself. What Odin calls the Coulton

Waugh gold is most valuable: cadmium yellow medium, raw sienna, and white.

The Ball of Air

The ball of air! Landscape painters, this is the special effect my book and I charge you to create—the layers of air between you and your distant subject that make colors vibrate and flicker and produce spots of muted, low-intensity color.

Color spots are the building blocks of your ball of air. You need to master these before you can make your ball of air truly breathable; you need to understand how the ball of air makes them shimmer and vibrate before you can paint them effectively.

Think of hot air rising from a radiator. Because the layers of air above the radiator are unevenly heated, there's often a kind of tremble in that area. Layers of air above the earth are unevenly heated too, and as we look through many such layers as we gaze into distance, we see the trembling of far away colors and tones.

You'll also notice that these distant colors don't have precise edges but tend to fuse and wobble together. These distant "fusions" can be beautifully executed in knife painting. Use the floppy Long-John blade, vibrating it lightly back and forth, or use its loose tip to blur the tones slightly. Blurring in one tone on top of another is an extremely useful technique for creating the effects of distance. Study landscapes by Monet and you'll often find that his distant objects are blurred by his laying one dab of paint over another.

Distant Sea Effects

My father told me, and often pointed out in nature, that when you're high enough above the rocks or beach that the waves no longer seem to rise up above the horizon, you can see a broad blur of color that extends from the horizon line to quite a way below it. Such an area is so far away that the details of the waves aren't visible. Painting this effect just as you see it, as a blur, adds a remarkable sense of distance to a picture.

Perspective

Besides the colors of distance, the softening of edges, and the general vibration and blurring of tones, there's another important aspect to distance: perspective. It's really curious how many artists balk at the mention of perspective. Their noses wrinkle and their eyes turn dark Prussian blue with distaste. "Perspective? Nasty stuff. Who needs it?" Well, I do. Not only do I need it, but I love it. It enables me to shoot my landscapes way out so that the beautiful life-giving air can rush in.

People are afraid of perspective because they think of it as horribly complicated, as a kind of web of eye levels, vanishing lines, horizon lines, and so on. But it isn't that way at all. It's extremely simple, as simple as a recipe for making cream sauce, which all of you undoubtedly know about (melt and blend one tsp. butter and one tsp. flour; add cup of milk and a little salt).

Eye Level

The most important ingredient in perspective is the eye level (Figure 36). You'll easily understand it if you follow this procedure. Stand facing a wall. Make a pencil mark on the wall just at the level of your eye. Now move back a bit, and look at the mark you've made. Imagine an extension of the mark going all the way around the room. If the mark is 5′ 6″ from the floor, the line around the room will be 5′ 6″ from the floor. This big, flat circle is your eye level; the level of your eye above the ground.

If you were standing on a flat beach looking at the sea, where would the 5′ 6″ high eye level be? The horizon? Exactly right, the horizon! This is of the greatest importance in landscape painting. And it wasn't so difficult to understand, was it? Have a cup of cream sauce.

INSIDE OUTSIDE

36. Eye Level. *Eye level and the horizon line are one and the same. There's only one eye level in any given picture—the artist's. But the artist can choose to do his picture from a great many different eye levels: from high up, from close to the ground, etc.*

Three Eye Levels

Remember that there's only *one* eye level in any painting: the eye level of the artist who painted it. Eye levels, therefore, vary according to the height of the particular artist's eye. But this particular artist may not be always standing with his eye level 5′ 6″ above the ground. Suppose he gets a crook in his back, and decides to paint sitting down. His eye level will drop to about 44″ above the ground. Now suppose he decides to paint the view from a nearby cliff, 75′ above the beach level. This will mean, assuming that the artist is standing up, that his eye level will be 80′ 6″ above the beach.

37. Three Eye Levels.

A. Standing, a normal eye level, and not particularly dramatic.

B. Sitting, which accentuates the sky area and can provide more drama.

38. Placing Eye Level.

A. Center, which divides the picture area exactly in half, an effect that is not very interesting.

B. Low, which is more interesting, as this arrangement will accentuate the sky area.

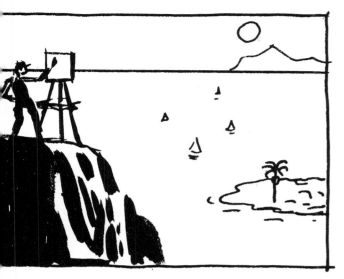

C. High eye level, which includes more of the sea, is more panoramic.

From this you can see that the artist can have many different eye levels, depending on the vantage points he decides to paint from. The three eye levels just described have tremendous significance, because the relationship between the objects in the picture will look entirely different when viewed from each one.

Look at eye level 1 in Figure 37a, for example. Here, the artist is standing on the beach. This is a very calm, normal eye level. The artist clearly sees the large waves ahead, and he can also look above them to get a sense of distance. Most pictures are painted from this eye level.

Eye level 2 (Figure 37b), in which the artist is sitting down, gives a sense of drama. Objects in distance, like the big cloud, tower up and look majestic. The foreground waves are tossed up above the horizon.

Eye level 3 (Figure 37c), gives a fascinating view of the world. The artist is high up, and his eye level has moved high up on the canvas with him. As a result, he looks down and paints all the interesting things lying below—boats, waves, islands, and so on. This viewpoint is very effective, and isn't nearly as widely used as it should be.

Placing Your Eye Level

Just about the first thing an outdoor painter does is draw a horizontal charcoal line lightly across his canvas to place the eye level, or horizon line. Where should the artist draw this line in each of these situations just described?

Look at the first box in Figure 38, which shows a horizon line drawn across the middle of the canvas. That's bad! It suggests two areas of exactly equal proportions; the eye becomes confused and doesn't know where to look first. Also, the center of the picture seems weak as if it might fold on the horizon line. From this you can see that you should draw your horizon line either above or below the center of the canvas.

The second box in Figure 38 corresponds to eye level 1 (Figure 37a), in which the artist stands on the beach. It is a normal layout, and you'll generally make your cross line like this, giving plenty of attention to things below the line as well as to the sky elements above it. It also corresponds to eye level 2 (Figure 34b). Here, the artist is intrigued by a dramatic sky effect, so he drops his eye level line down, leaving room for an enormous ball of air.

The third box in Figure 38 corresponds to eye level 3 (Figure 37c). Here, the artist is high up on the cliff, so it makes sense to place the horizon line high up on the canvas, leaving lots of room for all the interesting goings-on below.

I suggest that you try out these different eye levels, using them to make pencil sketches from nature. This may open up a whole new world of nature painting interest to you. It won't be drudgery—it'll be pure fun!

C. High, which is also interesting, as the land or sea area will be accentuated.

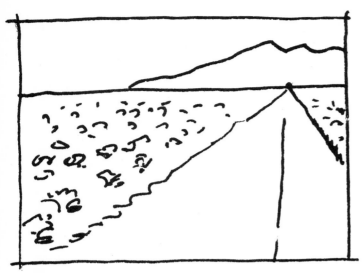

39. Vanishing Perspective. *The eye level in this sketch is the horizon line at the foot of the mountain. The vanishing point is a point at which the two sides of the highway converge and "vanish" on the horizon.*

40. Object in Perspective. *I've added a telephone pole to my sketch, but because there is only one, you don't get an accurate idea of its size in relation to its surroundings. It looks gigantic.*

Vanishing Perspective

I did the odd little sketch in Figure 39 as I stood in the middle of the road. It was my first view of California, introducing me to the strange fascinations of western landscape so different from the eastern kind. Over a perfectly flat plain of parched desert, the road shoots directly west like a rifle bullet; the bullet seems to locate itself at the point where the two perspective lines of the sides of the road meet and vanish.

The principle of vanishing perspective is illustrated very well by this sketch. The base of the mountain continues as desert meets the sky on either side. This constitutes the eye level, which we already know all about. The perspective lines—the sides of the road—meet and appear to vanish at the vanishing point, right at eye level, in front of the spot from which we're looking, the station point. The effect of distance is intensified by the principle of diminishing sizes by which objects we know to be the same size, such as the sagebrush plants on either side, appear smaller and smaller as they recede into the distance.

Enter the Pole

In the sketch in Figure 40, notice that I've added a 30′ telephone pole at the side of the road. Since the eye level is only 5′ 6″ above the road, the pole obviously towers into the sky. To add more poles leading away to the west we have only to draw a line from the top of the nearest pole to the vanishing point; this will indicate the height of each receding pole (Figure 41). Let's assume that the next pole is 50′ from the first. We would then estimate this distance, and draw the second pole so that the top just touches the perspective line.

Because distances between objects also seem shorter as the objects recede, we'd have to place the third pole closer to the second than the second is to the first. We can continue adding poles in this manner until they become lost in a blur near the vanishing point.

If you remember this very useful principle, vanishing perspective, it will help you to achieve the effects of distance in all kinds of landscapes. You'll always be placing trees or houses of similar height along a perspective line as you did with the poles.

41. Multiple Objects in Perspective. *Now I've added more telephone poles. The technique for making them recede into the distance is simple: I simply drew a straight line from the top of the first pole to the vanishing point and then filled in the other poles, being careful to place them at increasingly short spaces from each other. Any object seen in perspective is done this way—buildings, roads, figures that are at different distances from the surface plane of the picture, anything. In other words, all forms seen in perspective diminish in size as they recede toward the vanishing point of the picture.*

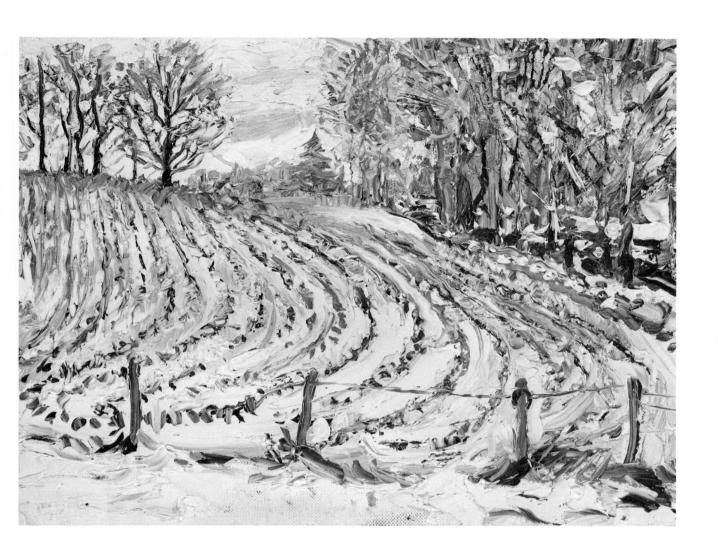

Corn Stubble Field in Snow, *9″ x 12″. This little painting was done by Odin. I asked her to paint some winter trees, but she was fascinated by the rows of corn stubble and couldn't resist doing the whole scene. "Odin, what knife and strokes did you use?" "I made the sky and the snow between the rows with my New York knife, using the full blade. I used just the tip for the stubble and the trees to the upper left. I used the edge, and also a brush, for the trees to the right. Oops, I drew the fenceposts!"*

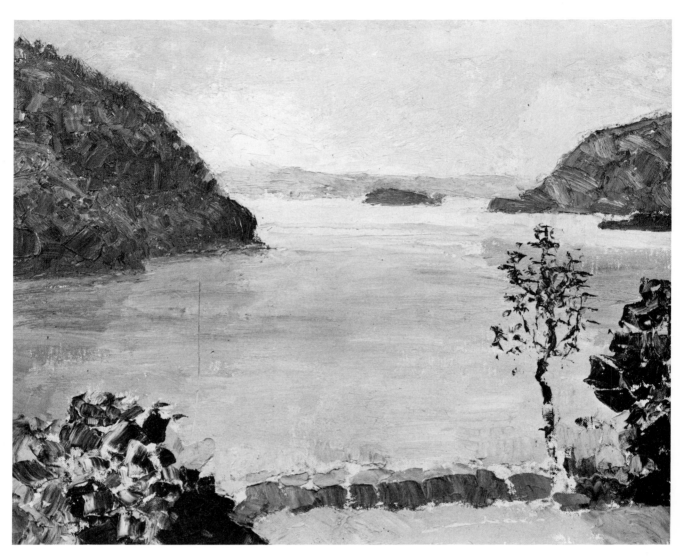

The Hudson from West Point, *16" x 20". Collection Odin Waugh. The ball of air! To get this effect you must have keen eyes; you must brood; you must dream. But above all, when you come to actually doing the painting, you must get down to the truth of those spots of color, those mutations and lowered intensities of things seen in the distance such as sky, mountains, water. These are the building blocks of your ball of air.*

Detail of The Hudson from West Point. *Monet would have rendered this lilac river with small dappled touches; my father, with broad, horizontal strokes; whereas I laid in the water with thick impasto horizontals, turning my floppy Long John knife loose. The shrouded mountains are done with subdued color blocks laid on with a Magic knife. The ball of air, which sinks into the river valley and seems to reverberate from its leafy mountainsides, was coaxed into life with the help of a paintbrush: use what you must to grab what you must!*

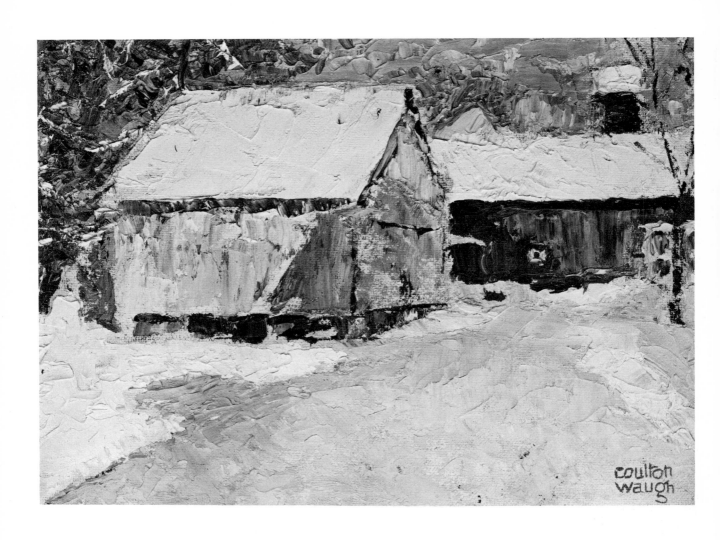

Sunlit and Cold (Zero Morning), *12″ x 16″. Collection Odin Waugh. This scene of my granary fascinated me but it was very difficult to do—mainly because my fingers were freezing as I stood in the snow trying to paint it! The picture area recedes only slightly here. Note the perspective lines of the side of the building and on the snowy expanse of foreground that lead the eye into the depth of the painting.*

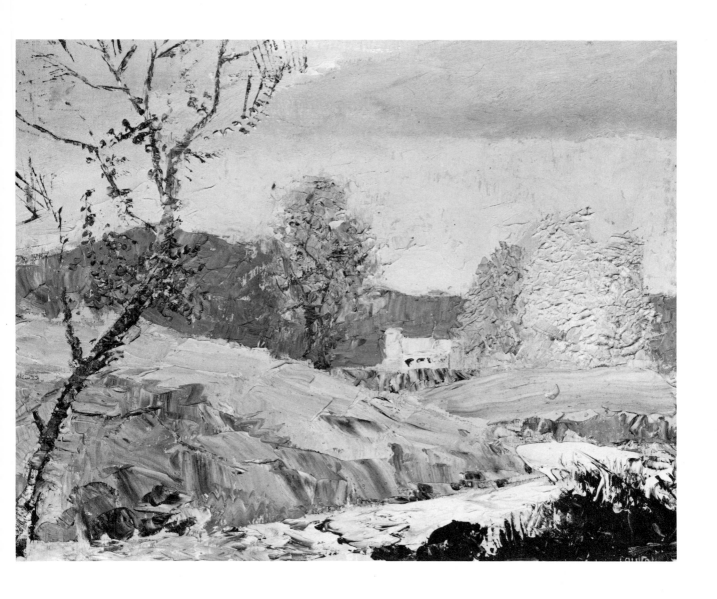

Marlboro in the Spring, *24″ x 30″. Collection Odin Waugh. Sweeping knifestrokes suggest the toss and dance of the apple trees, while small, twisty blobs, done with a flick of the wrist and the tip of the knife, suggest the pear blossoms. Note the path of vision made by the brook snaking around to the right and the sense of depth achieved by the smaller foliage in the farther-away trees.*

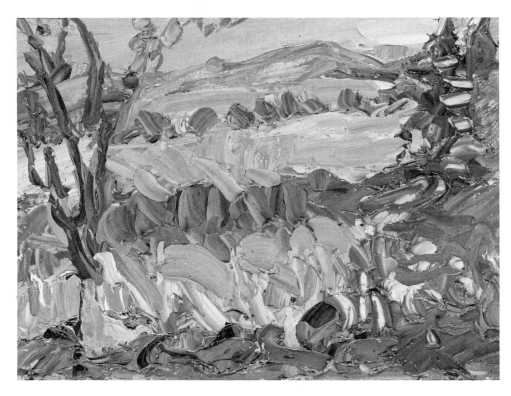

42. Color Shows Distance. *A three-dimensional effect is achieved here through the use of blocks of delicate color, seen in this illustration in terms of tone.*

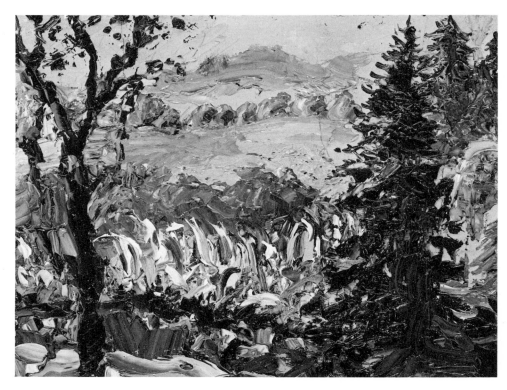

43. Outline Shows Distance. *Here's the same picture done in terms of outlines rather than color areas. The strong vertcal and horizontal outlines bring out the flatter, close-up front area of the picture plane.*

Three Dimensions or Two?

Now we come to a really fascinating question, a kind of dilemma in our distance story. Obviously, distance has three dimensions: it goes up, across, and in. When we are successful, we can bring to our two-dimensional canvases a strong suggestion of the third dimension. But suppose I hang such a picture on my wall and a critical modernist comes along, sees that my picture has depth, and says, "But Mr. Waugh, your wall is flat. It has only two dimensions, up and across. By hanging a picture with depth on a flat wall, you're breaking a hole in that wall, Mr. Waugh!"

As I escort my visitor politely to the door, repressing an urge to kick him in the pants, I think, "But that's what I want to do—knock a hole into stuffy indoor lives and let distance, air, and color come streaming in."

On the other hand, however, there's something in what my erudite friend says. A picture should always relate to the wall it hangs on. Now, is there a way to make the picture two-dimensional so that it will relate to the wall, and also make it three-dimensional so that it will have depth?

Yes, there is! It's neither intricate nor esoteric; Cézanne has done it very well. His famous color "modulations" were accomplished by laying delicate colors side by side with little outline between them; he used the complementaries, muted with blue in the most distant areas, to create depth. The big shapes were brought very strongly to the front, or picture plane, of the canvas, by firm outlines.

To show you what I mean, I've made a basic "grid-work" to correspond to the outlines in one of his paintings (Figure 44). Do you see what I'm suggesting? This is the ideal solution to the problem of two dimensions versus three: two separate color systems, one used to create a two-dimensional effect, the other used to create a three-dimensional effect.

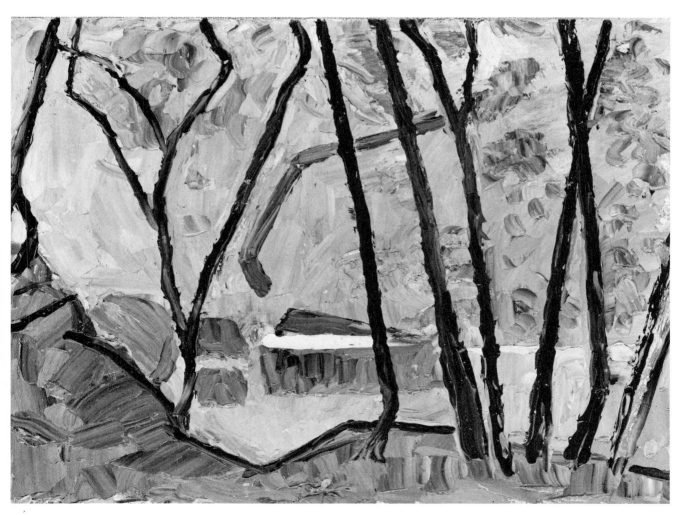

44. Dimensional Study Based on Cézanne. *This rough tracing of a Cézanne composition shows distance clearly, but it's distance as seen through a stained-glass window, the strong, straight lines of the trees keeping the picture on the wall.*

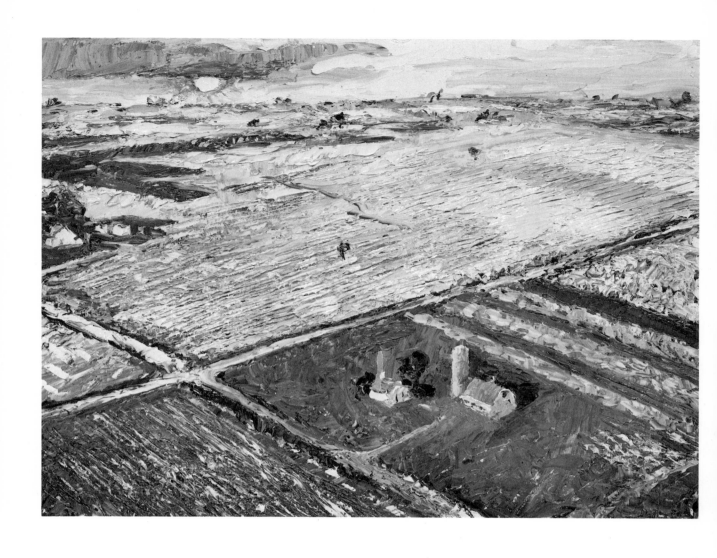

The One Farm, *9″ x 12″. You look across it when you look across Nebraska, Iowa, and the states of the Midwest—all the tiny individual farms blending into one gigantic farm that covers 765,000 square miles. This flat farmland becomes a rich tapestry of form and color: juxtaposed rectangles and complementaries of wheat gold land and azure sky.*

6
COMPOSITION

I love the shimmer, the light, the confusion of impressionism; and I feel indebted to Cézanne for combining his modulations of color with strong linear elements. But we've got to put some bones inside our sentiment. Behind the landscape gridwork and the depth created by complementaries, there should also be an understanding and use of the important principles of composition.

Figure 45 is an analysis of a highly decorative Japanese block print, by Hiroshige. I include it here to illustrate the composition principles that were rediscovered by Manet, Degas, Monet, and the other impressionists, and that brought to their paintings a new level in powerful arrangement and pattern. These principles aren't difficult to grasp. Basically, they fall into two categories, format and design.

Format

Format means simply the specific area and proportions of each individual picture. Many artists don't realize the importance of this aspect of composition, but it is the format that usually determines the character of the finished painting.

For example, imagine a canvas 25″ x 30″. Whether you hold it upright or horizontal, there's a serene, easy-going relationship between these two dimensions. Compare this with an odd-shaped canvas, say 16″ x 30″. Such a picture has a special character of its own, before it's even painted. This unusual format should be used only for special purposes: it won't in general contain the actual picture in a pleasing manner, but will distract the viewer from the design elements within it.

Design

Design is the arrangement of the shapes and colors that underly the actual painting; good design can preserve, and bad design can destroy, your creative inspirations. If you're to do your best painting, a rocket

should go off in your mind when you begin. You should see, or conceive of, something that sweeps you off your everyday feet and lifts you to a state in which only painting will keep you at peace with yourself.

And if you're really going to get your rocket into orbit—if you want your colors to fire up and fly—you must have a design foundation to hold them in place. When this foundation, like the colors themselves, is the product of strong artistic impulse and understanding, it will be powerful enough to receive the inspirational jets of pigment you throw at it and hold them inside an integrated pictorial unit.

Of course, it's true that in the heat of actual painting the artist does not, and should not, think in analytical terms. But the design should be studied between creative bursts.

Over the years, alternating periods of study and actual painting have given me the operational set of design principles I'm about to present to you. If I'm humble about my own work, I'm not the least bit humble about these principles. I make a vast claim for them: that they've illuminated the great art of all periods, and that teamed with color, they have been its inner core.

Center of Interest

The primary principles (elements) of design are the center of interest, rhythm, and areas of calm. The first we'll discuss is the center of interest. To understand its importance, think of the viewer looking at one of your paintings. As his eye darts about, what is it looking for? Something of interest.

This fact may seem absurdly simple, but many artists and students pay little attention to it. It's easy to slip into the bad habit of painting several centers of interest with equal pulling power. Although you'll usually need more than one point of interest in your paintings, you must establish priorities so that one is dominant and the eye can move from the first to the second and possibly the third without confusion.

45. Japanese Print. *(Above) I loosely traced this print, darkening the straight lines to show the forceful design structure of this simple scene.*

30"

25"

FORMAT

46. Format. *The "format" of your picture simply means the picture area: large, small, horizontal, vertical, narrow, square, etc.*

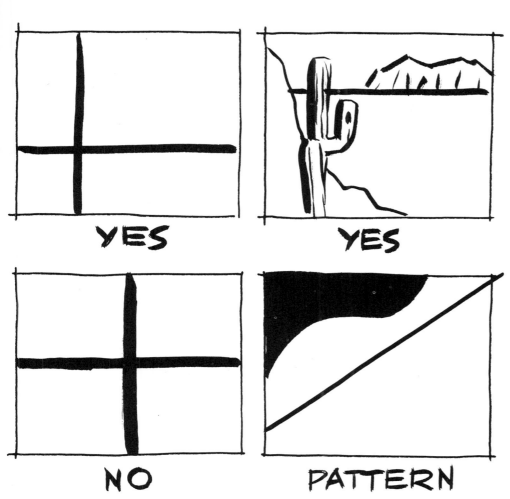

YES YES

NO PATTERN

47. Dividing Your Picture Area. *These glyphs show a few different ways the picture area can be divided. It's always more interesting if the composition is broken up into unequal segments; and exact division of the picture area, as in the lower left-hand box, is visually the least interesting.*

48. Contrast and Sparkle. *This quick night sketch was made by Odin from the Amtrak window. It illustrates how whites can be made brighter by the use of large areas of dark.*

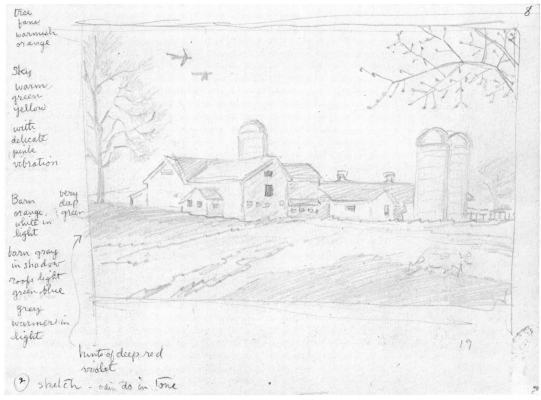

tree
farm
warmish
orange

Sky
warm
green
yellow

with
delicate
pink
vibration

Barn very
orange. dar
white in green
light

barn gray
in shadow
roofs light
green blue
gray
warmer in
light

hints of deep red
violet

② sketch - alus do in tone

Trial Sketches for Misty Spring Near Sara Wells Trail. *(See finished painting on the following page.) Driving along a road not far from Goshen, New York, I was suddenly aware of a great white barn, enormous, with three very tall white silos. Rooted in the ground, yet rearing up all white with pale gray roofing, it had a kind of legendary grandeur—like a castle? Yes, that was it. It brought to mind that castle of castles, the walled town of Carcassone in France, which I'd visited many years before.*

My left hand went up with thumb and forefinger forming a viewfinder to help me find the center of interest. And what was the center of interest? You've guessed it—that proud white castle-barn dominating its little valley and dramatically set off by wooded mountains with their dark cloud shadows of muted green and deep azure blue. There are three points about this barn which made me especially eager to paint the scene: its proud, castlelike, legendary feeling; its symbolism as a center of a fine industry that restores as much richness to the soil as it uses; its pure beauty in the abstract, with its massive white blocks and pillars against the deep shadows of the wooded hills.

It took a little experimenting before I located just the right place for the big barn in my composition. The sketch at top left *was made after I got home. The* sketch to the left *was done on the spot and includes color notes. The* sketch above *was the composition I finally settled on. I accepted this layout because it felt right; it was only later that I realized that there was also a rich symbolism at work. A dairy barn owns a large area around it—at least a hundred acres—on which the herd grazes and the needed crops—alfafa, hay, corn—are grown. So the big white barn, placed high up, is sensed as the focal point of its little valley, and by virtue of its placement seems to overlook the empire which it dominates. Also, the other design elements seem to fall right in place: a strikingly clear master path and an area of calm.*

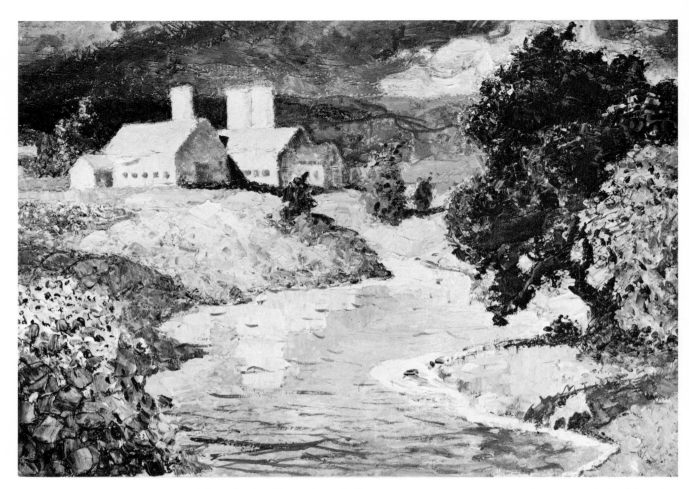

Misty Spring Near Sara Wells Trail, *20½″ x 30″. Collection Odin Waugh. In this painting I've tried to express my sense of integration with my particular part of the country, as well as my respect for the people and their way of life. I also tried to define the spirit, the mystique, of the chief occupation of the area, which is dairy farming.*

Detail of Misty Spring Near Sara Wells Trail. *Here you can get a good idea of the knifestroke sizes and directions in the water area. The clumps of leaves were done with dark dots over block strokes. Most of the dark areas of the water were laid on with sideways strokes, the lighter areas with vertical strokes. A slight wibble wobble and a few long, narrow strokes laid on top of the wet paint add to the watery feeling.*

Another situation that creates confusion, rather than drawing the eye to the center of interest, is the placement of two lines or areas of color to form an "X." The two lines then compete equally for attention and stop the eye from moving over the entire painting surface. The remedy for this situation is simple: remove one line.

Creating contrasts is perhaps the most forceful way to bring a center of interest into focus. For example, contrasting a white mass with a large, simple, dark area will draw the eye directly to the light and give a powerful impression of force and vitality. Darks make whites seem full of light, and a touch of a light color adds velvet to dark masses. Contrast, sparkle, and life are also produced by the juxtaposition of complementary colors as well as by the "complementary" relationship of black and white.

Many beginning artists miss this point. I see them working beaverishly to add a blaze of light to some object in a still life. The higher they pile the paint, the dirtier it gets. The problem is that they've omitted the contrasting dark.

There's one precaution you must take in creating contrasts: don't make the area of light and dark equal in size. The eye is looking for a single area to focus on, a place to rest for a moment. Make the dark area say, "look at the light," or vice versa.

Easy Magic

The best way to determine the most pleasing center of interest for your composition is to use the magic little tool, the viewfinder. You can cut one like that in Figure 49 from cardboard, or you can form a rectangle with your fingers. I happen to have such a good finger viewfinder that I use it everywhere, even in the crowded streets of New York. (It elicits a very odd reaction from people who see me squinting through my fingers at them!) To find the right spot for your center of interest, move the viewfinder around and experiment with various arrangements, and do this with care and thoroughness. The place of the center of interest will be the heart of your picture and you must get it right at the beginning.

There are so many possibilities that I can't give you exact rules regarding the placement of the center of interest, but you'll find as you try a variety of arrangements that one will seem to have an easy magic about it. The space relations will sing together, and the eye will move through the picture area without strain. When you find this arrangement, you'll have something precious. Make a little thumbnail sketch at once to fix these relationships. Later, if other parts of the picture go bad, you can always scrape them out, go back to this central construction, and start all over again.

49. Viewfinder. *Some people make viewfinders from a piece of cardboard with a "window" cut out of it; I make mine from thumb and forefinger. There's one advantage to my version—you're never without it.*

50. Curved Master Path. *This master path recedes into the depth of the picture. I worked this sketch of Odin and one of the children up into the painting reproduced on page 98.*

51. Straight Master Path. *Master paths can travel from side to side of the picture area as well as from front to back.*

Besides helping with the center of interest, this finder principle shows what can be left out to simplify the confusion of nature. Watch for a winding line, the master path curve of beauty, to appear in your finder.

The Master Path

Since the eye is constantly in motion, the observer will eventually look away from the main center of interest and move along the path running between this and the secondary areas of interest. I call this the "master path," the primary rhythm that winds in, around, and through the canvas. It links the various centers of interest and invites minor excursions as it leads from the outside toward the main center of interest, or perhaps winds around it. The master path holds the pictorial elements together as does the string inside a beaded necklace, and its primary characteristic is rhythmic movement.

The master path should correspond to the movements of the painter's own eyes when he first looks at the scene in nature. If this track is strong and rhythmically arranged, the eye of the viewer will be attracted to it, and it will generate in him some of the artist's original inspiration and creative excitement. If there is more than one path, only one should be allowed to dominate.

What attracts the eye to a master path? It's usually the line or flowing edge of the path, which jumps out of the confusion of tones and shapes. Geometry hints that a line is described by a moving point. As it looks for a point, the eye is caught by a line and moves rapidly along it. When the line ends, the eye jumps off to be caught by another line, and shots off in a different direction. Some of the most powerful and successful art styles have capitalized on this fact, notably that of van Gogh.

The straighter and bolder the line, the faster it pulls the eye. When van Gogh's impulse was to execute a large, baroque curve, the nervous energy in his wrist rendered it with a series of straight lines set at angles to one another. These made the viewer's glance accelerate as it whisked along one bold line, then jumped onto the next one. The rhythm and pure speed of such compositions provide glow and excitement.

But not all lines hurry along at a fast pace. If you draw a clean, straight line, your glance will scoot along it. If you cover this line with pencil shading, your glance will move slowly, picking up details of the shading along the way.

Areas of Calm

As my eye moves along my favorite painting spot—the brook on my farm—I look for that element called mystery. Details will blur in some areas, and shadows and forms melt and interlock. Such areas are perhaps one

52. Sketch Taken from a van Gogh cypress. Notice the rhythmic, curving lines, made up of short, straight strokes, that lead the eye through the center of interest and on into the background.

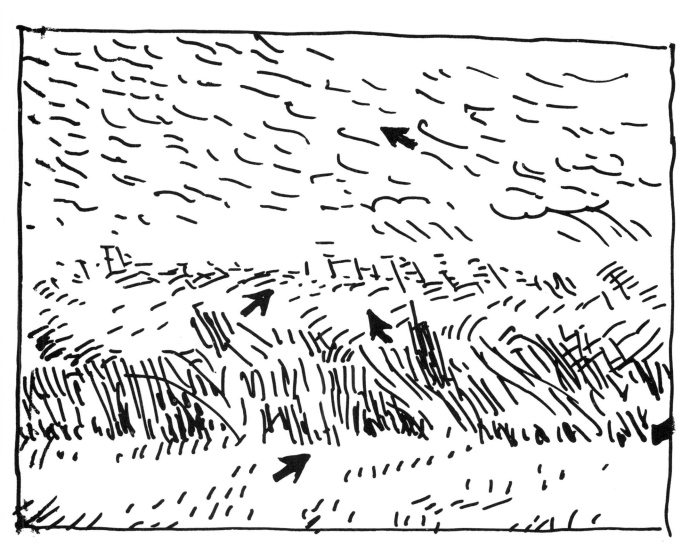

53. Sketch Taken from van Gogh's "A Wheat Field". *(Above) This diagrammatic sketch shows how rhythmic lines can be used to carry the eye in an interesting zigzag path through the picture.*

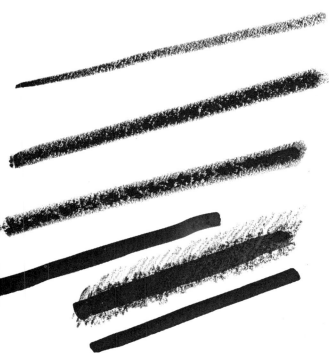

54. Fast Lines. *Different kinds of lines affect the eye movement of the viewer in different ways. They also help the painter create different kinds of surfaces, from slick and shiny to rough-textureed.*

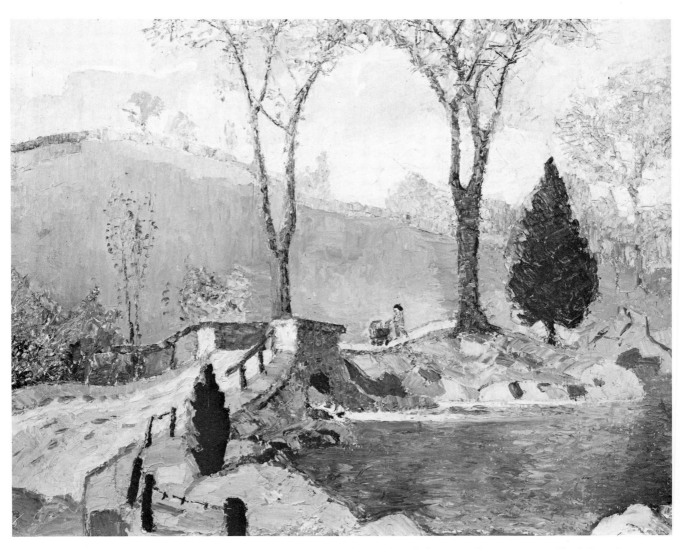

Beyond the Elms, *24″ x 30″. Collection Odin Waugh. You can easily follow the master path here, and also spot the center of interest, in this little scene showing Odin and one of the children.*

Detail of Beyond the Elms. *The cumulus cloud above is thin, scraped paint. Notice, too, the contrast created by the juxtaposition of broad, flat strokes in the sky with the short, choppy vertical strokes of the hedgerow on the hill.*

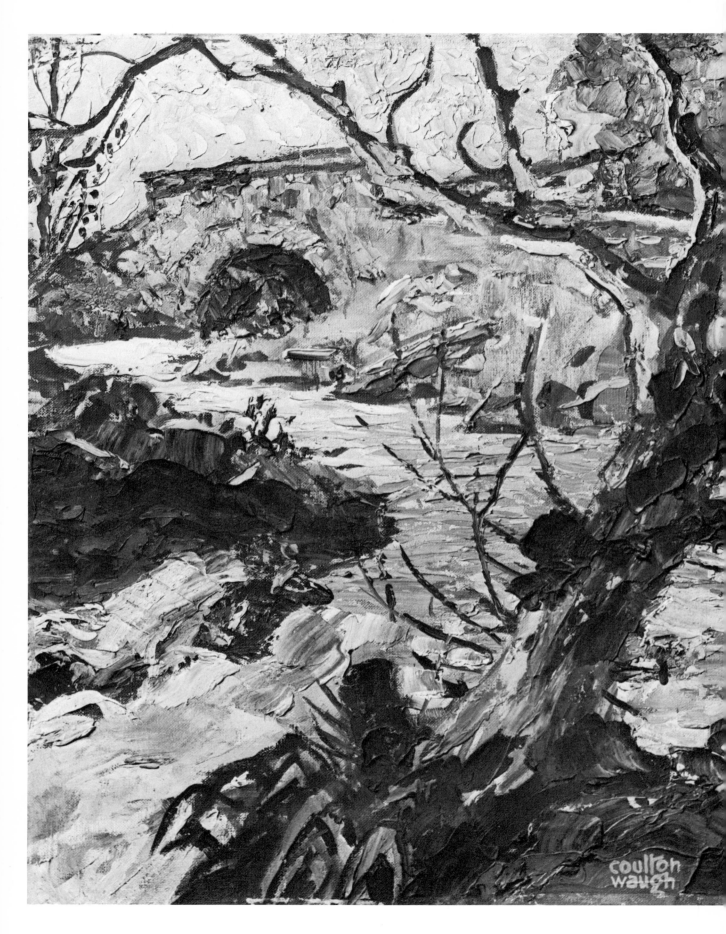

of the major reasons for painting. We want to escape to places like this. Grim people tell us to face reality foursquare, but the common sense of the average man tells him something different—that, sometimes, he must dream.

The opening, the expansion of the mind created by a suggestion of mystery, brings me to the last of my design principles—the area of calm. This principle is the least utilized by beginning painters. The artist, in his worthy zeal, usually drags everything, including the kitchen sink, into his painting. I know this because for years I was a victim of this lug-it-all-in mania. My pictures weren't pictures but collections.

Finally, exasperated, I took to the palette knife, which by its nature renders things in large scale. At first the operation was surgery. Later, I began to wonder if, since the removal of superfluities is so gratifying, why not allow for areas of calm right from the beginning. I saw that such areas should be integrated into the original structure.

To test this hypothesis, I turned to the history of art and emerged from a period of study quite sure of my idea. The area of calm was related to simplicity, which is surely one of the most cogent principles of art. The simple area, the blank area, has been characteristic of the finest art since the days of the Egyptians, who employed it with restraint and decorative feeling. I found simplicity in Assyrian bas-reliefs, in the art of the Greeks, and throughout the history of oil painting, which carried the pictorial use of areas of calm from a decorative function to a huge extension into space where man could breathe the universe.

This vast expanse is often sky, but not always. It might be the simplicity of a costume on a Titian fig-ure, or the shadowy background areas of a Rembrandt painting. Simplicity dignified the works of Daumier and Manet. Degas adopted the principle largely from a study of Japanese prints, for it is one of the cornerstones of Eastern art. In a Cézanne canvas, the negative areas are in themselves functional as they work with the shapes of the positive elements.

Use Your Customary Stroke

Areas of calm should not necessarily be rendered with flat paint, laid on like wall paint. An artist's special texture is his own handwriting; if it suddenly stops in a particular area, the mood of the painting is broken. So use your customary stroke and technique in the calm areas, too, in order to maintain the unity of your conception, which is, after all, the primary requirement of any work of art.

Using the Principles of Composition

I'm sure you'll adopt a critical attitude toward the suggestions I've made here, and this is just what I'd like you to do. They're of no relevance if they don't work for you.

Look for centers of interest, the master path, and areas of calm. When you've found them, use a viewfinder to pinpoint them in nature. When you've arrived at your composition, make a thumbnail sketch to establish the relationships. (Don't waste time on detail.) This will sustain you, set you right if you go wrong. Then get these elements onto your canvas as quickly as possible. Forget about the hour, day, and year.

Stone Bridge and Winding Brook, 20″ x 16″. Collection Odin Waugh. The tree in this painting shows what fun it is to draw with wet paint into wet paint. I moved around and around when I was fixing this composition until I found just the right balance: the tree framing the bridge and the stream, a strong master path, and an area of calm.

COLOR
DEMONSTRATIONS

Demonstration:
Badlands

A

Badlands: Step 1. *When my wife Odin showed me her sketch (A) of this South Dakota scene, I said, "Look, these badlands seem to want to spit and snarl. By crowding them so high up, you haven't left enough spitting room. Why not drop the eye level below center?" "Horrible—I mean, exactly right," I said when she showed me sketch B, which includes the design principles I've stressed in this book. The center of interest is the jagged sawtooth badland area against the sky; the master path starts at the lower right, weaves around behind the badlands, and connects with what will be dark clouds at the upper right; the area of calm is the soft, open surface of the plain in the foreground.*

B

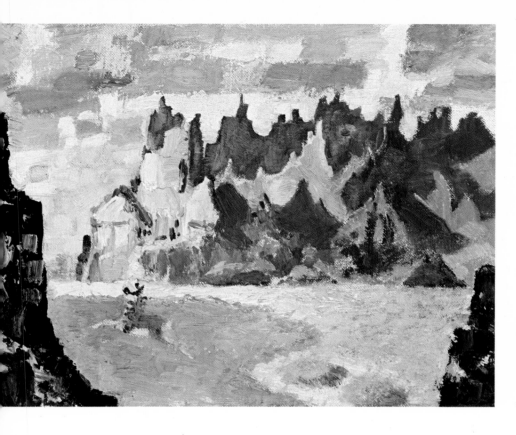

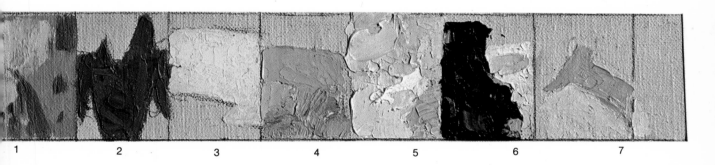

| 1 | 2 | 3 | 4 | 5 | 6 | 7 |

Badlands: Step 2. I carry out the same design principles in this black and white tone sketch. This will bring me to grips with the dramatic power of this layout.

Badlands: Step 3. While I do the tone sketch, I ask Odin to make a "color chord," reducing the main colors of the painting to six or eight blocks and noting the colors she uses to mix them. This helps me establish the light and shadow pattern for the painting, as well as to determine the correct tonal values. Block 1 represents sunlight falling on the badlands' rocky spires: you can mix it with burnt sienna, raw sienna, and white. For highlights, use more white, with accents of cobalt violet. Block 2 is the mysterious badland shadow color. Use cobalt blue lightened with white, and turn the blue into mystery by muting it with a little burnt sienna. Block 3 is sunlight streaming over the plain. Use cadmium yellow pale and white. In the actual painting, I'll mute this with a trace of cobalt violet toward the right and introduce vibrations of raw sienna in the center. Block 4 is the shadow over the plain. For that brilliant blue-green, use phthalo green and white; soften it with delicate, warm greens and cobalt violet, letting these colors flicker together to produce a soft light. Block 5 represents the sky. For this, I'll use extremely delicate phthalo green tints at the bottom and move upward into a distant cerulean tint. The areas of warm white, faint pink, and pearl and deep gray are clouds. Block 6 includes the colors of the close-up rocks. Apply massive, blocky strokes of deep ultramarine and cerulean blue, and add deep raw sienna and cobalt violet for variety. For the sunlit edges, use undiluted cadmium yellow medium. Block 7, according to Odin, is "a little red-orange antelope that just jumped across the shadow."

Badlands: Step 4. The reason I take so much time for the preliminaries to my paintings is that when the actual moment of painting truth arrives—when I start to put down those block-and-knife manipulations "for real"—I want to be a free man. Now as I begin the actual work on canvas I can breathe easily, because I've worked out the routine considerations in advance. I usually use gold outlines—made with a mixture of cadmium yellow, raw sienna, and turpentine—because after the final colors are blocked in, the gold (or some of it) will remain visible to add richness along the edge of each color area. This will turn the picture into a color painting *rather than a cold, undigestible color "photograph."* I begin this stage by sketching the outlines with charcoal, then I dust off the charcoal and apply the gold lines with a small square-tipped brush. Now there's nothing to hold the color back, so here I go!

Badlands: Step 5. Where should you start adding the actual colors? Wherever your creative fire is burning most urgently! In this case, I start with the dramatic badlands themselves and in the great flood of color and light that flows in front of them. I work very freely here but I try to keep my magic knife going in a choppy rhythm of blocks and strokes. I keep cleaning the knife and picking up fresh, Gauguin-like colors. I claim no equality with Gauguin, but I do love his painting; he creates light by contrasting daring, outre colors. I try to do that, too.

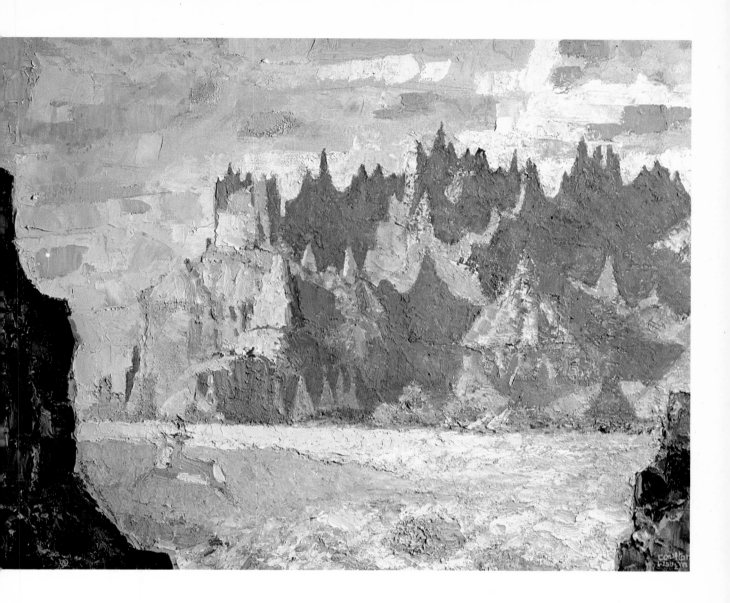

Badlands: Step 6. *This final step is meant to carry the intensity and excitement of Step 5 into all the incomplete parts of the canvas, as well as to create extreme contrasts so that the mysterious, muted colors will "sink" into the shadowed obscurity of the badland crevasses. At this stage you may want to put one color over another to produce a sense of vibration or texture. Okay if you must, but you should understand that this idea of "finishing" is where most bad painting begins. The first strokes are almost always the best, with the most light, brilliance, and distinction. Tinker with them, and you may lose that distinction. If that happens, follow this procedure. First, wipe your knife* absolutely *clean. Then get a perfectly clean new palette or a perfectly clean new area, and squeeze out completely fresh colors. Mix the new tones with the least possible muting or "dirtying." Pick up the new, clean gobs of paint and lay them over the original areas with fast, light strokes. Don't dig; adjust the paint as little as possible. Finally, celebrate—and I won't make any suggestions on how to do that!*

Demonstration: Squall

The sea is rhythm

Squall: Step 1. *Memories! You have to rely on them when you paint the sea and boats. For many years, I sailed in and out of Provincetown harbor, crooking my fingers to make a picture finder whenever I saw something of interest, and storing the image away in my memory. One of those memories, the beautiful little ketch* Cynosure, *makes a good beginning for a picture. Another memory provides the rugged-looking fisherman and his dory, placed at a lively angle to the* Cynosure. *I'll also add some big schooners drying their sails at Railroad Wharf, and I'll bathe the entire scene in the marvelous colors of the approaching squall. The whole composition is so vivid that it fits together in this layout sketch at first whack.*

SQUALL first layout sketch

Squall: Step 2. In this tone sketch, I translate the action of the theme into contrasts of value. I create excitement by placing the high white sail against the ragged dark clouds.

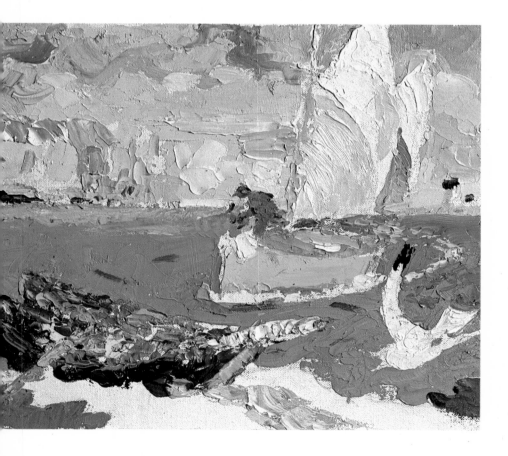

Squall: Step 3. Now I record my vivid color impressions in this color chord, using the rich, strong colors that can be seen before sheets of dark rain close down on the scene. Provincetown water is often as brilliant as the Mediterranean. I capture this blue by using phthalo green, phthalo blue, and white, and add darker ripples of deep ultramarine blue. I accent these colors by using golds and rich yellows for the doryman and his oilskins and add similar notes around the distant fishing schooners. The hull of the Cynosure is a tender spring green, and the sky is a wild combination of blues.

Squall: Step 4. I start my usual gold outline, sketching very loosely in charcoal and dusting it off only a bit. I pick up a large, floppy brush, load it with lots of turpentine-diluted gold paint, and begin to sketch as I think about the approaching squall. Some of the charcoal combines with the gold paint to create a pleasing effect. I'm not outlining so much as playing around with mass and form.

Squall: Step 5. I scoop some phthalo green and white on my magic knife and begin to paint the sea. I use thick paint to emphasize the excitement of the storm, creating similar textures as I follow the shapes of the twisting clouds and the choppy water. I let the knife flutter and skip over certain places that would naturally appear blurred—the fish houses and the ships in front of them, for example. Above all, I keep experimenting and adding new spots of color, trying not to add too much at one time.

Squall: Step 6. *I render the fisherman as a blur of color and use a mixture of cadmium yellow light, phthalo blue, and phthalo green for the boat. I begin at the bow and make one sweeping stroke right down to the stern; the heavy paint gives the boat a solid appearance. I use similar strokes to apply the lightest areas of the sails, leaving the unpainted canvas as the shadow areas. In the sky, I first lay in some broad, calm undertones of gray-blue. Then I pick up an angry greenish gray mixture and twist my wrist as I apply it with the knife, making my strokes first in one direction, then in the other.*

Demonstration:
East Branch

East Branch: Step 1.
Squinting through my fingers, I focus on a glittering white spear of light flashing across this somber and mysterious section of a small river in New York State. I see a truly Rembrandt-like center of interest, but my general impression is that this scene is much larger than what I see through my fingers. Then I remember how my sea-painting father demonstrated what he called "nature's scale." He held out both arms and painted the shapes he could see between his fingertips, using a 25″ x 30″ canvas. I hold out my arms in the same way, and record my impression as a sketch.

East Branch: Step 2. *I use pastel pencil to sketch the two elements I glimpsed in Step 1: the white glitter of light and the expansive surroundings. With a little juggling, the shapes come together naturally into a large patchwork of light and dark mountains and light and dark reflections, all seemingly sewed together with light.*

East Branch: Step 3. *Now that I've decided on a design, I set up my color chord. For the main note of sunny green on the mountain, I mix permanent green light and white. This mixture alone is too light, so I waft in traces of cobalt blue and use even more cobalt blue for the darker notes on the mountain. The deep shadows in the foliage are viridian green muted with cobalt blue and burnt sienna, with touches of ultramarine blue added. For the foliage reflections in the water, I use the same colors with more raw sienna added. For the reflection of the tall mountain, I use one of my secret techniques: I mix viridian green, a little alizarin crimson, and white, experimenting and varying the proportions until the color has a remote quality.*

East Branch: Step 4. Now I put down the gold lines, using a mixture of raw sienna and cadmium yellow light thinned with turpentine and applied with a small, square-tip brush.

East Branch: Step 5. Now I mix a big pile of mountain "apple" green, using permanent green light and white and adding touches of cobalt blue. I slap the pigments on roughly, turning my wrist to create texture in the trees. I experiment with rich cloud shadows and add pink and bronze notes to save the painting from what Picasso called "the green sickness."

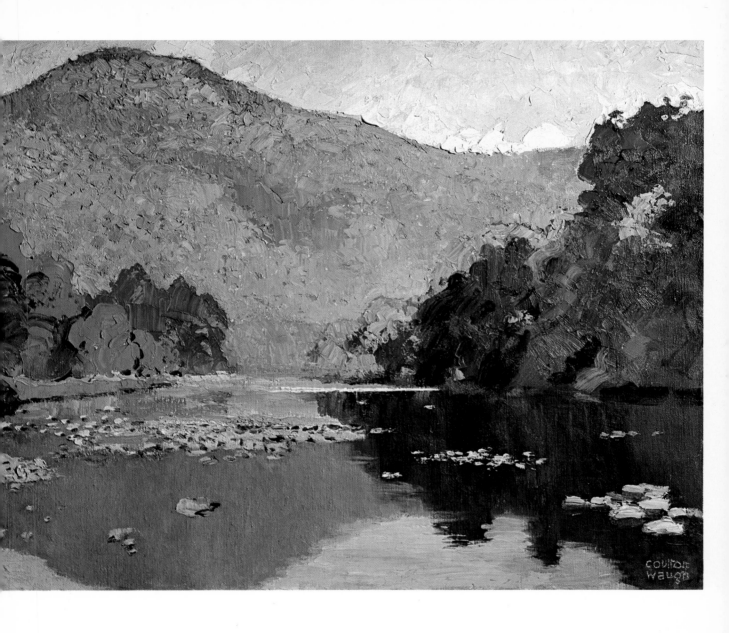

East Branch: Step 6. *I begin the finishing in the area of dark, shadowy foliage, using wide brushes and painting knives to add "whirlwind squiggles." I follow this by chopping in touches of pure ultramarine blue and viridian green with my magic knife. Because the light is deepening, I tone down the apple green mountain with hints of bronze, violet, cobalt blue, and viridian green. Next I swiftly add the dark reflections in the water as large masses. I use large knifeloads of viridian green, pure except for occasional shots of burnt sienna and ultramarine blue, and fuse the colors together by using the knife to pull them downward. Then I fill in the sunny pinks of the glacier-flattened rocks in water.*

**Demonstration:
Bill's Field**

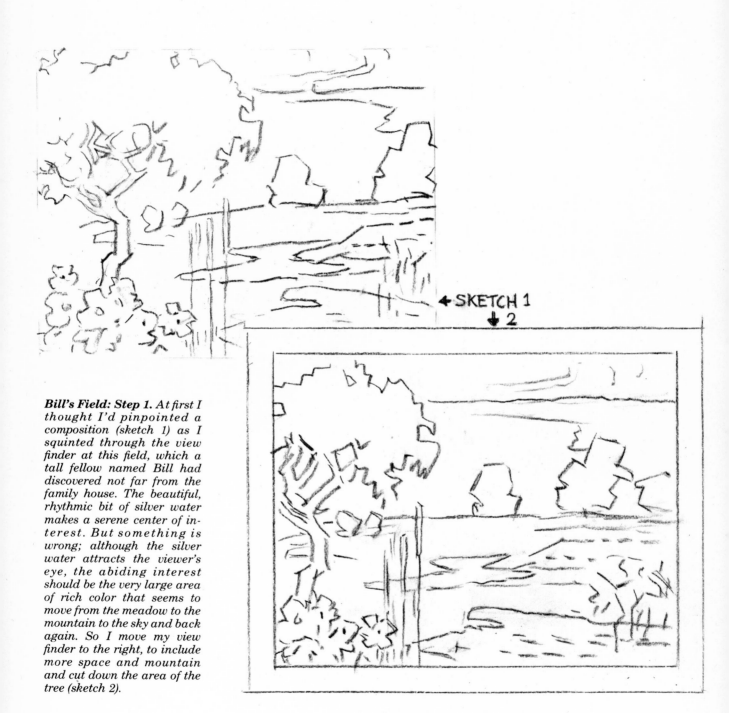

SKETCH 1
2

Bill's Field: Step 1. *At first I thought I'd pinpointed a composition (sketch 1) as I squinted through the view finder at this field, which a tall fellow named Bill had discovered not far from the family house. The beautiful, rhythmic bit of silver water makes a serene center of interest. But something is wrong; although the silver water attracts the viewer's eye, the abiding interest should be the very large area of rich color that seems to move from the meadow to the mountain to the sky and back again. So I move my view finder to the right, to include more space and mountain and cut down the area of the tree (sketch 2).*

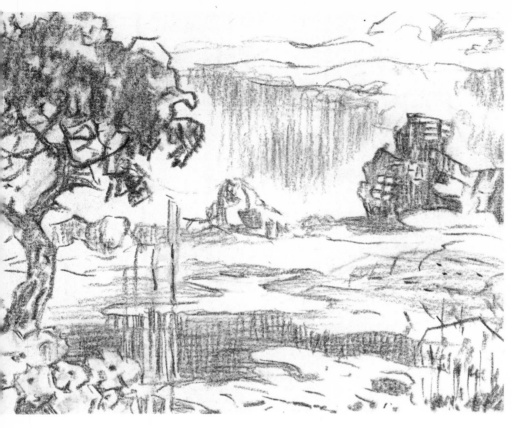

Bill's Field: Step 2. *This tone sketch shows the dark, almost silhouetted tree in contrast to the light areas. It also suggests how the eye can move from the close-up group of wild roses in the lower left, along the dark, shadowy area of foreground, past the silver water, to continue around the distant tree on the right and up into the shadowy edge of the mountain (the master path). The mountain itself is the picture's area of calm.*

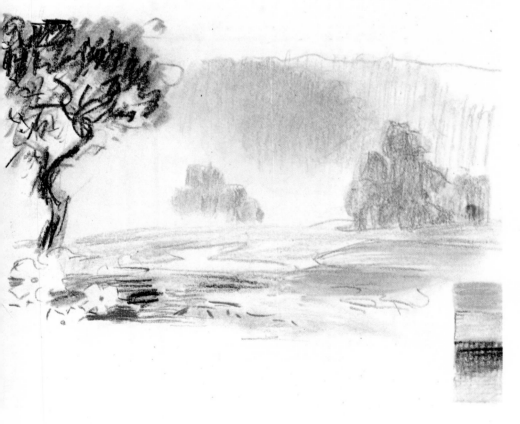

Bill's Field: Step 3. *I use pastel pencil to quickly dash off this color chord, registering the splendor of a passing color effect. You can see the essence of the colors in the shadowy areas in the foreground, which include brilliant red-violets and sunny, shining greens. I continue this basic contrast of complementary colors beyond the water. Also beyond the water is the first hint of blue shadows, creeping up the distant greenish gold mountain.*

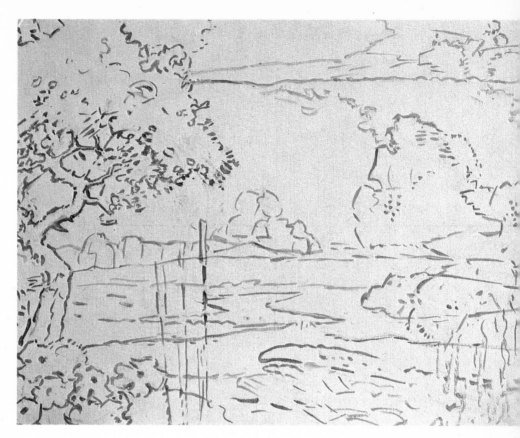

Bill's Field: Step 4. The gold lines will work as complementary accents against the blues and blue-greens soon to be added. I use a brush to apply the loose, thinned-down gold mixture.

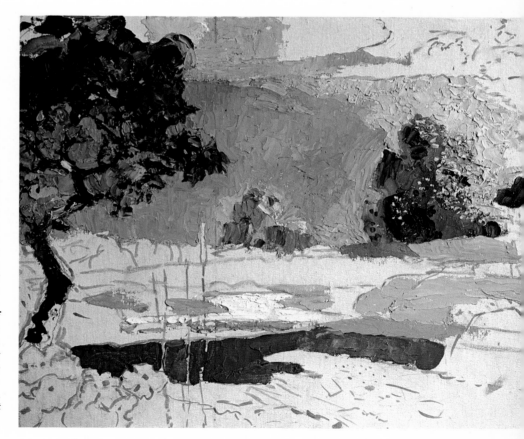

Bill's Field: Step 5. Now my colors, rags, and knives are all clean and ready! I establish the deepest notes first—the dark ones close at hand in the powerfully silhouetted tree on the left, the deep moss green shadow stretching from the base of the tree toward the right, and the bold, blocky darks of the tree in the middle distance. Then I slash in big notes of cobalt violet and phthalo green warmed with cadmium yellow lemon, adding echoes of these beautiful colors in the distance. Now for the main element—the haunting shadow of a cloud on the mountain. For this, I use cerulean blue and white, slightly muted with burnt sienna.

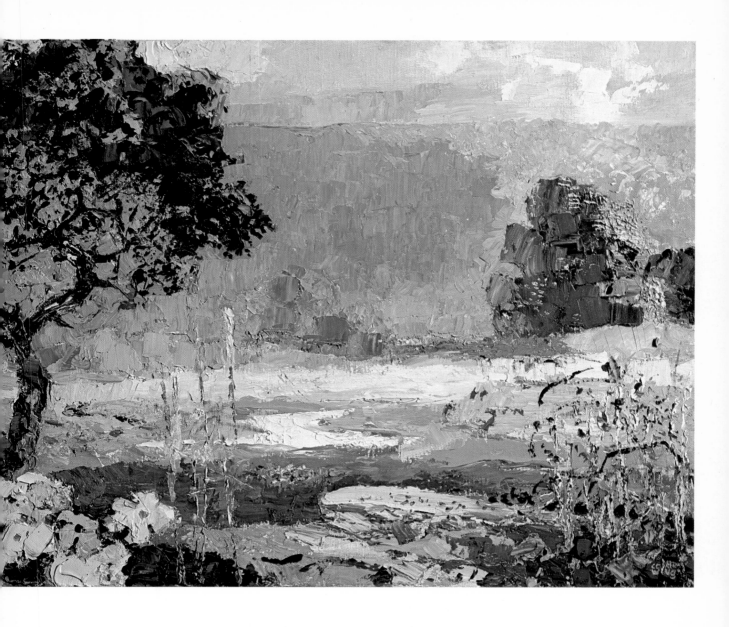

Bill's Field: Step 6. *I continue to balance the complementary colors: if one area of red-violet seems too "blazing," I drag a bit of fiery yellow-green over it; if one color spills over too much on the right, I add its complement on the left. Without trying to tighten up or become too specific, I suggest detail by sketching with the knife blade, continually picking up new mixtures of the major colors. In the large tree, for example, I use loose, flickering knife work to suggest the small, deep blue branches. I fill in the brambles at the right and the leaves in the distant group of trees in the same spirit.*

**Demonstration:
High Fall**

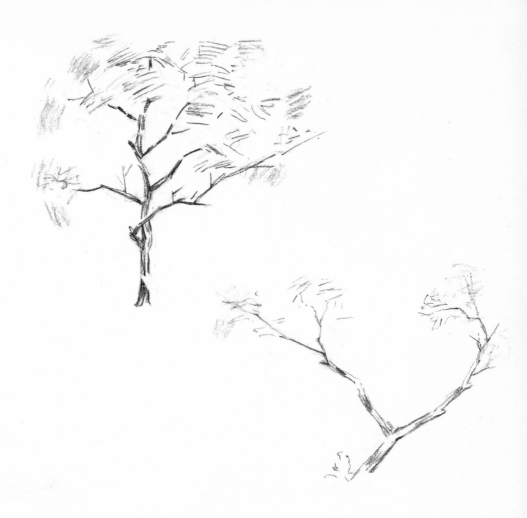

High Fall: Step 1. *High (early) fall is that short season when the useful but monotonous greens of summer withdraw, allowing all the brightly colored chemicals beneath them to come out and "celebrate." One early October day, I found these trees crossing their branches in the pose of celebration you see in sketch 2, and I planned my composition around them. Although my wife Odin had reservations about it, I included the cow at the lower left because it added a note of exotic color. Although the composition sketch seems very symmetrical, the eye moves from the cow to the tall hedgerow trees at the right and then to the distant center of interest.*

High Fall: Step 2. This tone sketch, done in sepia pastel pencil, further consolidates my compositional plan. The branches of the celebrating trees will be part of the darker, close-up framework, and the fall colors will flare outward from there. Between the framework and the distant colors will be the meadow, over which pours a flood of lemon yellow sunlight.

High Fall: Step 3. My color chord includes the lower right, center, and left areas, as well as the upper right part of the composition. Here you can see the contrast between the areas of color in shadow and those in the light. As I look at nature I try to see blocks of color, then I ask myself just what each of these colors is.

High Fall: Step 4. *It's al-ways a thrill to leave the analytical work behind and push off into the painting it-self. Here I make the gold lines, which are very appro-priate, as everything on this high fall day seems to be out-lined in gold.*

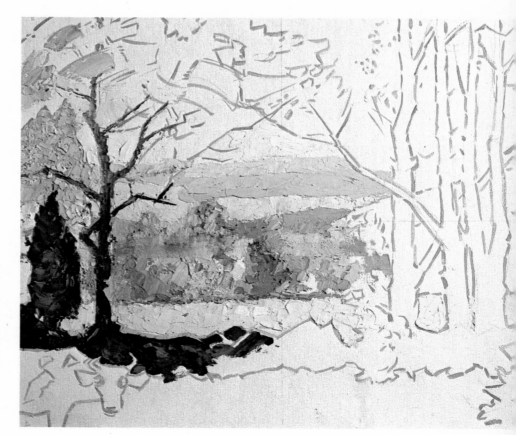

High Fall: Step 5. *I pick up yellows and oranges on my magic knife and slap them into the distant trees, using straight, downward strokes. I fill in the pink areas that are picking up the glow from the sun at the right, then add patches of yellow and burnt sienna, yellow ochre, and muted pink. I clean my knife blade and begin to add co-balt, ultramarine, and ceru-lean blues.*

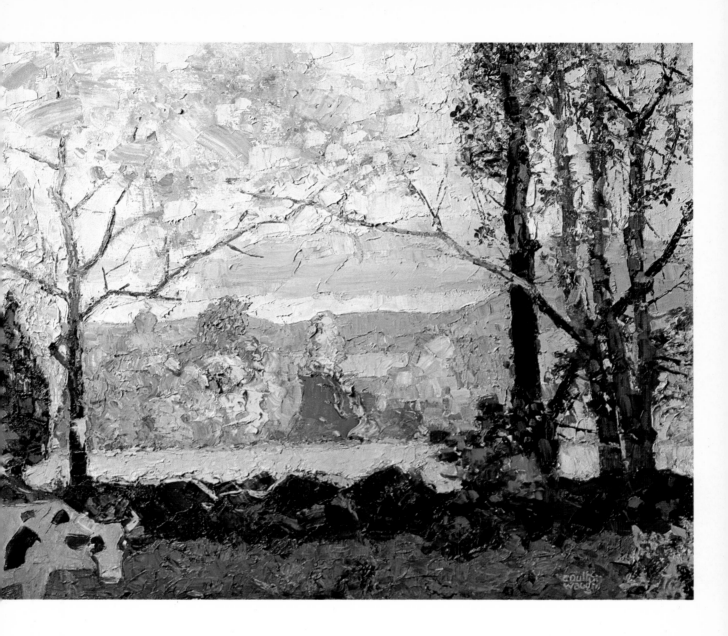

High Fall: Step 6. *In this stage, I block in the color on the rest of the canvas. I take my time, because I want to create a similar density of paint in every area—something learned critics who roll their phrases love to call "equalized surface tension." Wherever necessary, I overlay different shapes and vibrations of color, letting my wrist go as I paint. The area of warm lemon yellow sky between the groups of trees has become an important area of calm that is much needed amid the fall activity. This warm sky is echoed by the warm gold in the tree on the left and by the golden colors behind the tree group on the right.*

Spring: Step 1. *The following is an agreement made between Flora, Goddess of Spring, and Coulton Waugh, painter: "I, Flora, agree to visit your fruit country and all other fruit countries between May 10 and 20 of each year and release upon them the full splendor of my personality. It is my understanding that you will do your utmost and a whole lot more to render a faithful portrait of my work, representing it in terms of light and luminous color." Being fiercely impatient, I set out a couple of weeks early for a certain patchwork hillside I'd seen before. There I found my design principles: the quaint little hilltop house made the center of interest, the road up the hill was the master path, and there were distant areas of calm. But it was still cold, so I quickly sketched the layout (upper left) and returned to my farm. A week or so later, I returned to find that Flora had moved up the hillside (lower right).*

Spring: Step 2. *I'd begun a quick tone sketch for values when I noticed a lovely gray cloud drifting up behind the white trees. As the soft but dramatic cloud shadows began zipping in and out over the entire hillside, I included them in the sketch.*

Spring: Step 3. *The spring color chord is delicate and soft, fragile and translucent. Use the brilliant tube colors available these days— phthalo blue and green, cobalt violet, permanent green light. Mix these with enough white to make them gay, and contrast them with high-value complementaries and other light colors that "dance" together. For example, look at the third color block from the left. It's a marvelous spring green mixed from phthalo green, a lot of white, and the cleanest lemon yellow you can find. To the right of this block is a complementary mixture of cobalt violet and white. The dark accents are pale cobalt blue. Can such delicate colors be applied with a knife? Yes—a knife can produce cleaner and purer colors than any other painting tool!*

Spring: Step 4. *I whisk these gold lines in, letting my wrist go free to follow its own rhythmic impulses. These gold outlines help to retain luminous color in the final painting; even if mostly covered with subsequent color, they remain visible in some areas to radiate sunny sparkles and to contrast with the blues and violets to follow.*

Spring: Step 5. *Work freely now and use plenty of paint! Remember to use complementary colors and make them vibrate. Put dashes of pink over the green, for example. Let your wrist "talk" and your knife flicker, not dig. If you add too many pink spots, wipe your knife blade clean and lift off a couple of spots until you hit the perfect balance.*

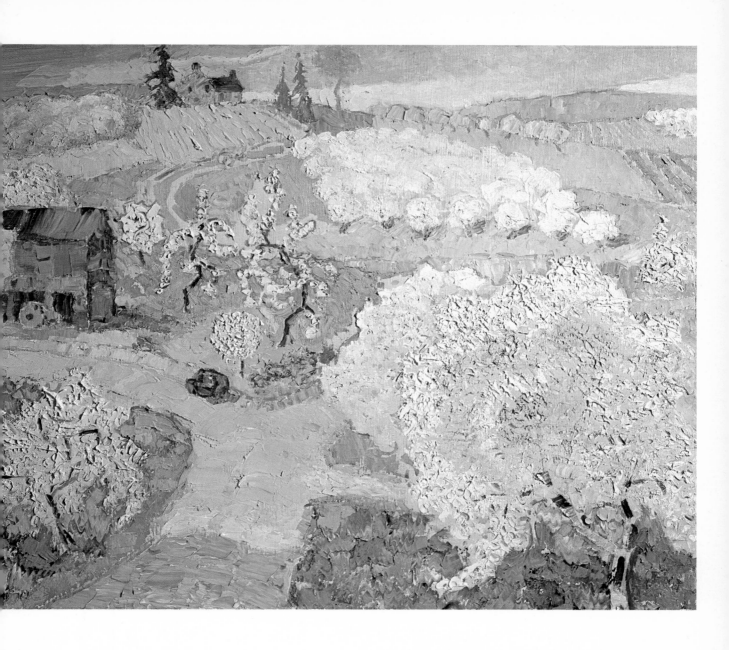

Spring: Step 6. *Now I go at the unfinished areas, trying to bring the painting together as a whole. I use echoes of color—in the blocks of cobalt blue shadow under the foreground trees, for example. I emphasize the rhythmic lines and patterns, adding bold orange-gold along the edges of the road and little notches of darks under the trees. Without over- working them, I add suggestions of blossoms to the white trees. Painting is suggesting, and suggestions are stronger, richer, and more refreshing when they're the result of fresh, powerful painting.*

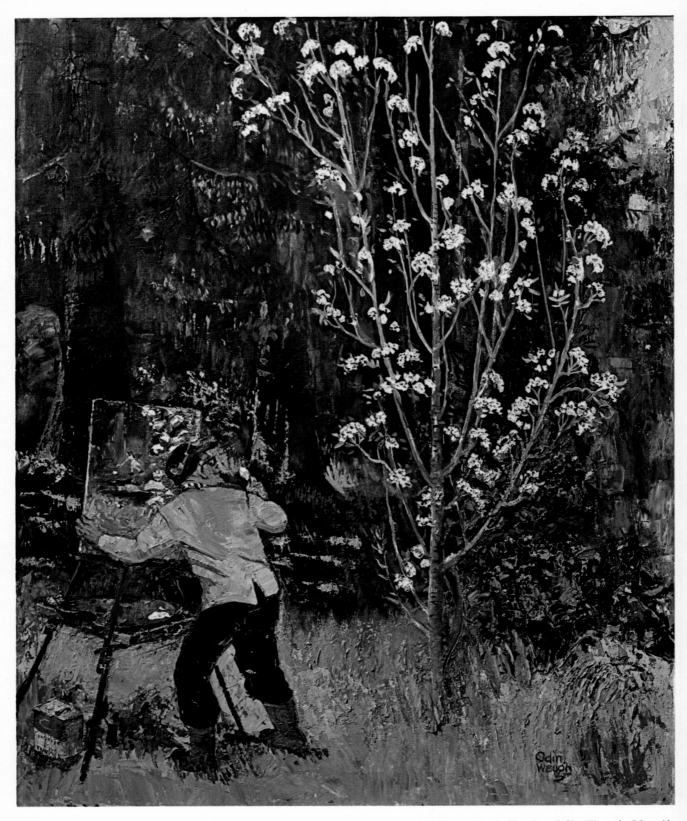

Coulton and His Pear Tree. *Oil on canvas, 26" x 32". Collection Odin Waugh. My wife Odin painted this one, using the painting knife in every area except the fiery red, translucent trunk and branches of the tree. There, she used a secret technique of her own. In the studio, she first painted the trunk and branches with white casein, then glazed them with a mixture of alizarin crimson, raw sienna, and oil painting medium.*

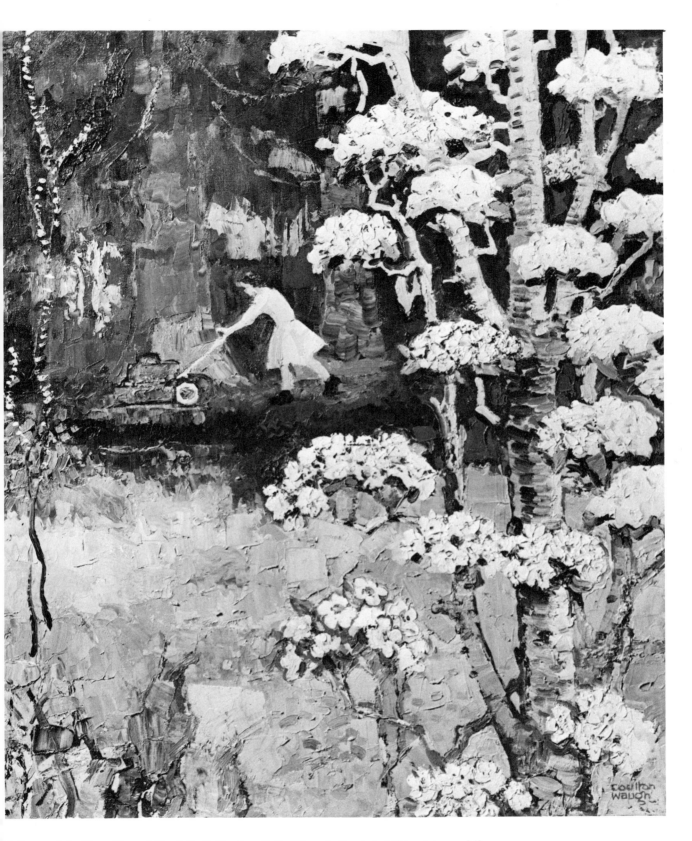

Odin and the Pear Tree, *28″ x 24″. Collection Odin Waugh. I painted this picture while Odin painted me and my pear tree (opposite page). Odin's picture captures the graceful shape of the tree, mine plays up the typical umbrella shape of the blossoms. The little bud dots on the left were done with the knife tip.*

Hole in the Wall, *Collection Odin Waugh. This picture is a good example of what I mean by letting you look deep into the woods, while the picture still manages to stay on the wall because there are strong upright and horizontal elements in the foreground. Even though you get a sense of terrific depth—looking far into the shadowy distance between the trees— you never lose the sense of the picture plane because those vertical tree trunks, those few horizontal branches, and that broken line of light across the center all remind you that you're looking at a painting on a flat, rectangular piece of canvas. Notice how the leaves and other debris on the forest floor are suggested by thick, chunky strokes, while thin, knife-edge lines produce the effect of needles and sunlit branches.*

7
TREES

A landscape may originate from the land itself—as the earth stretches out, rolling with its geological rhythms and erupting into distant blue mountains. But trees, surely, follow closely after the earth in the landscape painter's consideration. Trees are alive. We're all living creatures together, and living creatures *grow*. This fact, I believe, is at the bottom of the strange sympathy and understanding we have with trees. I lay my hand on a tree and something electrical passes through me. Something passes through my mind, too, and I think: "Brother."

As we grow, trees and men, the life force makes continual readjustments. We move this way and that way, seeking that which allows us to live. In the process, the living thing becomes flexible. A human body moves by a marvelously flexible mechanism. In much the same manner, the limbs of a tree reach outward, trying to find the sunlight so that the leaves can use it in the vital business of making food—good old necessity! I salute you, friend necessity. In obeying you, we living things create perhaps the most vital element of art: rhythm. Remember, as we study trees and growing things, that the rhythms of necessity create and explain their growth, and play an essential part in the artist's interpretation of them.

Clear your mind of the concept that you can take an exquisite little knife, put down one exactly right dot and another exactly right dot next to it, and have the beginning of an exactly right tree. In my experience, it doesn't work that way. Rather, it's the wild flaring up of the spirit, as the artist sees something intoxicating in rhythm, beauty, color, and light, and uses his technique to capture it. Sounds horribly difficult, doesn't it? Well, what's even more difficult is painting a tree without inspiration. If you paint out of a bucket of inspiration, that inspiration will zip into the pigment and paint for you.

How do you get a bucket of inspiration? By observing nature, by looking at it with poetic feeling. It's like the sap buckets that Vermonters hang from pegs on their sugar maple trees. They look in them; if sap has accumulated, they pour it out and go to work making maple sugar. So, look in your bucket; if you find it brimming with inspirational sap, unhook it, and go to work painting. (For art's sake, don't go to work with a dry bucket!)

If there's nothing in the bucket, don't despair. Perhaps there were holes in it, or perhaps you didn't know how to approach the tree—and perhaps I can help you in that respect.

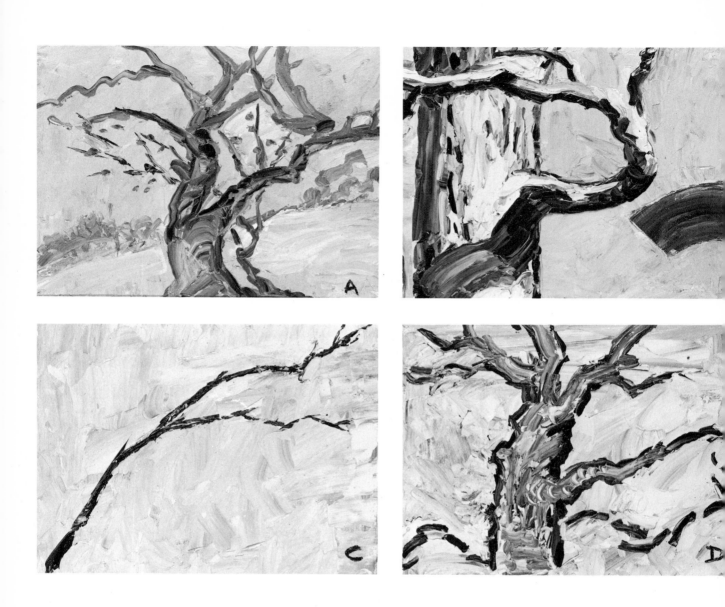

Tree Strokes. *Most of the strokes on this page were done with the tip of the knife. These narrow strokes are really like drawing and you are often working over a wet background, so remember to hold the knife very lightly, as if it were a violin bow, so the paint will lie on top of the wet color underneath. When you are painting the whole tree (A), you can pile on thick, short strokes for the trunk and use longer, more rhythmic strokes for the branches. More of the knife blade is used for the broad strokes of the shadow side of the trunk and the cast shadow of the branch (B), while narrow lines are made just with the tip. A jagged-looking branch (C) is done with a knife-edge stroke, not pulling the blade, but laying it on and then lifting it off. Van Gogh used short, straight drawing strokes (D) to get his curved shapes.*

Three Aspects of One Tree. *The trunk (upper left) is built up with lots of short, thick strokes. The large branches (upper right) are made by pressing and lifting off, pulling in the direction of the blade, or moving the blade sideways just a little. Small twigs (lower left) are mostly made by touching the knife edge to the canvas and then lifting off; but avoid that fly-screen look I have shown you in the corner.*

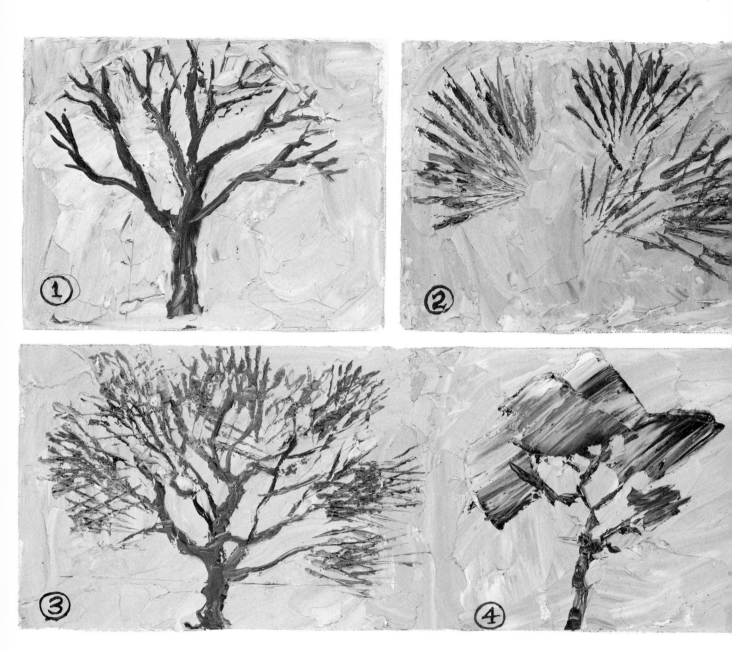

Twig Haze. *When an inexperienced painter is faced with rendering a leafless tree, he sees that the branches and twigs all narrow as they grow farther away from the trunk and toward the light. The outermost twigs melt away into a kind of haze, which the beginner can't paint, so he simply ends the little twigs (usually quite neatly) against the sky (1). Actually, nature creates a fan of little twigs (2), which you can paint with lots of knife-edge touches (3). You can also use flat, broad knifestrokes (4) to get twig haze.*

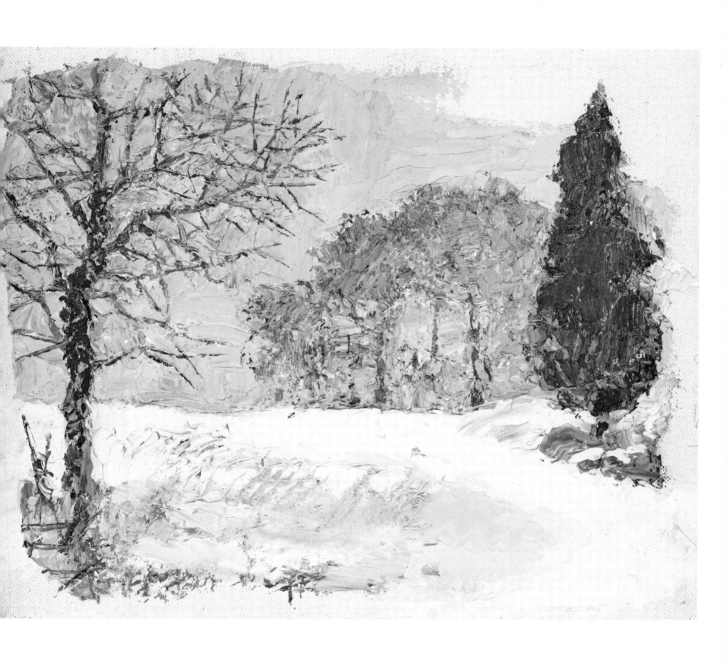

Bare Trees, Near and Far. *Close up, winter trees display the intricate framework of their branches and twigs. But in the distance, twigs blur. So the same tree can look terribly different close up and far away. The nearest tree (left) clearly shows the strong inner trunk, full of character; the pattern of branches reaching out, each determined to get the most sunlight for its own special load of leaves; and the small twigs that actually bear the leaves. The same tree appears in the distance in a blurry group, painted with the flat blade of the knife.*

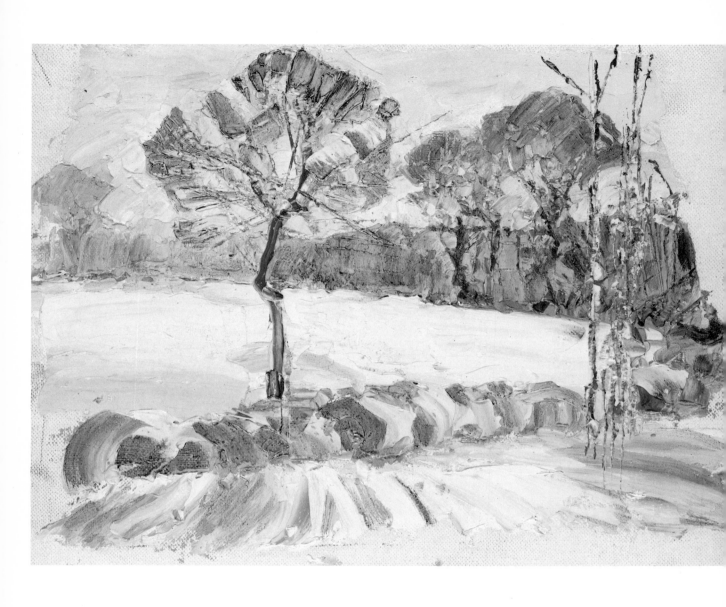

Winter Tree Haze. *To paint the haze of small branches on the nearest tree, I used flat strokes of the knife; notice how the strokes seem to radiate from the center of the tree. I also used flat strokes to paint the hedgerows and the distant trees. The group of slender tree trunks to your right are made with very thin strokes, but the paint stands way up from the canvas because I dug in with the edge of the blade and pulled away strongly. The strokes in the immediate foreground give you the feeling that they're receding to an invisible vanishing point, lending a sense of perspective.*

Twig Haze and Sky. *The horizon line is a lot lower here, and you can see all kinds of sky holes between the flat strokes of the twig haze. The strokes of the sky swirl around the tree and there's a great deal of texture at the base of the tree, where large and small strokes intermingle. The small, more distant tree on your left is hardly there at all, but I've suggested it with a pattern of irregular strokes.*

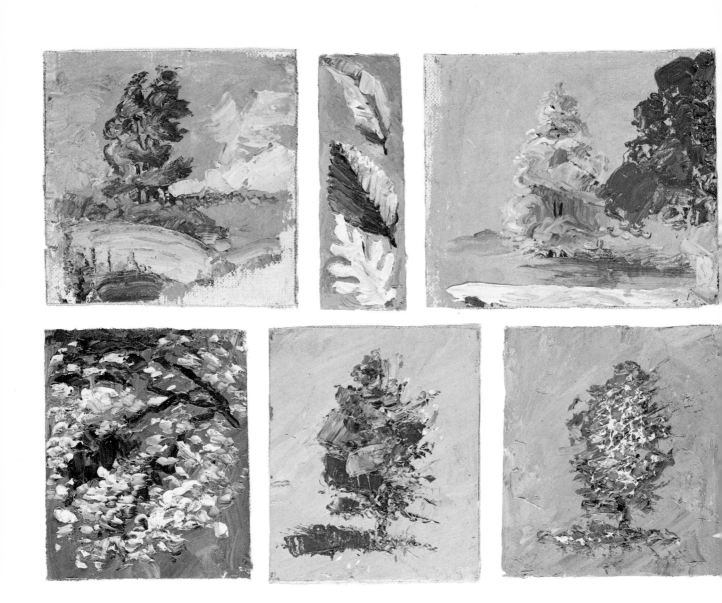

Summer Blur and Shimmers. *As in simplified Japanese painting, the power of knife painting lies in its simplicity. The knife is the natural tool for creating broad tones for use as underlays or surface areas; for piling up rich pigment texture; for making fluttering, suggestive veils of pigment; and for chiseling in one tone over another to create sharp edges. All these effects, natural to knife painting, are the ones I like best, the ones that come closest to suggesting the exhilaration of nature. In the top three sketches here, I show massed shadows, silhouettes, and cast shadows. In the bottom three, I show leaf textures close up (left), in the middle distance (center), and far off (right).*

What to Watch For Through the Year. *In winter, try to catch the blurry, hazy effect of bare trees (top left) and see how sky holes in the distant woods can be suggested by scraping the darks off, allowing lighter bits of sky to show through. Spring buds and blossoms (top right) are done with the tip of the knife, while the straight lines of twigs are done with the edge of the blade. Buds and blossoms of trees in spring (bottom left) should be suggested with a few simple strokes, as I've done in these apple blossoms; note how the opening bud suggests a fleur-de-lis. "Teenage" leaves, in transition from spring to summer (bottom right), are best expressed with flickering strokes.*

More About the Seasons. *Try an experiment in translucency (top left): look at a leaf that you hold away from the sun and then look at it again when you hold it between you and the sun—what's the difference in color? Looking into the summer light (top right) gives a soft, halo effect to tree edges against dark woods; keep in mind that you have to simplify the light and dark with broad Magic-knife strokes. Make blocks of light and dark leaves (bottom left) with bold block or rectangular strokes. When the leaves cover the ground in the fall (bottom right), look for interesting patterns on the leaf carpet; especially in woods, there will be sunlit areas making patterns leading into the woods. Cut loose with slashing strokes on trees, leaves, and fallen leaves.*

Tree Shapes. *Make yourself some silhouettes of different kinds of trees, maybe with two tones of paint and with two types of knifestrokes. Every tree has its own unique silhouette and you must never yield to the temptation—common with beginners—to paint every tree with the same mass of strokes, as if they are all alike. The elm (1) has a lot of sky holes, while the ash (2) is a much more closed up form, as I've painted it here. The spruce (3) is roughly triangular, but the branches make lively, irregular edges as they jut out from the central mass. The maple (4) and the beech (5) are both fairly dense, as I've painted them here, but I've done the maple with lots of small strokes and the beech with a few big ones. The oak (6) spreads out horizontally and I've used a lot of long, sinuous strokes to paint it.*

Aspen, Pencil Sketch. *For artists who simply* must *render the exquisite and intricate nature of the woods, I suggest that you do as much sketching as possible so that you get to know each tree intimately. The freedom of the painting on the next page would not have been possible without the kind of study you see in this pencil drawing.*

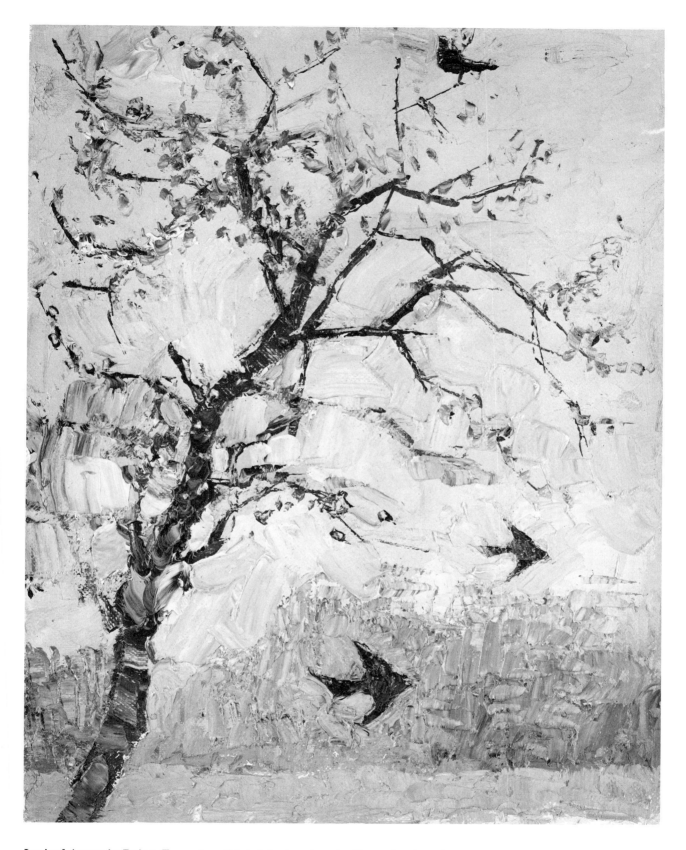

Lyrical Aspen in Paint. *To capture this intricate network of branches in paint, you first paint the dark tree lines and then cut back into them with lighter background paint. The songs of the birds and spring peepers spurred me on. I love to paint to music.*

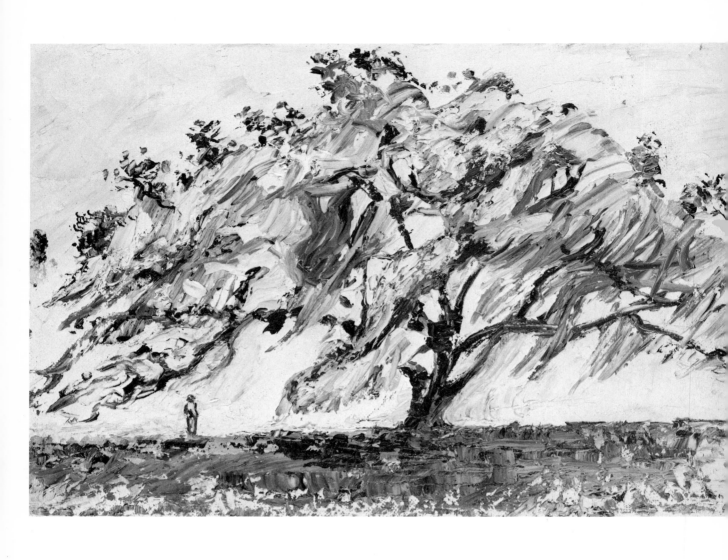

Live Oak and Spanish Moss. *Here's Odin's sketch of me standing, dreaming, under a southern tree. The dark outer leaves of the tree were tapped on with the tip of the knife and the moss is stroked over wet paint with the knife's edge and tip. The movement of the knife actually follows the long, rhythmic, wavy shapes of the moss. Contrast these rhythmic strokes with the short, staccato strokes on the ground beneath the tree.*

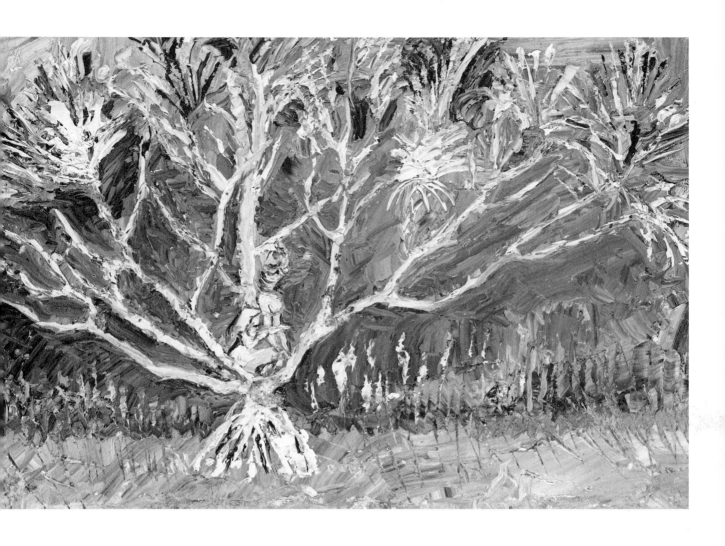

Another Southern Tree. *The painting on the preceding page was a dark shape against light; here's a light shape against a dark background. No matter how intricate a tree gets, try to hold onto the silhouette or the pattern of the branches. It's very difficult to get the narrow drawing lines of the branches the first time. Try drawing them on with the tip of the knife and then neaten them up by cutting the darker background paint along the sides of the branches.*

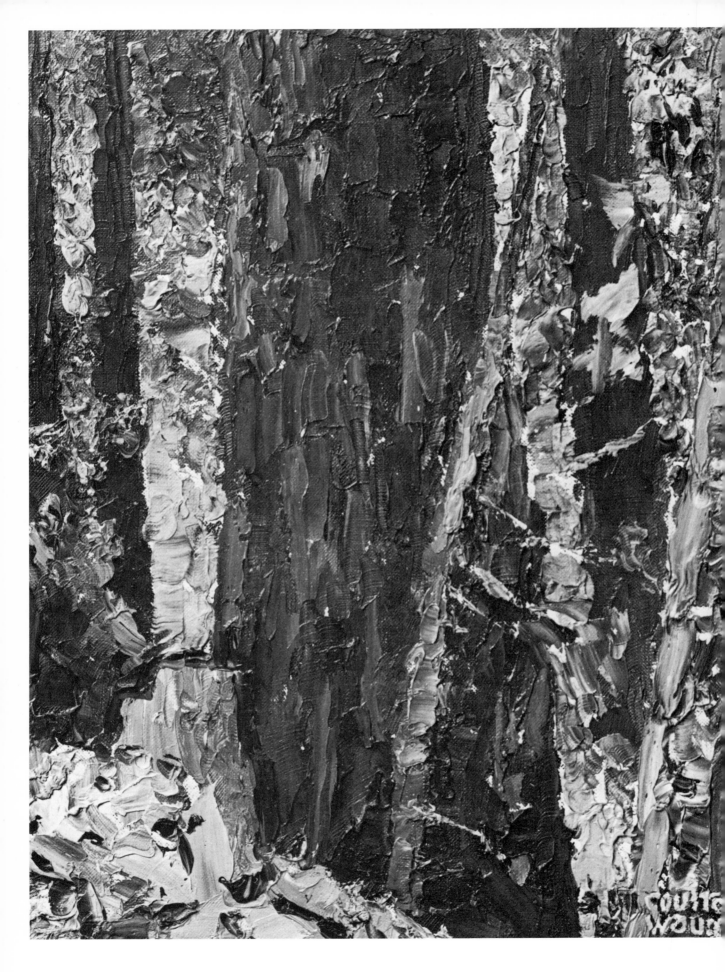

Big Trees of California, *16″ x 12″. (Left) Collection Odin Waugh. The rough knifestrokes in the upper left give a feeling of light sifting down from above through many leaves. The mysterious darkness between the trunks was painted with long, vertical strokes in fairly murky tones. I wanted the trunks to come forward out of the darkness and painted them in lighter tones and much more varied textures.*

Deer and Sycamore, *20″ x 24″. (Above) An unfinished painting is always instructive. This unfinished study shows you the square blocks of paint on the trees on the left, the simple dotting of the sycamore, and the dark, deep center. Even at this early stage, I've defined the silhouettes as clearly as possible.*

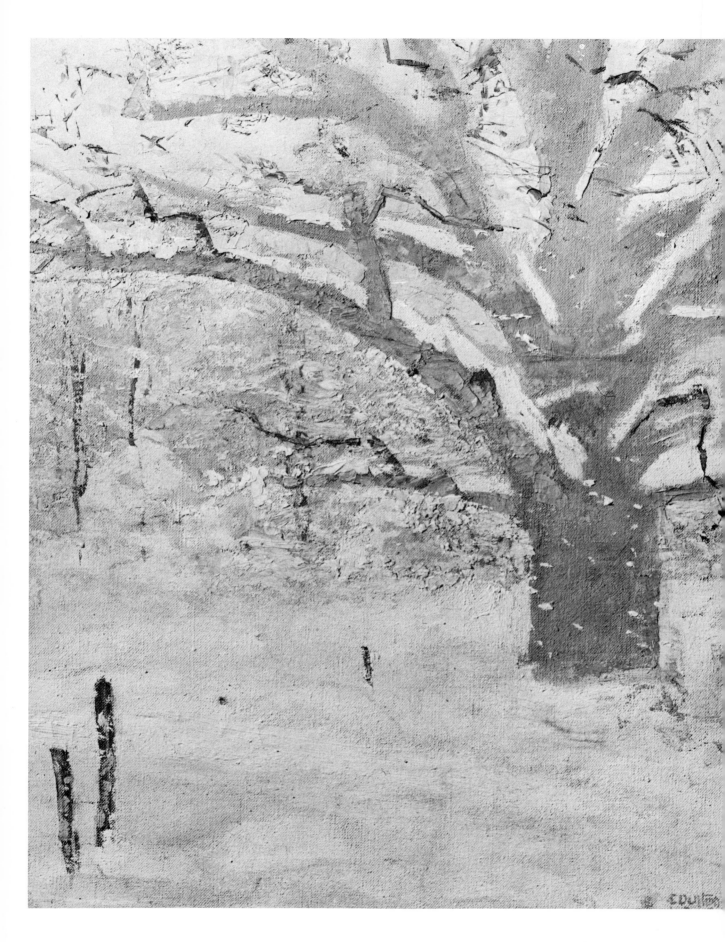

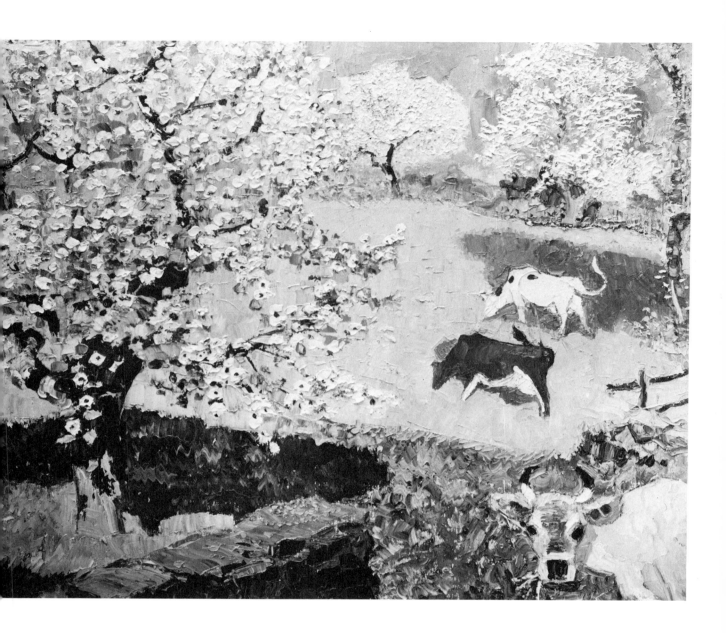

Oak Inside the Snow, *20″ x 24″. (Left) Collection Mr. and Mrs. John Coulton Waugh. If the sun is shining on your snowy landscape, look for the veil of violet in the shadows. Look for the ball of air and try to get the aerial truth of spots of color. Watch for mutations, lowered intensities, soft edges. When you paint out in the snow, be sure to dress for it: thermal boots and underwear, and a wooden palette—the wet will curl up a paper one.*

Spring Orchard, Afternoon, *20″ x 24″. (Above) Collection Odin Waugh. The close-up blossoms are done with a button-like twist of a paint dab. The distant trees have their blossoms pounced on. Note the sharp edge of the near tree shadow and the softness of the distant shadow around the white cow. Be bold, be careful, make every stroke a jewel.*

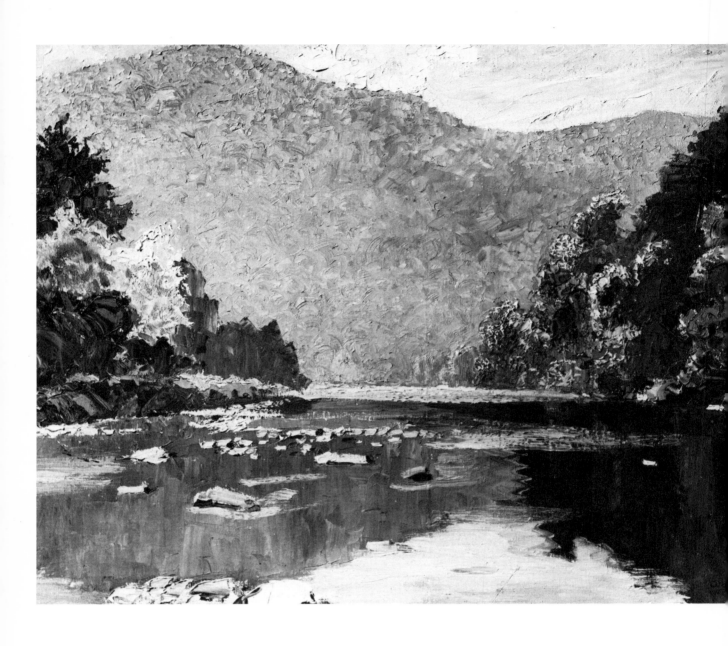

Shinhopple, New York, *24" x 30". Collection Odin Waugh. A one-store place with camp-sites along the upper Delaware, this is a spot I always wanted to paint whenever I drove by, going to Cooperstown. We finally made it. Odin and I tented by this river one glorious week. With so many trees, you have to simplify, mass, make blocks of color. Then, too, I simplified and dramatized the reflections. Notice how I got the deep shadow reflection, both by wibble-wobble edges and by vertical, lighter strokes over the darks.*

8
WATER AND SKY

The water and the sky change so rapidly that it requires a well-trained eye and a wonderfully retentive memory to paint them. A tree will stand still, more or less, though it may sway in the wind a bit. But the water is constantly moving past you and a slight change in the wind or the light will change both the texture and the color of the water. Clouds seem to move just as fast as water and change their shapes constantly.

But don't give up! A tourist once stopped a musician on the street in New York City and asked him, "How do you get to Carnegie Hall?" The musician looked him squarely in the eye and said, "Practice, man, practice!" And that's the secret of painting water and skies.

But what should you practice? Above all, you've got to practice *looking*. If you look at water day after day—in different kinds of light and weather—you'll soon discover that water isn't just the picture postcard blue or green that most beginners *think* they see. Water can reflect the color of the sky, which is sometimes blue, sometimes gray, and sometimes lots of other colors like red and violet. Water also picks up the colors of its surroundings—trees and grass and rocks, among other things—and can even turn out to be the color of the sand beneath the water or the silt that's running through the water, which means that you might find yourself painting water yellow or brown. So you can't just decide that there's something called "water color." You've got to look as closely as you can.

In the same way, you've got to look at clouds not as shapeless blurs, but as *things*, each with its own unique shape, color, and texture. In addition to the usual puffy clouds that everyone sees, or *thinks* he sees, there are flat clouds, streaky clouds, wispy clouds, clouds piled in layers one on top of the other like a seven-layer cake, and clouds that are like the scales on a fish (you've probably heard the phrase, "mackerel sky"). And don't forget that clouds cast shadows on land and water. Cloud shadows are very momentary, but beautiful; watch for shadows and the colors of shadows to add interest to your composition.

I see skies, clouds, rocks, cows, trees as things, yes; as textures, yes, but above all, I see them as *colors*. This is my own painting creed. The knife gives me such colors, such textures, but it also gives me a new slant on the things themselves. They come out perky, jaunty, new, a bit surprising, a bit exotic, and tremendous fun to do.

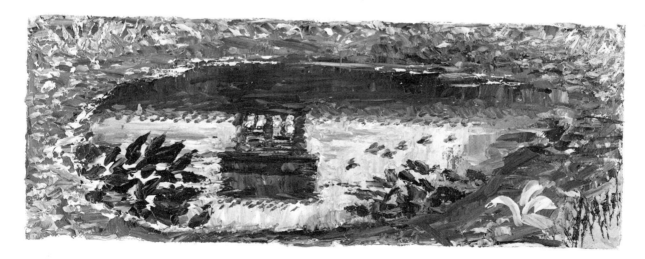

Puddle Patterns. *I started with charcoal outlines (top left) for the size and shape of the puddle. Starting to paint, I tried to see the whole picture in three tones. A boy came by to see what I was doing, so I quickly caught his reflection (top right). To keep a puddle from looking like a pond (middle left) is partly a matter of scale: one thing that helps is the size of the leaves floating in the puddle. The gate makes an interesting reflection (middle right) which comes out gray against the lighter water. Look for plenty of contrast (bottom) and glitters of light.*

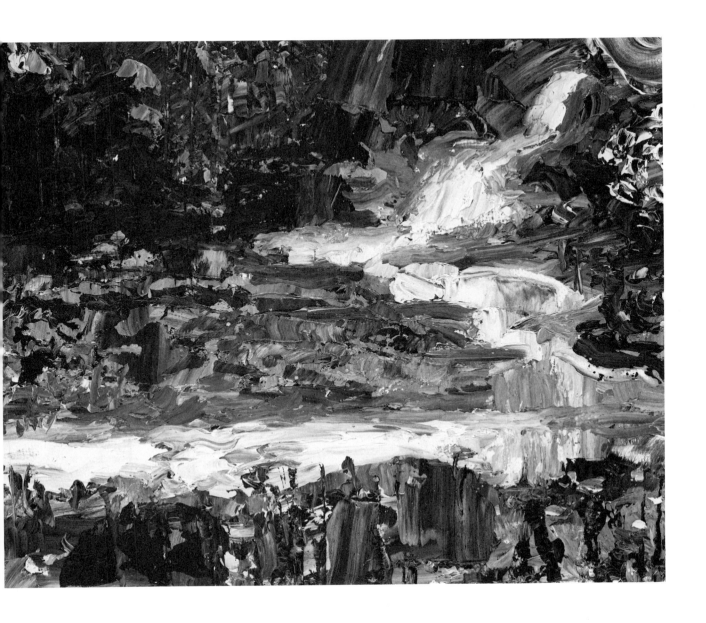

Waterfall. *All that moving water looks bewildering at first glance, but the secret is to watch for the silhouette. Here, the waterfall has a distinct shape, like a stairway, and then winds around into a stream that runs to your right and then straight across the foreground. It's a continuous, ribbon-like, pale shape against a dark background. To make the soft edges, mix a medium tone halfway between the dark rock and the white water, rather than just smearing the light over the dark.*

Pond. *In this drawing of the pond between Quissett and Sippewissett on Cape Cod, I carefully studied the shape of the dark reflection and noted the dark lines in the water.*

Golden Gate Bridge. *I drew the bridge from the yacht harbor and noted how the water broke the reflection of the lighthouse and created wiggly reflections of the masts.*

light
green

dark
green

light
green

Pond or Puddle? *To get the difference between ponds and puddles, the main thing is to make the puddle look shallow. This one is a puddle and I played down the contrasts of light and shadow.*

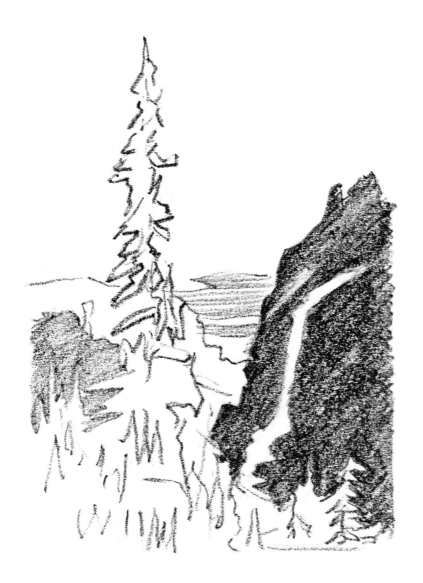

Western Waterfall. *In this first pencil sketch, I couldn't possibly have recorded all the little ripples and veils of foam anyhow. What was more important was to record the precise shape of the waterfall, which formed a white strip against the darkness of the cliff. If you get the shape right, you'll have a convincing waterfall and then you can add all the necessary detail afterwards.*

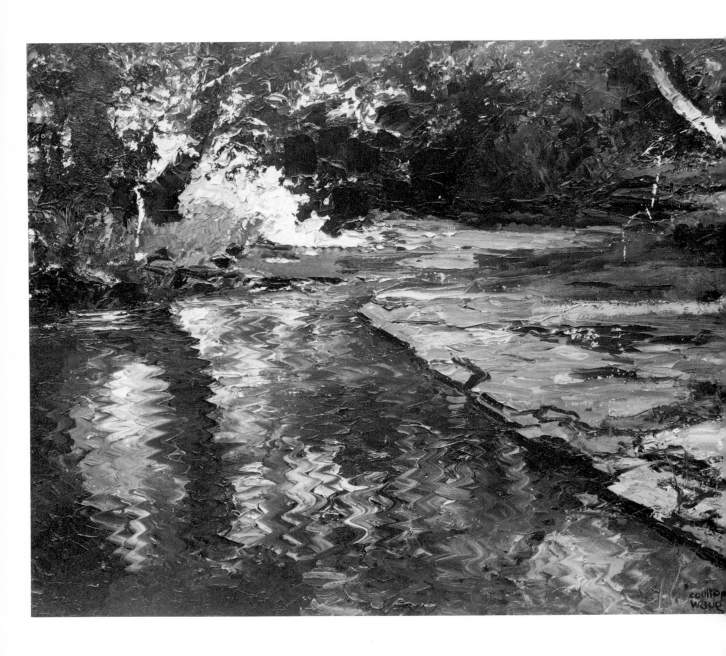

Brook Patterns, *25″ x 30″. (Above) It's important to see that one side of the brook dominates, making the master path. Then the tree and its reflection form a center of interest. The mystery is in the water (bottom left) and in the darkness along the top.*

Debussy Brook, *30″ x 25″. (Right) Collection Odin Waugh. When I got to the brook, I was afraid I was too late for the evening show. Suddenly, I looked and saw that this last light effect was more beautiful than the earlier one I had seen the day before. Fast and furiously, I wibbled in the wobbles and slapped the paint on almost everywhere at once. The picture got me my first show at the Grand Central Art Galleries.*

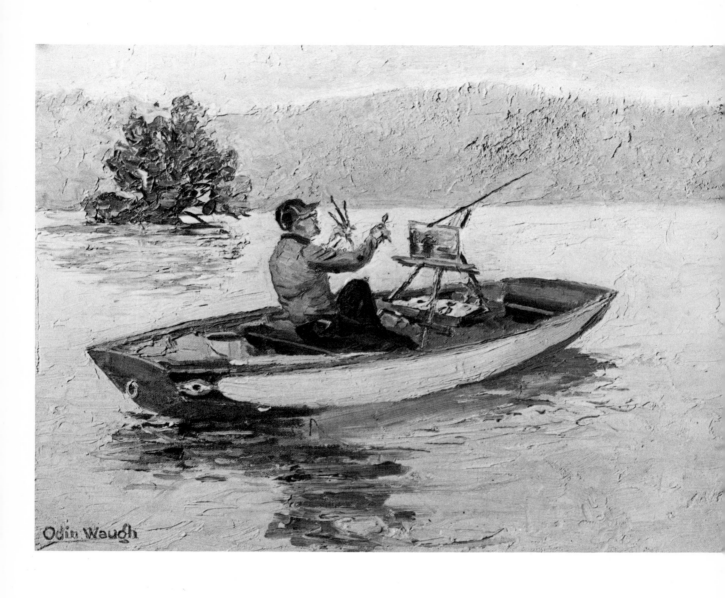

Coulton Discovering the Magic Color, *12" x 16". Collection Odin Waugh. Odin painted Coulton painting Otsego Lake from his boat, "Claude Monet," which was built from a kit. The picture is a subtle combination of brushstrokes and knifestrokes. The brushstrokes are in subtle places like the water in the immediate foreground and Odin switched to a knife for the more distant water and dramatic textures like the tree in the upper left.*

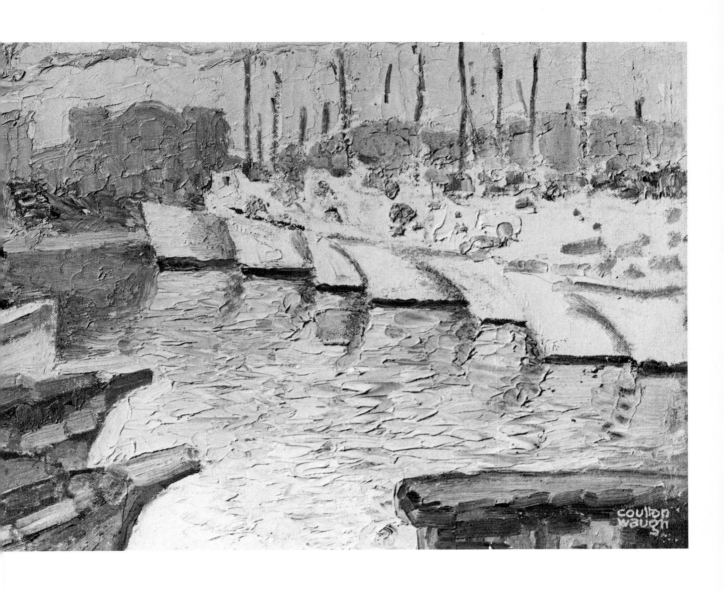

Yacht Harbor, San Francisco, *12" x 16". Collection Odin Waugh. Here the feeling of boats and their confusing detail are loosely suggested by dots, daubs, and lines. The actual texture of the paint catches the flicker of the water. There are vertical strokes on the buildings and horizontal strokes on the clouds to add to the natural feeling of their structure. The water ripples were painted with the tip of the knife, pulled sideways.*

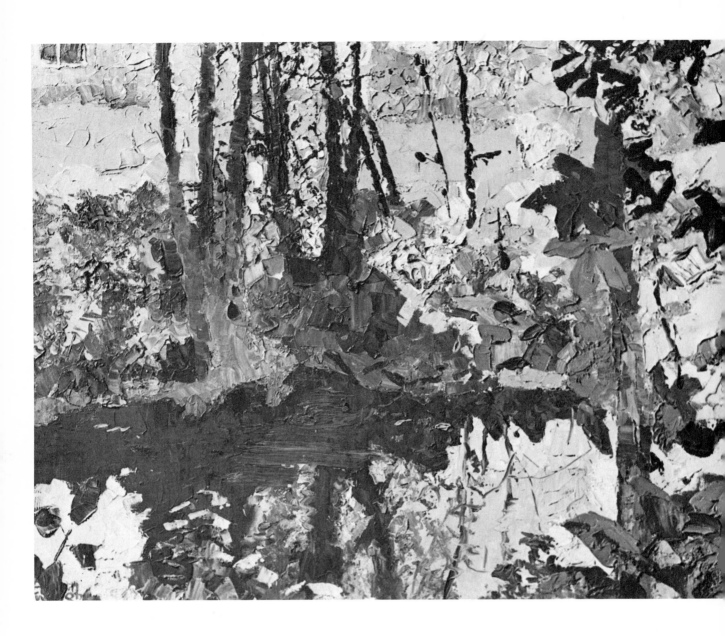

Pond in the Woods, *22″ x 28″. On a sunny day, there are terrific contrasts of light and shadow when the sun breaks through the woods, making jagged holes of light between the dark shapes of the trees and spotlighting bright patches of water. All these contrasts can be chaotic and confusing unless you watch for the simple shapes. Look carefully and you'll see that there are clearly defined patches of light in between the trees, neatly defined dark silhouettes of the trees themselves, and just as clearcut shapes for the lights and darks in the water. There's lots of detail, but don't paint it all; just seize on a few details like the leaves in the right foreground and the viewer will imagine that all the other details are really there.*

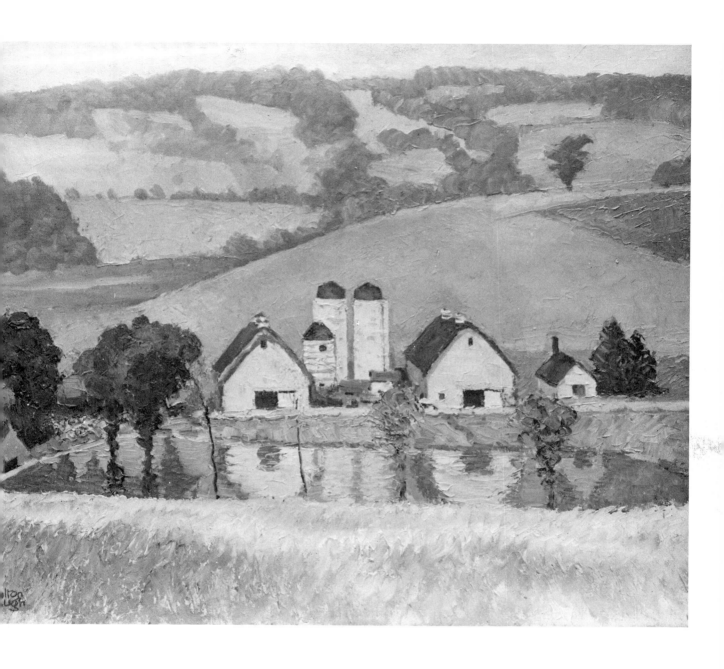

Meridale Farm, Near Cooperstown, New York, *24" x 30". Collection Odin Waugh. The same wibble-wobble stroke that turns paint to water will turn other paint to grass when you blur the stroke more. Compare the grass in the foreground with the pond just beyond it and you'll see what I mean. I've kept all my really strong textures and obvious strokes in the foreground and middle distance, painting the distant hills much more flatly, so they won't jump out.*

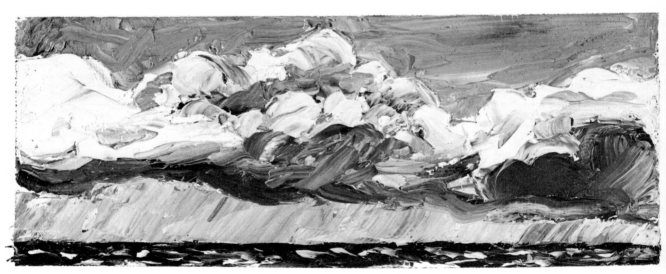

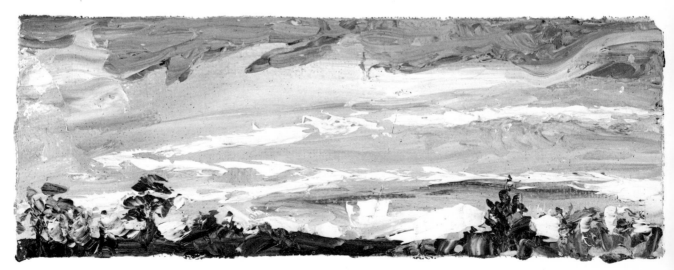

Kinds of Clouds. *Clouds are not all puffs of cotton. There are distinct kinds, with their own characteristic shapes. Three typical cloud forms are nimbus or storm clouds (top), cumulus (middle), and stratus, which you often see in a sunset (bottom).*

Cloud Closeup. *Just a few twists of the wrist and you have a delicate puff of cloud, making so much out of so little. Wet paint over wet helps with the vapory feeling of the cloud.*

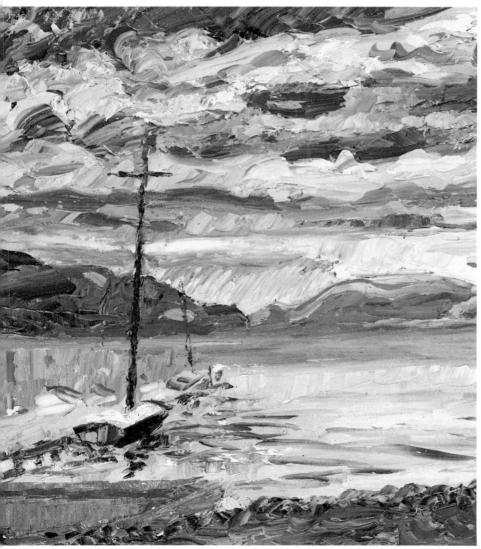

Storm Clouds. *Storm clouds move even faster than other clouds, so I set up my easel quickly and worked at white speed to make this oil sketch. These clouds were made with two kinds of strokes: broad, side-sweeping strokes of the whole knife blade; and narrow, drawing strokes, made just with the knife tip.*

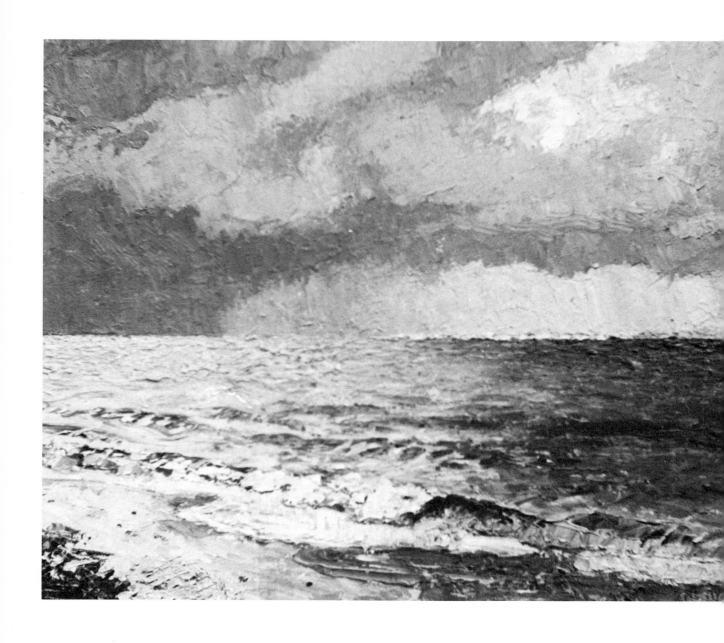

Approaching Storm, Florida East Coast, 20" x 24". Collection Edwin A. Ulrich. A most dramatic, fleeting moment. Actually, the effect lasted only five minutes, but I had my easel set up on the beach and I put down the area of greatest contrast first—the glittering horizon and the dark water—finishing the picture from memory. Most of the strokes are Magic-knife verticals, but the right horizon and the light water to the left were done with horizontal strokes. What fascinated Odin and me was the change from dark to light in the sky and in the water, always a help in making a beautiful design.

Evening Over Green Pastures, *20″ x 24″. Collection Odin Waugh. It's important to decide when to apply paint smoothly and when to really pile it on in big, rough strokes. Here, the paint is applied quite smoothly over almost the entire picture, except for the sun, clouds, and trees. The thickest strokes are where the bright sun and dark cloud meet—the area of greatest contrast, which I really wanted to play up. The secret of painting a good sunset is to play down most of the picture and save your drama for the center of interest.*

Summer Evening, *9″ x 12″. You'll notice that I used a brush on the house and trees. In fact, you'll see brushstrokes in much of the sky as well. Knifestrokes were saved for certain decisive spots where I wanted exceptional brightness, like the burst of cloud just above the little house and just above the dark tree in the lower right. All the lighter spots in the clouds were painted with a knife, which makes brighter color because the paint is smoother.*

Calm Sky and Stratus Clouds, *9″ x 12″. Collection Odin Waugh. This picture was painted on a small scale because I didn't have much painting time. Although I used a square, ½″ brush on much of the picture, I applied the thick, undiluted paint in the same way as I would normally have used a knife. As in the picture on the preceding page, I saved the knife for the smoothest, brightest spots in the sky. The contrast between the smooth, bright sky and the rougher, dark trees is the essence of the picture. The dark tree mass at your left is a combination of knifestrokes and brushstrokes: the brushstrokes tend to melt and the knifestrokes tend to stand out.*

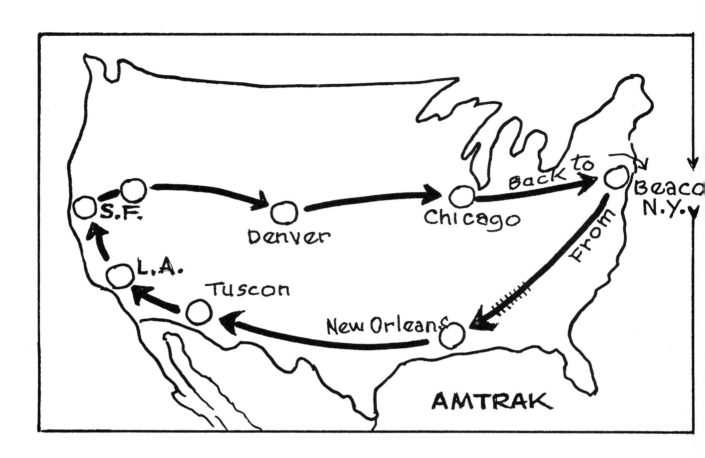

(Above) here's the route we'll take on our painting trip via Amtrak.

(Left) Two oil-sketch boxes, 20 small panels, and a stack of sketchbooks; this is our painting gear, all neatly fastened together for easy carrying.

9

A PAINTING TRIP
WITH COULTON

Early in 1972 my wife Odin and I took to Amtrak to test knife painting out on the great open spaces. Would the knife express the enormity of the West, the feeling I had experienced on a previous visit 25 years before? Would its crackle texture turn into the crackle of cactus spines? Could I sweep the desert tones into one, yet successfully suggest millions of grains of sand, as I had suggested millions of leaves while working in the Eastern forests? Would the giant redwoods be too big for the little painting knife blade to digest? It wasn't only one special effect I wanted to check up on. Not just the West, or the Soutwest, but all the other fascinating, characterful landscapes, too. And in addition to these individual landscapes, I wanted to see *landscape*: the thing back of everything, the thing the individual landscapes have in common. To do this required trip planning of an unusual nature.

In a way, I wanted to fly over the whole country, to absorb the different kinds of terrain, to analyze, to compare. But the point of view from a plane is not one you can paint from. I had to skim along the surface. Busses? One could do it that way—but it's a jolting way to pack in knowledge; and a bus is too difficult to paint from, too confined.

The solution was Amtrak. I found I could buy a ticket for Odin and myself from Beacon, New York, to New Orleans, Houston, the Southwest, Los Angeles, then north to San Francisco, Reno, through Utah and Wyoming and the great plains to Chicago, on to Ohio, Pennsylvania, New York City, and finally back to Beacon again (see the map at left).

So we packed two oil-sketch boxes with some 20 small panels and a stack of sketchbooks (shown at left) and we were off!

What fun! Tremendous! A trip like that for the purpose of collecting landscapes—what an argument in favor of the painter's life!

As soon as we glided out of Penn Station (and busses don't glide!) I realized we had chosen the right mode of transporation. We each had a "roomette," like a minuscule ship's cabin, with folding bed, toilet and wash basin, a fine seat, and a huge window that offered a view of America unrolling before our eyes. We could set up our small paintboxes and actually go to work.

*　　　*　　　*

Necessarily, on a long trip, the format of the sketch panels must be small. My father, Frederick Waugh, used tiny 6″ x 8″ panels, carried in minute paintboxes that he made himself. Later, he settled on sizes around 12″ x 16″, which allowed him to make many beautiful little pictures, some highly finished; too finished, in fact, for he often neglected the sketches afterward—he had said all he wanted to say in the sketch and didn't feel the need to make a full painting from it.

Odin and I took two sizes of panels along on our trip: 9″ x 12″ and 12″ x 16″. I found the smaller size to be the most satisfactory; you just can't get too far with detail work, especially when painting with blunt palette knives. This keeps the sketches as sketches and makes it imperative that you enlarge them later to a more powerful size. The larger size tempts you to make cute little paintings rather than sketches; it also may throw off your sense of scale, which I'll discuss later on.

*　　　*　　　*

Almost at once after leaving Penn Station we were in a picture situation. It was a jolly winter day at 4 p.m., with those rich winter-afternoon colors: pinks and oranges, light green-blues and deep cobalt blues, and shadows intensified to colors. Moving through the giant industrial area of outer New York and New Jersey, I found rich, abstract chords of color and design everywhere. Huge high-rise apartment buildings thrust up eagerly and sharply against the warm blue sky, softened by violet (here, at least, pollution gives us something to enjoy). And while close up I am repelled by the hard, even brick colors of these apartment buildings, from a distance wonderful things happen in the mellow afternoon light: they rear up in

pattern of
purple black

Cubistic
design of
small houses
with shadows

very rich blue

Newark Industrial Area Shorthand. *This pencil sketch is done at around 4 p.m., after having pulled out of Penn Station. The colors are noted, as well as striking pattern effects, for a later painting (right).*

Shorthand in Paint. *Here's the sketch turned into a painting. The transformation is accomplished in our studio on wheels; it's painted on a 9″ x 12″ canvas board.*

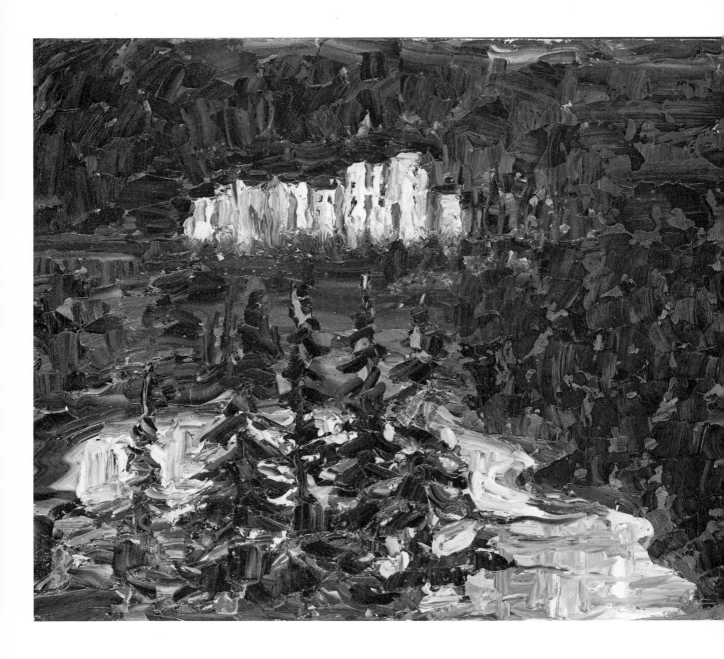

An American City (Houston) at night

Out of the Night. (Above) Quite an example of night short-hand in paint. This ghostly castle of a city is done on a wet, dark canvas prepared beforehand so that the application of a few whites and grays will pull the vague forms out of the dark background.

Night City Near Water. (Left) This little sketch captures a perfect subject for the knife blocks and wibble wobbles of a painting knife landscape.

glittery gold and pink, cut by striking cobalt shadows; and in the foreground, power-line wires make fantastic dark weavings. Perhaps, in a day or so, the dark weavings may be the eerie plant growths of the Southwest and the high-rise masses may turn into rock mesas touched by golden sun. But cityscape or desert scene, they are both *landscape*.

* * *

It's the first evening on the train going west. We discover the delight of turning out the roomette lights and sitting quietly in the dark as the train rolls smoothly on. We watch the widening Virginia night landscape, so big and mysterious. Trees in the night are blurs, yet they have shape and meaning. We roll past houses lost in the dark except for their low, orange windows. Little towns, little cities, loom and disappear as collections of red-blue-white-orange electric dots. Because you can't see the buildings, the little towns look like arbitrary arrangements, sometimes sparkling and beautiful, sometimes too brutal for the soft and lovely dark. Are these light spottings landscape? If they are beautiful, then I say Yes. They are just right for painting with dots and dabs of color, wet-on-wet. Their reflections are dark and brilliant wibble-wobbles on the surface of vague night streams and ponds. Yes, they are certainly landscape—and more specifically, they are painting knife landscape of the most exciting kind.

* * *

How can you paint from a moving train, you may well ask. You get hooked on some shape or effect and the next moment it's five miles behind! For those of you who would like to try this kind of painting trip one day, here's the method that Odin and I used for sketching on the run. All landscapes have one broad, underlying component that can be grasped very fast. This is its "color chord." The color chord is the group of main colors, seen in terms of broad, simple poster-like colors that make up the large patterns of any scene you may be looking at. Squint your eyes to reduce detail; look for four or five large patches of color, forgetting everything else. With a little practice, you will be able to make quick color-chord notations for later use: to study, to review, and to paint from.

Color-chord notations are simply written notes jotted on a black and white sketch that will remind you of the major color areas later on when you transfer your sketch idea to a full-size painting. Or you can actually do your sketch in color, using any medium—oils, watercolors, pastels, etc.—and matching the colors of nature. My three-step color-matching method has served me well over the years; perhaps you'll find it useful too. First, you'll need a color wheel like the one illustrated in the color plate on page 65. This color

The "X." Odin is intrigued by the interesting shadow patterns in these sketches of the Sierra Blanca mountains in Texas. In the picture at the top, the X-shape is too accentuated; it stops the eye from roaming over the whole picture area. In the bottom picture, the cross-lines of the X have been broken up so the eye doesn't read the shape of an X, but freely takes in the lights and shadows of the mountain range.

West Block Glyphs and Mountains. In studying and painting mountains, remember this: mountains are sculptured land. The have simple, positive, three-dimensional block shapes, and the use of the right block shape will give you the feeling of the particular mountain you're looking at. Block-forms and light and shade can give the character of many different shapes, simply. Note that desert mountains can rise from the desert without foothills.

Color Chord Key to Los Angeles Palms. *(See the color plate on page 68.) The circled numbers indicate the color chord colors: (1)* brown *the color of the reverse side of the canvas, for the shadow side of the building; (2)* violet *mountain and ground; (3)* smokey yellow *sky; (4)* pink and white *building; (5)* terra cotta pink *wall in sunlight. The circled C's indicate complementaries: warm green sun on palms and terra cotta pink on building; violet mountains and smokey yellow sky; distant pink building and blue-green trees.*

to get shadow in Western pics

Sketch combines
1. composition, and
2. tone patterns.

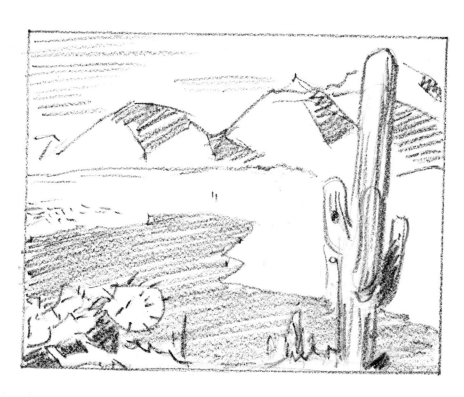

The Big
Saguero

use as tone
sketch or
do similar
pencil
one—

Cast Shadows. *(Above) Watch for cast shadows from rocks or other objects in the foreground or outside the picture format to help dramatize the center of interest.*

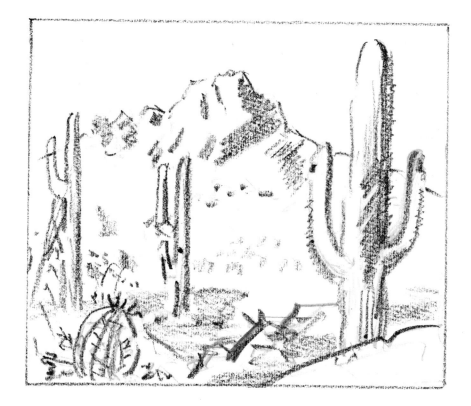

Time of Day. *(Right) Consider the time of day. Usually noon is the least interesting. Early morning or late afternoon gives longer shadows. I find just before sunset the most poetic time and best for color as well as shadow.*

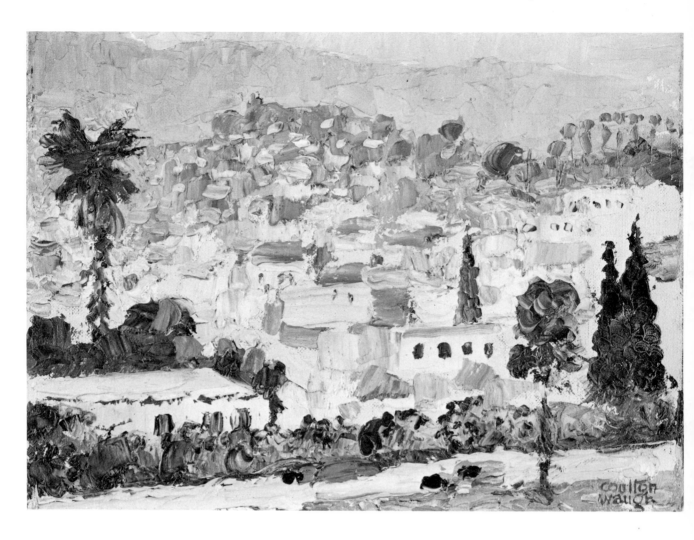

Bldg pink, orange light blue green — roofs, some red, some green. Cars white red, blue— Sky smog blue, smog violet.

Down Wilshire Boulevard. *(Above) This painting was done from the sketch below on 9" x 12" canvas board. Unfortunately, in this reproduction you can't see the colors: the lovely shell-like tints of the buildings and the overall violet color of the smog.*

Sketch for Down Wilshire Boulevard. *(Left) Here you see the color notations I made so that I'd remember the colors when I painted from this sketch later on.*

West and Far West. Here's the sketch I used for the painting Los Angeles Palms *shown in the color plate on page 68. In this sketch, the color notations are penciled in.*

Odin at Venice. *In sunny California we can work without gloves in January—but that's all we can be without!*

Coulton Looks at the Skies. *And out toward the Pacific, in this sketch by Odin, done on our trip to Venice.*

Our Stuff at L.A. Station. *Here, we gratefully make use of the supermarket-type carriages available to the traveler for hauling luggage.*

wheel should be right in front of you—I fasten mine to the inside of my paintbox lid. Now, as you look at each broad color area of the scene you're sketching, ask yourself the following questions: (1) What color is it, based on the colors in my color wheel? (2) What value is the color, light or dark? (3) What chroma, or intensity, is the color? In addition to the color wheel, it's a good idea to jot down these three steps on the inside of your paintbox lid so you'll remember them. By mixing your colors based on these three questions, your color sketch will be true to nature and serve as an accurate guide for doing a larger painting back in the studio. (A more detailed description of my three-step color matching method can be found in Chapter 4, *Color*.)

*　　　*　　　*

When first seen, the desert is a revelation to the Eastern eye—almost as strange as the landscape of the moon. Mountains seem to float on the flat desert eye-level as if they had suddenly popped up from below—which is probably just how they got there. The enormous distance from which they can be seen in the dry desert air turns the bare reddish rock to pink or violet: pink-violet in the lighter part, blue-violet in the shadow. The plants don't have green leaves, they have green stems. I know my picture *Desert Fascination* (see the color plate on page 66) is not a photographic likeness, but I wouldn't want it to be. The picture is true to my feeling about the desert.

In approaching the desert as a landscape subject, I was a bit afraid of the great empty sky; but then I thought, if God could do it, why couldn't I? No other landscape looks like the desert, with its clear, bright color and strange plant and rock shapes.

*　　　*　　　*

Meeting the California color chord for the first time, I find it soft, gentle, gray. The sky is overcast this morning, about 9 a.m. The surrounding mountain ranges show distant muted purple-blue. The vegetation seems a drab and generally uninteresting green. Soft sand colors are everywhere, accentuated by the color of the groves of small fruit trees. Human beings have certainly taken over the landscape hereabouts: the hillsides are pockmarked by dots of neat white houses.

As an Easterner, I was a bit disrespectful of the glories of the West, especially of the city of Los Angeles. But to my surprise and delight, I found that L.A., like Rome, is built on a series of hills, and that these hills are covered with buildings and Italian-type trees that melt with extreme beauty into the smokey air. The scene reminded me of Cézanne's charming views of Gardenne, where block houses pile up one behind the other. I saw at once that the painting knife would be perfect for rendering the simple, blocklike masses.

Drawing in Paint. *A good way to get a definite drawing quality with your paint is to cover the surface with an overall thick paint tone (or, as in this case, with two tones, one dark—the mountains—and one light—the sky and desert) then with the tip of your knife scrape out lighter drawing lines in the dark parts and paint in dark drawing lines in the light parts.*

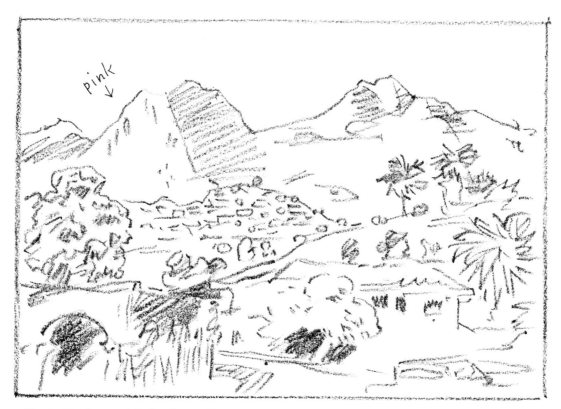

pink
↓

Santa Barbara with the Santa Ynez Mountains in the Background. *This mountain range was the color of orange sherbet mixed with strawberry ice cream—lovely.*

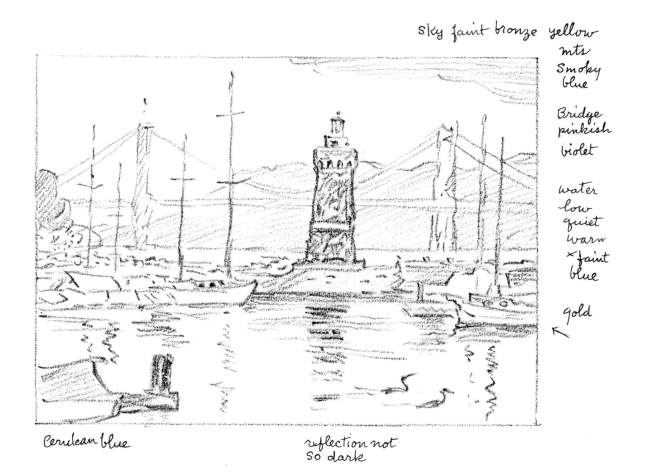

sky faint bronze yellow

mts
Smoky
blue

Bridge
pinkish
violet

water
low
quiet
warm
× faint
blue

gold

Cerulean blue

reflection not
so dark

Golden Gate Bridge.
(Above) The color notations
on this sketch reflect a late af-
ternoon light.

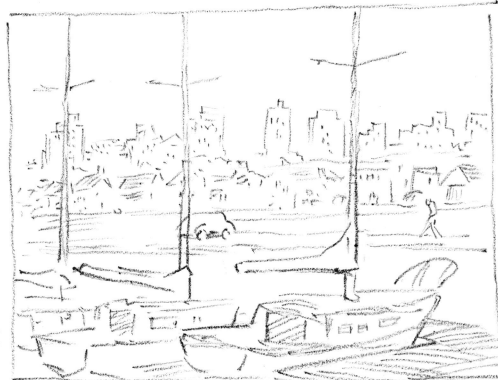

**Golden Gate Bridge Yacht
Harbor Looking Toward
San Francisco.** (Right) I
sketched this scene because I
love boats—and I fell in love
with the city that boats built.

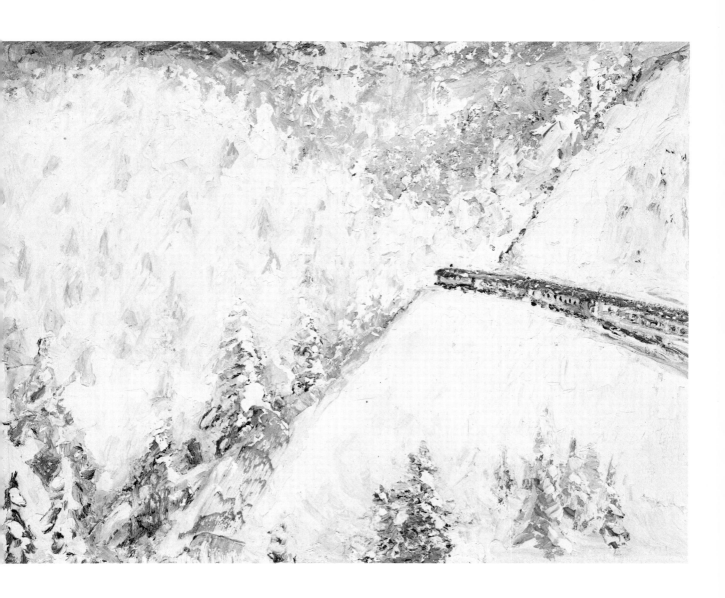

Donner Pass in Winter. *As our trains plows through this snowstorm in the Donner Pass, I see landscape such as I've never before seen. The nearest thing is in the prints of the great Japanese artist Hiroshige. Our observation car has a clear dome so that we literally feel we're inside the snow. To get the snow effect in this painting, done on 12″ x 16″ canvas board, I scrape with the tip of the knife and blur the paint with both knife and finger.*

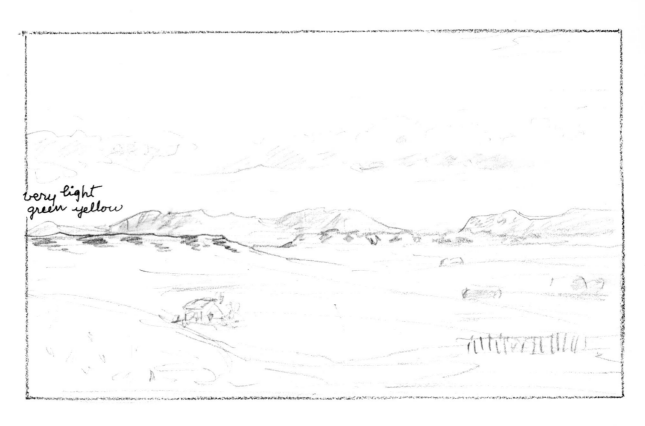

very light
green yellow

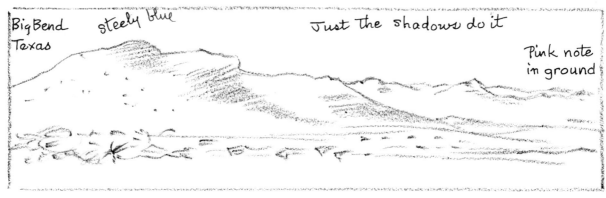

Big Bend
Texas

steely blue

Just the shadows do it

Pink note
in ground

The dancing hills of Reno

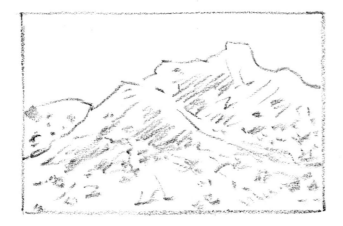

East of Reno Hills with light
Snow spoted with weeds

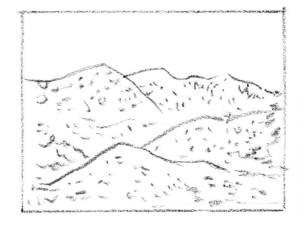

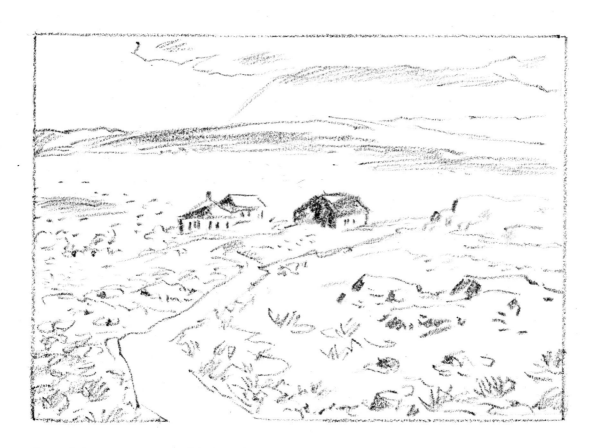

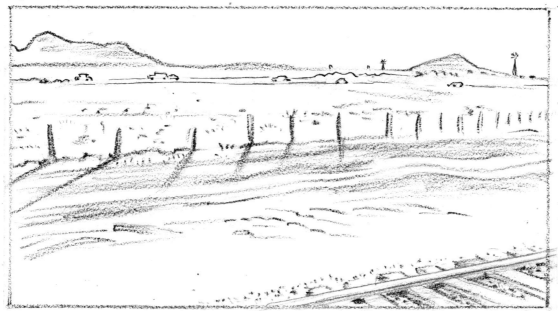

Three Tracks West— Auto, dirt road and Amtrak

Western Lanscapes. *These sketches are done from the train as we roll through Nevada and Wyoming.*

We stayed in Los Angeles for a while, and before leaving, we went to Venice, where we enjoyed painting the Pacific. We also took trips into the countryside around L.A., discovering a great variety of different kinds of landscape: desert, mountain, farmland.

* * *

There is certainly such a thing as falling in love at first sight. At first sight I fell in love with the California redwoods; and at first sight I fall in love with San Francisco. Its sweetly lyrical hills, grouped around the enormous serene bay, are a delight to the landscape painter's eye. The houses, built after the earthquake and fire of 1906, are unified in a color scheme of light, sandy off-whites—the color of seashells bleached by the sun. Which suggests San Francisco's link with the sea. If the history of Los Angeles brings to mind pioneers trekking across the desert, that of San Francisco is linked to the great sailing ships that crossed the sea and rounded Cape Horn to enter its hospitable port. Even now, when the great age of the sailing ships is long past, the city offers all kinds of sights to gladden the eye of a sea-loving artist. For the landscape artist with a touch of salt in his spine, therefore, I highly recommend San Francisco as a theme for a painting holiday. Also, I think you'll find this city less formidable than others.

* * *

After leaving California, on the way back East, we rolled by the Rockies—an inspiring sight, but one that gave me quite a lot of trouble when I tried to paint them back in my Newburgh studio. Those mountains had me down. I remembered them well: the high, very distant peaks glittering with snow; blue shadows, obscure foothills, and enormous mountain-colored clouds forming a pattern of rich contrasts on a grand scale. Below, the broad Colorado plain, rolling flat, impressive, and somber, a rich carpet on which the awesome crest of the continent was displayed. Throughout the trip I had had a lot of fun painting Western rock formations on my 12″ x 16″ panels. I had worked in my block method, taking the rocks one block at a time. The Magic knife had been just fine for this: a square block of the main local color; another, lighter, on the top; another, darker, nicked sharply in for the shadow.

When the trip was over and I started to turn my sketches and notes into larger paintings, I remembered this successful block-and-nick method for dealing with rock forms and applied it to painting the Rockies. I used the same little Magic knife, but I worked on a much larger surface, 24″ x 30″. Backing away from my picture at the end of the day, I saw immediately that I hadn't built the Rockies after all. The paint was just standing there. I was confused. Maybe my trip concept had been wrong. Maybe you have to get out and paint from nature. I decided to get a good night's sleep and look at what I'd done in the morning.

The following morning, after a large breakfast—and two and a half cups of coffee—I again faced my version of the Rockies. They still didn't look good. They looked exactly as they had the night before.

Was I discouraged? NO! In the clear light of day, I saw the reason for the failure. It was a mistake that was as big as the Rockies themselves. It was the mistake of scale. The beautiful little light and shadow nicks and blocks, so perfect on a small 12″ x 16″ panel, just didn't carry the same message, the same feeling of mass, on the larger 24″ x 30″. They were just piled-up itty-bitties. The good breakfast *was* working!

The answer was to work on the large-size panel with a larger knife. The Long John was perfect for the larger scale I wanted. It enlarged my stroke to four times its previous size; now I was painting with my whole arm, not just with my fingers. That, too, produced much better results—you can't tickle the Rockies to life with finger-painting!

Please remember this little story of my tussle with the Rockies; when you change sizes, shift into another gear of painting strokes.

* * *

Back home again, I asked myself, what have I accomplished on this trip? What am I doing as I paint the myriad landscapes that pass by my window? I am celebrating the earth. I am celebrating nature. I am doing something else, too, something that is more than a celebration of beauty. I am creating something entirely new—something that nature cannot create, but which we, God's children, can. I speak of course of art, that wonderful device by which we can return in some measure the richness that Mother Nature gives her children.

My pictures are gratitude.
They give back,
They sing,
They render again.
They are musical, they are of and
* compounded of music.*
They are hymns, chants.
Above all,
Yes, above all,
Closest to them, the best definition of
* them,*
They are psalms
For all the breadth and fire of my life,
For color, for light,
For my life richer or poorer,
For the sea,
For the old dark heave,
For the light spray (as she dips her
* nose under, dusting the helmsman*
* with a fresh and delicious sting),*
For the gurgle under the boat's nose,
And around the dark stones of
* my brook.*

Coulton and Odin, *1973. And "Arturito," A Spanish-speaking parrot brought back by son John and his wife Susan from a recent trip to Mexico. Photo by John Waugh.*

EPILOGUE: COULTON REMEMBERED

Coulton Waugh's art was both a product of and a vehicle for his profound love of life. The following are but a few of the comments made about his work by those who knew him, worked with him, and saw him develop over the years:

Color, strong palette knife strokes of it; warm, vibrating tones of it; deep shadows against brilliantly colored sunlight! This is the technique of Coulton Waugh's paintings, and a masterful technique it is. An inadequate description of his splashy paintings could be: rhythmic play of color, form, light and shade. He knew what he was going to paint and how to paint it. Then he went to work with his precise palette knife strokes of color and texture. He called it "painting with a knife," and he did it masterfully.

His subjects were mostly studies of the rural surroundings where he lived in Orange County, New York. They were scenes of fields, woods, brooks, stone walls, and of his own house in the changing colors and light of the four seasons.

I think of Coulton's work as being among the best of our time.

Gordon S. Marvel, A.I.A.

Coulton Waugh's charming, dynamic, wholesome, warm, outgoing personality was reflected in all his paintings. His unique insight was equalled only by his rare skill in interpreting the beauty that surrounded him for everybody to enjoy. Never has the world needed the uplifting character of his work as it does today.

Sister Mary Eusebio Guala O.P.
Art Instructor
Mt. St. Mary Academy
Newburgh, New York

I have known Coulton Waugh for at least fifty years, beginning at the time I visited his father, the famous marine painter, Frederick J. Waugh, at his various

locations, especially during his later years at Provincetown on the Cape.

Coulton was a husky boy, a very able sailor . . . but what I liked most about him was his refusal to do the same type of painting over and over again simply because it was salable. He was always an experimenter, and he put his full enthusiasm for art and life into each new painting. I believe his recent works done with a knife instead of a brush are the most interesting. They have that freshness and clarity so essential to his expressionistic technique.

His recent passing is a loss not only to our galleries but to contemporary art.

Erwin S. Barrie
Director and Manager
Grand Central Art Galleries, New York

Years ago I roamed the woods with another boy, Coulton Waugh. We both had a passion for nature, but Coulton was dissatisfied; he wanted to express his feelings but didn't know how. Many years later, I stepped inside his farm studio near Newburgh, New York. The walls were crowded with paintings; I saw at once that he had found out how to express what had moved him as a boy. This book is a thorough and painstaking explanation of his painting system. Those artists who love color, air, light, nature, will want to profit by it.

If life is a matter of sharpening one's soul on the grindstone of reality and developing one's talent to the greatest possible degree, Coulton surely rates high on the scale. I do believe that he was one of the outstanding American artists of our time.

Henry S. Fenimore Cooper, M.D.
Treasurer, Cooperstown Art Association
Owner, Pioneer Gallery

Wichita State University started collecting paintings by Coulton Waugh because they consider him one of

Coulton at Work. *In this little wash drawing done by Odin, Coulton is shown doing what he loved most—conspiring with nature to make art.*

the important artists of the first half of the 20th century. We are grateful that Coulton felt impelled to record his method of painting for future artists who might be interested in understanding more about how to paint color and light, his special subject matter.

Dr. Martin H. Bush
Vice President
Wichita State University

Not only was Coulton Waugh an artist, Coulton Waugh was a man greatly loved by those whose lives he touched. These tributes speak volumes. The first is by his son, John C. Waugh:

Coulton often told me that if he had not been an artist he would have been a naturalist—his love of nature was as great as his love for painting, and I think this is quite clear from the paintings in this book and from all his paintings. Apart from this, and his love for his family, he was excited by sailing boats; in his early life he did quite a bit of adventuring on the seas, and this gave him the material with which to do the comic strip Dickie Dare *for so many years.*

His life was full and happy, but, as I suppose it is with most people, he was not able to do all that he wanted to do. He had to choose, and he chose to work at a steady comic strip for many years to support his family. I'm sure he'd have liked to have had more time for painting and sailing and wandering, but even so he was never an unhappy man. He was an optimist; he cheerfully took whatever course he saw to be necessary to the health and happiness of those he loved.

And yet, he did get an amazing amount of variety into a single lifetime. In addition to the worldwide adventuring of his early life and his success at raising a family, he managed to paint literally hundreds of paintings—and to write three books as well. He didn't waste any time; he was always active and productive. He was interested in contributing to mankind and to the general elevation of concern for the world, and in this respect I believe that this book and the one before it represent a fitting culmination to his life—they are his efforts to pass on, to whomever cares to listen, what he had learned of beauty and its human expression.

Bill Goodman remembers his father-in-law in this moving account:

When Phyllis and Odin were on their way back to New York I called up a very close friend of mine, Matt Gallelli, who had had the pleasure of meeting and talking with Coulton many times. I would like to share with you his words upon hearing of Coulton's death because they seemed so true and beautiful to me when I heard them: He said that Coulton was a good man; one of the best he had ever met. And his goodness was

all the more striking, he said, because it permeated his whole soul and his whole thinking.

Certainly there is much that could be said about Mirfan, as I used to call him, but I think my friend's words explain very well why I loved Coulton Waugh so very dearly. As father to me and Phyllis he was willing to do everything he could to help us, and to encourage us to fulfill our abilities. Whenever we made a major decision, Mirfan's sincere moral support was always evident and always appreciated. His thoughtful and constructive criticism always carried with it respect for our own feelings and choices and a hope that we would ultimately steer our lives in directions he could be proud of.

I feel compelled to say a few words about my experiences with Coulton on that day which turned out to be his last with us. I optimistically believe that the events of that day clearly illustrate the qualities which have made him and will continue to make him such an inspiration to me in my own life.

One of Mirfan's dreams had come true. Phyllis had graduated from college. And in celebration he wanted nothing more than to come up and witness the convocation ceremonies. To help ease Odin's driving load on the way up, Phyllis and I took a bus to meet them at Fort Erie so we could drive them back to Waterloo. Needless to say, our meeting at the bus stop was a very, very happy one for all of us.

When we made a coffee stop on the way, Coulton chanced to see a picture of a fossil which was printed on the front of our road map. This set him to thinking, as so many things did, and ultimately led him to this conclusion: "For so long as I live," he said, "I do not ever want to become fossilized. Instead, I want always to be open to new avenues of thought, and new ways of looking at things. I want always to be alive to the fresh impressions and sensations around me." And he succeeded. During the whole day he attentively watched the landscape, always wondering how he could paint it, or how something he saw there would help him in his book. Not even the mighty airplane, that metallic beast which has been threatening the privacy, indeed the very boundaries of his beloved Green Pastures, could hope to force Mirfan into pessimism; instead he drew us some pictures on a napkin showing how beautiful the form of an airplane really is! A cartoon he drew showed Odin dodging madly for cover from the graceful wings of one of these intruders.

It was surely no fossil who asked me, that last evening, to help him learn breath control on the melod-

ica, or who told me to take life by the teeth and simply force it to meet with my requirements, not sitting back and taking no for an answer. No, it was a man very much alive and who shall always remain alive in my heart.

I have before me, in writing this, a small print of J.L. David's painting, The Death of Socrates. *In it, the philosopher is telling his comrades forcefully to stop weeping, and to start thinking about how to live their own lives as virtuously and as well as possible, as he had tried to do; meanwhile, Socrates himself does not even flinch at his own impending death. Coulton Waugh died the same sort of death, and left the same message to us—I feel honored and greatly inspired to have been with him on his last earthly day.*

And, finally, this tribute by former student and long-time friend Lillian Poulin:

Coulton Waugh was in partnership with God in the creation of beauty. He loved God's world: wild flowers, hills, valleys, brooks, and especially the woods. He shared his unique vision of the world with all who had the soul to perceive and appreciate.

His creation of beauty didn't end with jewels of color on canvas, but also extended to the playing of Brahms' sonatas exquisitely on the violin, to my accompaniment on the piano. And just as enthusiastically he played his accordian and sang rollicking sea chanties. I'll never hear "Away to Rio," "Drunken Sailor," or "Blow the Man Down" without hearing Coulton playing and singing along.

Music is my field, just as painting was Coulton's field. He often wistfully confided he wished he could have the command of all the chords on the piano; as I wistfully confessed I had only a small spark of his leaping flame before my primed white canvas.

I imagine Odin and my family will never forget Coulton singing these words of "Danny Boy" in our home the Sunday before he left this world, words he had copied from a nun who had sung it for him:

> *And when you come and all the flowers are dying,*
> *If I am dead, as dead I well may be—*
> *Ye'll come and find the place where I am lying*
> *and kneel and say an Ave there for me.*
> *And I shall hear though soft you tread above me*
> *and all my grave will warmer, dearer be—*
> *For you will bend and tell me that you love me*
> *and I shall rest in peace until you come to me.*

BIBLIOGRAPHY

Every artist owes a debt of gratitude to the artists who preceded him and who provide inspiration, point the way, and—most of all—let him know he is not alone in his glorious struggle. Unfortunately, many of the books that accompanied the author through the years are no longer in print. Three which are, and which provided much food for thought, are:

Henri, Robert. *The Art Spirit.* Ed. by Margery A. Ryerson. Philadelphia: Lippencott, 1960.

Loran, Erle. *Cézanne's Composition: Analysis of His Form with Diagrams and Photographs of His Motifs.* 3rd ed. Berkeley: University of California Press, 1963.

Paul Gauguin. Ed. by Giuseppe Marchiori. New York: Grosset & Dunlap, 1968.

Other illustrated volumes that might interest the reader are:

Lindsay, Jack. *Cézanne: His Life and Art* (Icon Editions Series). New York: Harper & Row, 1972.

Murphy, Richard W. *The World of Cézanne.* New York: Time-Life Books, 1968.

Roskill, Mark. *Van Gogh, Gauguin and the Impressionist Circle.* Greenwich, Connecticut: New York Graphic Society, 1970.

The author has found inspiration in Impressionist art in general and in the work of Cézanne, Gauguin, Monet, and van Gogh in particular. Another rich source has been Chinese and Japanese art, especially the work of the great Japanese printmaker Hiroshige. The reader will find reproductions of the best artwork available in the large-format art books and portfolios published by Abrams (New York), Phaidon (London and New York), and Skira (Switzerland). Here are a few of the Abrams volumes in the Library of Great Painters Series which the reader may wish to investigate:

Paul Gauguin. Ed. by Robert Goldwater, 1957.
Claude Monet. Ed. by William C. Seitz, 1960.
Georges Seurat. Ed. by Pierre Courthion, 1968.
Vincent Van Gogh. Ed. by Meyer Shapiro, 1950.

The reader might also like to take a look at the inexpensive, handsome, full-color Phaidon series, which includes volumes on Cézanne, the French Impressionists, Japanese prints, Renoir, Seurat, and van Gogh, among others. There is also a Skira volume, *Impressionism,* which has been a constant companion to the author. It is now out of print but can be found in libraries.

INDEX

Edited by Margit Malmstrom
Designed by James Craig and Bob Fillie
Set in 10 point Century Schoolbook Medium by Publishers Graphics, Inc.
Printed and bound by Halliday Lithograph Corp.
Color printed in Japan by Toppan Printing Company, Ltd.